THE AEGEAN WORLD

ASHMOLEAN

For further details about the Ashmolean Museum's
publications please visit: **www.ashmolean.org/shop**

KAPON EDITIONS

For further details about the Kapon edition's publications
please visit: **www.kaponeditions.gr**

THE AEGEAN WORLD

A Guide to the Cycladic, Minoan
and Mycenaean Antiquities
in the Ashmolean Museum

Edited by
YANNIS GALANAKIS

ASHMOLEAN

KAPON EDITIONS

CONTENTS

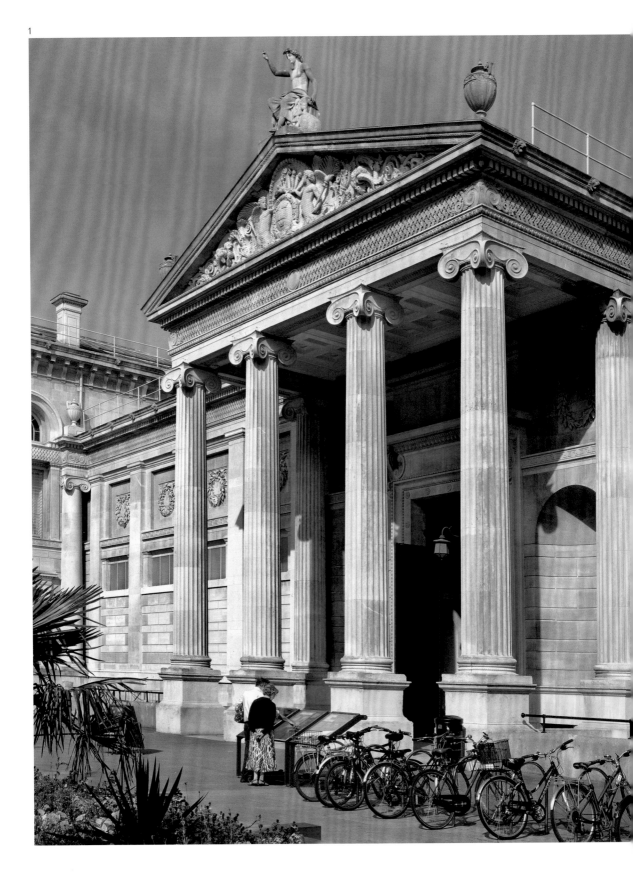

To the staff of the Department of Antiquities, part and present

Editor's Acknowledgements

This book owes a lot to a number of individuals: Dr Christopher Brown, Director of the Ashmolean Museum, and Dr Susan Walker, Keeper of the Department of Antiquities, endorsed its production from the very first moment it was suggested to them by the editor. Declan McCarthy, the Museum's Commercial Services Manager, provided constant support and encouragement. Rachel and Moses Kapon of Kapon Editions and their indefatigable team in Greece were responsible not only for producing a very handsome book, but also for putting their unfailing trust and expertise in its materialization. Katherine Wodehouse and Amy Taylor from the Ashmolean Picture Library assisted greatly with the sourcing of images. Bethany Coxon, volunteer in the Department of Antiquities, offered graciously unstinting editorial support towards the completion of the manuscript for submission to the Publishers.

Most of the excellent photographs that appear in the book were specially commissioned for the Aegean companion guide and are the result of the hard work and talent of David Gowers and Nick Pollard of the Museum's Photography Department. The objects photographed in groups owe a lot to the talent and artistic direction of Moses Kapon. Keith Bennett produced the maps, while the drawings of seals and rings that appear in this book are courtesy of Professor Ingo Pini and the CMS team (Marburg and now Heidelberg), to whom we also extend our thanks.

The book is meant to accompany visitors to the Aegean collections at the Ashmolean and the Aegean World gallery. From its original design to installation, the gallery was curated by the editor and took about three years to prepare (2007–2009). Clare Flynn and Junia Brown were responsible for the 3D and 2D design of the gallery respectively. The throne room artwork was painted by Matthew Potter. The objects were treated by Mark Norman, Dana Norris, Liz Gardner, Nicky Lobatón and Elspeth Morgan of the Conservation Department. Tim Gardom Associates (TGA) and the Education Department at the Ashmolean contributed to the planning and interpretation strategy. Metaphor developed the overall design, Luxam, Kevan Shaw and Ashmolean Building Services supervised lighting in the gallery and Meyvaert manufactured the cases.

1. View of the main entrance.

The Antiquities Department team at the time (Dr Susan Walker, Professor Michael Vickers, Dr Helen Whitehouse, Alison Roberts, Dr Jack Green, Dr David Berry, Helen Hovey and a number of volunteers and friends) provided an ideal and stimulating environment throughout the project's period of materialization. The mountmakers (David Provan and Shelley Seston) and the technicians (Kieran Champion, Timothy Crowley, Kevin Jacques and Emma Denness) led by Vicky McGuinness helped install the objects in the gallery.

Heartfelt thanks to the following people and institutions that provided permissions and assistance: Professor John Bennet, Dr Susan Sherratt, Professor Jack Davis, Professor Cyprian Broodbank, Professor Peter Warren, Gerald Cadogan, Dr Lisa Bendall, Dr Hector Catling, Helen Hughes-Brock, Lesley Fitton, Dr Paul Collins, Dr Georgia Flouda, Sinclair and Rachel Hood, Professor Chris Howgego, Dr Volker Heuchert, Dr Peter Tomkins, Dr Jacke Phillips, Alexandra Greathead, Julie Clements, Suzanne Anderson, the Herakleion Museum (Dr Giorgos Rethemiotakis), the British Museum, the University of Cincinnati (Dr Carol Hershenson), the Managing Committee of the British School at Athens (Helen Fields), the British School at Athens (Amalia Kakissis), Craig Mauzy of the American School of Classical Studies (Athens), the German Archaeological Institute at Athens, Jane Bruder and Josephine Daley (Sackler Library, Oxford), and Professor Cemal Pulak (Institute of Nautical Studies at Austin, Texas). Chronis Papanikolopoulos (INSTAP, Crete) and the Ayios Nikolaos Ephorate offered valuable and speedy help with the Psychro Cave photographs.

Work on the Aegean collections, the Sir Arthur Evans Archive and on the book itself was made possible through the generous support of the Arthur Evans Fund and the Knossos Trust, to whom we are immensely indebted.

The book would not have appeared without the financial assistance of a publication grant from INSTAP (Institute of Aegean Prehistory). We are thus grateful to the reviewers and Mrs Karen Vellucci, the Director of INSTAP's grant programmes, for their support and humbling generosity.

Undertaken with the assistance of the Institute for Aegean Prehistory

Preface

The Ashmolean is home to a remarkable collection of art and archaeology, now displayed in a stunning new building which opened in 2009. As part of the redevelopment of the Ashmolean, we paid tribute to a number of great researchers through whose efforts the Museum and its collections expanded and the Ashmolean became known internationally as a centre of archaeological research. The main figure, often rightly described as the second founder of the Ashmolean, is Sir Arthur Evans (1851–1941). Evans managed during his leadership of the Museum (1884–1908) to strengthen significantly its archaeological holdings and also merge it with the University Galleries, thus creating the Ashmolean Museum of Art and Archaeology as we know it today. However, to a wider audience Evans is primarily known for his excavations at the largest palace site in the Aegean, the so-called Palace of Minos at Knossos on the island of Crete. In the new Aegean World gallery a special display tells the story of Evans, particularly his career at the Ashmolean, his travels in Crete and the excavation of Knossos. The objects he excavated, many of which are now in the Ashmolean, defined the accepted view of Minoan civilization for a hundred years. They represent the finest collection of Minoan material outside of Greece and as such are a continuing source of study and inspiration for scholars and the public alike. This is appropriate for a museum that is a key part of a university where research is constantly producing new ideas and new questions. It is the aim of the Ashmolean to make these objects accessible to the widest possible audience in an engaging and instructive manner and this Guide is part of that endeavour. It addresses and expands upon many of the stories told in the gallery, drawing on the expertise of an extremely distinguished group of contributors in a series of essays that brings to life the world of the ancient Aegean as well as evoking the personalities of some of the individuals involved in its rediscovery. Indeed, the Guide continues the vision of Arthur Evans himself who, in his inaugural lecture in 1884, stated that it was the job of the Museum, as part of the University, to ensure that students of classics and history had a real understanding of art and archaeology. With the aid of this Guide they have an excellent means of doing so.

DR CHRISTOPHER BROWN
Director
December 2012

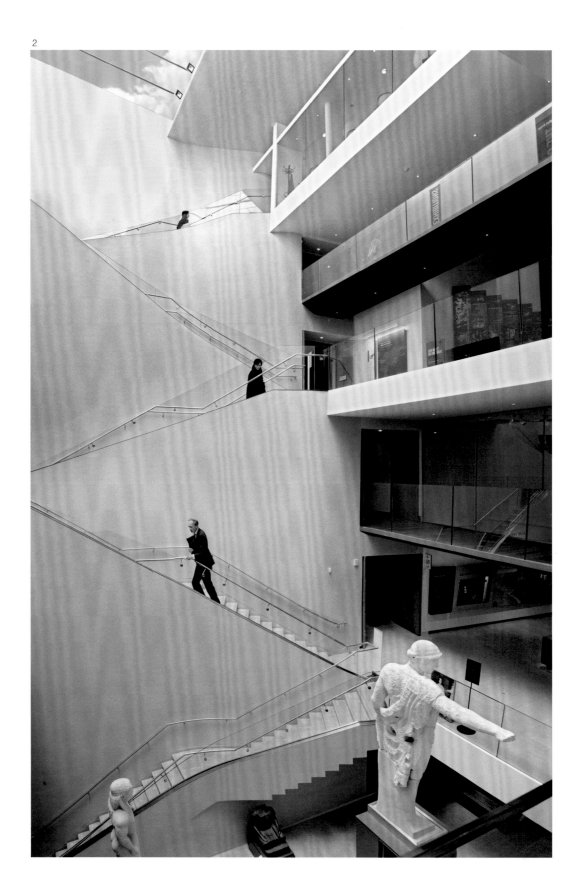

1. The Redeveloped Ashmolean Museum

SUSAN WALKER

Keeper of Antiquities, Ashmolean Museum, University of Oxford

The opportunity to develop a guide to the Aegean World gallery arose during the recent major redevelopment of the Ashmolean Museum (Fig. 1). The development plan saw the transformation of Britain's oldest museum by building 39 new galleries, four of which host temporary exhibitions, a new facility for the Ashmolean; educational, design and conservation studios and offices, along with study rooms, environmentally conditioned stores, new curatorial and administrative offices and a rooftop restaurant. The plan comprised the demolition of the late 19th-century and subsequent extensions to the north of the neo-classical University Galleries designed by Charles Robert Cockerell and completed in 1845, and the construction in their place of a finer, state of the art building designed by Rick Mather Associates to cope with the demands of 21st-century museum visitors. The new building, funded by the Heritage Lottery Fund, the Linbury Trust and numerous other private donors and foundations, was opened by Her Majesty Queen Elizabeth II in December 2009. In its first year of re-opening the museum's visitor numbers increased fourfold, with more than 1.2 million visitors, and the Ashmolean was short-listed for the Art Fund and Stirling Prizes.

The new building, six storeys high, was planned around an atrium housing a ziggurat-style staircase on its east wall (Fig. 2). Adjustable roof lighting allows natural light to permeate down to the lower ground floor. A second stairwell was built at the north-west corner of the building, again allowing some ingress of natural light. The main atrium is aligned with the heightened and remodelled front door of the museum in the Cockerell building, with which it is connected through a gallery of the same height as the Cockerell galleries. Equally, on the west side of the new building, a new, north-west stair is connected to the west end of Cockerell's sculpture gallery by a stone-floored room of similar height. To fit a six-storey building into a cramped, urban site, the architect excavated down a level, and devised an interlocking system of galleries at single or double height from the ground to the fourth floor, with rooms of medium height on the lower ground floor (Figs. 3-5). From the first floor upwards, the interlocked rooms are linked by bridges which offer tantalising views across the museum (Fig. 6). Some windows looking onto the north-south transects described above also entice visitors to move to inspect another floor. Each room offers a view into another of different height, so there is nowhere a sense of being trapped in a low-height room with no way forward.

2. The redeveloped Ashmolean Museum.

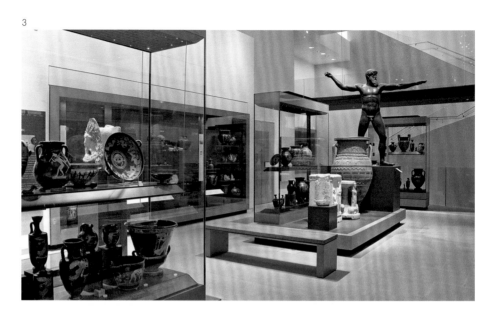

3. Greece Gallery.

4. Islamic World Gallery.

5. West meets East Gallery.

6. View of the atrium.

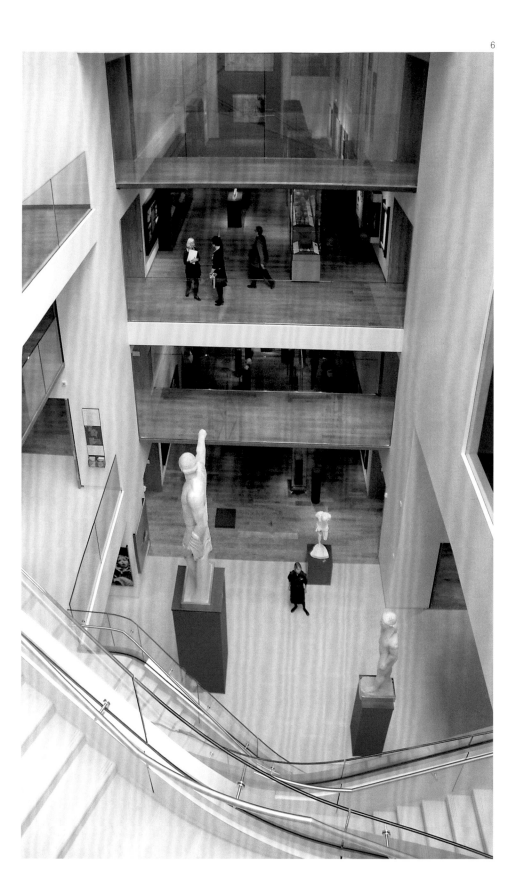

To rise to the challenges posed by the new building, the Director, Dr Christopher Brown, invited the curators to develop a new display that bridged the divisions between the Ashmolean's five curatorial departments: Antiquities, Eastern Art, the Heberden Coin Room, the Cast Gallery and Western Art, whose collections mostly remained in the Cockerell building. Henry Kim and Luke Treadwell, respectively curators of Greek and Islamic coins, devised the concept 'Crossing Cultures, Crossing Time'. After much negotiation across the museum, the concept was accepted and the lower ground floor of the new building was devoted to cross-cultural displays. These include Exploring the Past (an introduction to materials used by the various cultures

7

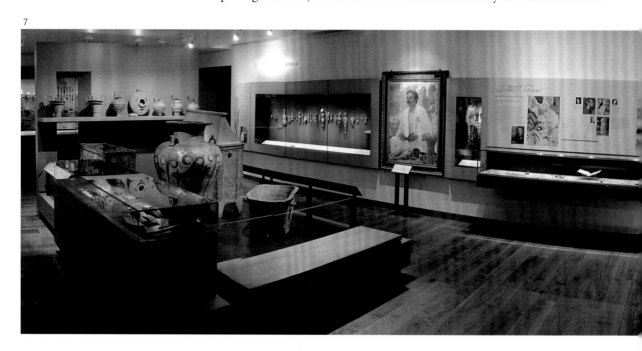

7. View of the Aegean World Gallery.

represented in the Ashmolean's collections) a Money Gallery, and next to it a Reading, Writing and Counting Gallery; beyond that a Textiles Gallery and the Human Image Gallery, where visitors are introduced to the collections through representations of the human form from all five departments. The remarkable history of the museum is told in the Ark to Ashmolean Gallery. Two galleries explore what happens to objects when they come into a museum, in Conservation and History of Conservation spaces, in which the visitor is invited to play a role in evaluating some of the ethical dilemmas of conservation.

Objects from the Aegean collection are displayed at lower ground floor level, such as the Cycladic, Minoan and Mycenaean figurines in the Human Image Gallery, the Linear B tablets in Reading and Writing and in the Restoring the Past Gallery a Neolithic sherd from Dimini (4800–4300 BC) with the oldest ceramic repair in the Ashmolean's collection. In the latter gallery the story of William Young is also told. Young was the Museum's first conservator and his work can today be seen on a number of objects from Knossos (Figs. 8–9). He wittily signed most of his works, including numerous casts, with the Greek version of his name: NEOS.

From the ground to the third floor, the 'Crossing Time' element of the concept is realised. The museum is arranged like an archaeological trench, with the earliest objects at the bottom. At every level there is a focus on the connections between peoples and cultures, and the Asian collections are integrated on the circuit. The ground floor is devoted to the Ancient World, the first floor covers the period from late antiquity to early modern times, and the second floor from early modern to modern. On the first floor there is an emphasis on links between central Asia and the Mediterranean, while on the second floor the longer sea routes from Europe to the Far East are explored. Each floor has an introductory gallery exploring these themes.

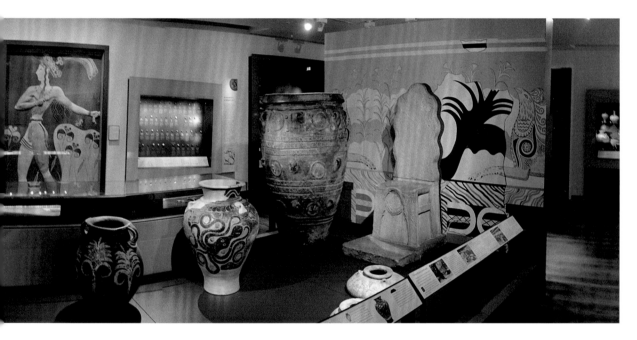

8. Bridge-spouted clay vessel from Knossos, much restored by William Young (NEOS). Middle Minoan II (1900–1800 BC). 14 cm (H). AE.912.

9. One-handled vessel in grey serpentine with plait-work in relief on the body, probably in imitation of basketwork. Much restored in plaster by William Young (NEOS). Middle Minoan IIIA (1800–1750 BC). 45 cm (H). AE.850. From the Palace at Knossos.

In December 2011 phase 2 of the Ashmolean's redevelopment was completed with the re-opening of the Egyptian Galleries, also redesigned by Rick Mather Associates (Fig. 10). The Director reassigned to Ancient Egypt and Nubia a grand gallery formerly used for the museum's shop (and earlier as a lecture theatre and, originally, for a display of casts to be studied by students of drawing at the Ruskin College of Art). This allowed for the first time the display at the correct height of colossal limestone figures of the god Min from his shrine at Koptos. Indeed, the Lisa and Bernard Selz Gallery is given over to the early prehistory of Egypt and the formation of the Pharaonic dynasties in the early Bronze Age. From here there is a direct view to the A.G. Leventis Gallery of Ancient Cyprus, located at the southern end of the western transect within the new building (Fig. 11). The western wall of the Ancient Cyprus gallery is used to display early Cypriot

10

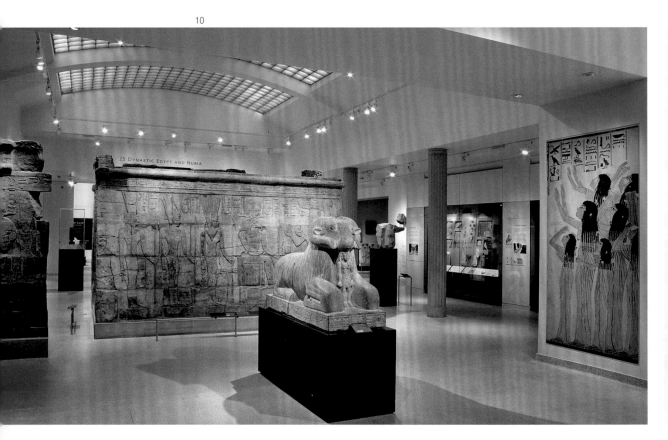

10. View of the redeveloped Egyptian displays at the Ashmolean Museum.

cultures to the end of the Bronze Age, with a focus on the island's Bronze Age development and a personal story about Sir John Linton Myres, who not only undertook pioneer excavation and publication of Ancient Cyprus, but also in later life played a key role in the decipherment of Linear B. Opening off Cyprus to the east is the gallery of the Ancient Near East. This gallery presents an overview of the art and archaeology of the civilizations that prospered in this vast geographical area from the earliest times down to the Persian period. Twinned with Ancient Near East immediately to the north is the gallery of the Aegean World which focuses primarily on the period between 3000 and 1000 BC and the civilizations of Bronze Age Greece.

Thus the visitor may compare with ease the development of Bronze Age civilisations in all of these eastern Mediterranean regions, without losing a sense of the distinctive nature of each culture. Within the Sackler Gallery of Death and the Afterlife in Ancient Egypt, a showcase displays evidence of royal authority and the links of the court beyond Egypt in the Late Bronze Age. Here Aegean objects are displayed in an Egyptian context, just as Egyptian objects discovered outside Egypt find a place in the joint display of trade and contacts in the eastern Mediterranean in the Aegean and Ancient Near East galleries. At the western end of the Aegean World Gallery, a showcase explores the take-up of the Aegean themes of Minotaurs and labyrinths in classical Greece (displayed immediately north of Ancient Cyprus) and Rome. The gallery of Rome 400 BC–AD 300 is accessible from the Aegean Gallery by bridge across the Human Image Gallery.

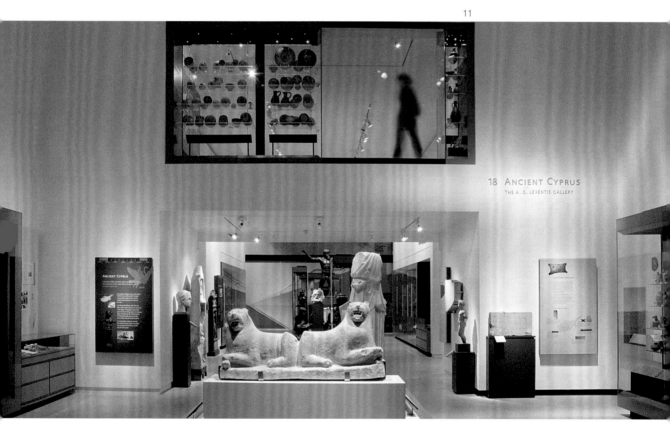

11

We hope in this way to have risen to the challenge to create displays that reflect the early history of the eastern Mediterranean region, moving across the boundaries of modern scholarly disciplines and not least those of modern nation states. We are very fortunate in the size of the Ashmolean's collections, large enough to set out such a narrative but not so large as to be daunting; in the unique quality of the museum's archaeological archives, which allow us to get inside the heads of the extraordinary people who formed and interpreted these great archaeological discoveries, and not least in the opportunity to redevelop the display of these remarkable collections in both old and new settings.

11. View of the A.G. Leventis Gallery of Ancient Cyprus.

Centrally located within the 'Ancient World' sequence on the ground floor, the gallery of the Aegean World is a bridge between the old and the new, and a tribute to the work of Sir Arthur Evans (1851–1941), the main figure of this guide. Arthur Evans was not simply Keeper of the Ashmolean Museum (1884–1908), but a true visionary who first realised the need to exhibit the archaeological collections of the museum under the best possible conditions. As is often rightly said, Evans re-founded the Ashmolean Museum by moving the archaeological collections from their elegant but inadequate 17th-century home in Broad Street (Fig. 12) and merging them with the University Galleries to produce the Ashmolean Museum of Archaeology and Art, an act completed in 1908 (Fig. 13). During Evans's keepership the Museum's archaeological collections were enormously expanded reaching some 2000 new acquisitions each year. In this respect, he managed to transform the Ashmolean into an international centre for art and archaeology that has since shaped the institutional structure and development of the Museum. Evans was also the first to envisage and carry out a major re-organisation by expanding the building in Beaumont Street. It is indeed his 1891–1894 expansion and subsequent additions to the building, that having served the life of the museum for a century, have now been replaced at the outset of the 21st century to exhibit the Ashmolean's outstanding collections to a wider public.

12. Michael Burghers (1647/8–1727). East front of the original Ashmolean building. From a 1685 engraving.

13. Frederick Mackenzie (1787–1854). South east view of the Taylor building and the University Galleries. The University Galleries were opened in 1845 and in 1908 were finally amalgamated with the Ashmolean Museum. WA1850.96.

12

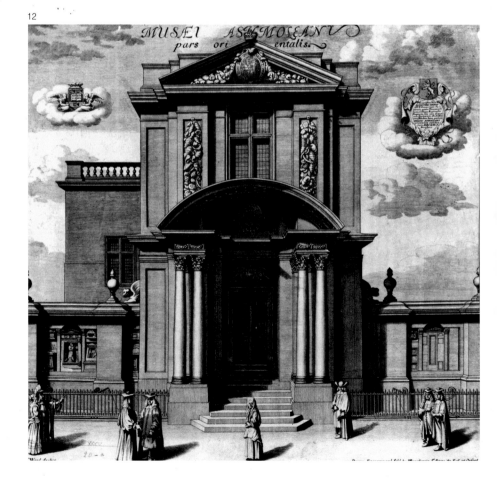

The main aim of the guide is to offer an informed introduction to the Museum's outstanding Aegean collections as they are currently understood, placing emphasis on the work of Arthur Evans both as a Keeper of the Ashmolean and as one of the main figures in the archaeology of Greece in the first half of the 20th century. The objective is to give the opportunity to a wider audience to discover some of the most interesting aspects of Bronze Age Greece through the collections of the Ashmolean Museum (Fig. 7). For this reason the book is organised chronologically and thematically. Although it is mainly focused on the third and second millennia BC, earlier and later material is also used for comparison and greater understanding. The book begins with an introduction to the Aegean World gallery and the history of the Aegean collections at the Museum and a brief introduction to Arthur Evans. With leading scholars as their guides, readers may then explore some of the most interesting aspects of the Bronze Age Cyclades, Crete and Mainland Greece, including the Aegean scripts and seals.

This is the first guide ever to be written on the Ashmolean's Aegean collections, the largest and most comprehensive outside of Greece. Richly illustrated throughout, we hope that you will find this guide a useful companion to the Aegean collections of objects and archives at the Ashmolean Museum (Fig. 7–8) and an attractive introduction to the archaeologies of Bronze Age Greece.

13

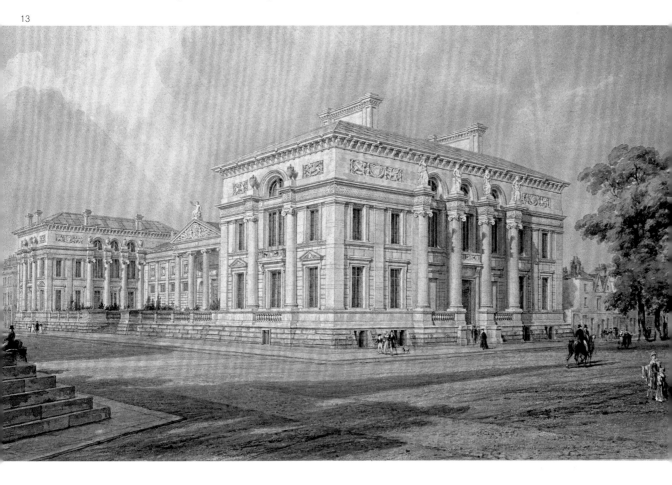

14. The Aegean World at the Ashmolean.

15. Two Mycenaean pots as drawn in the Ashmolean register book for 1896–1908.

14

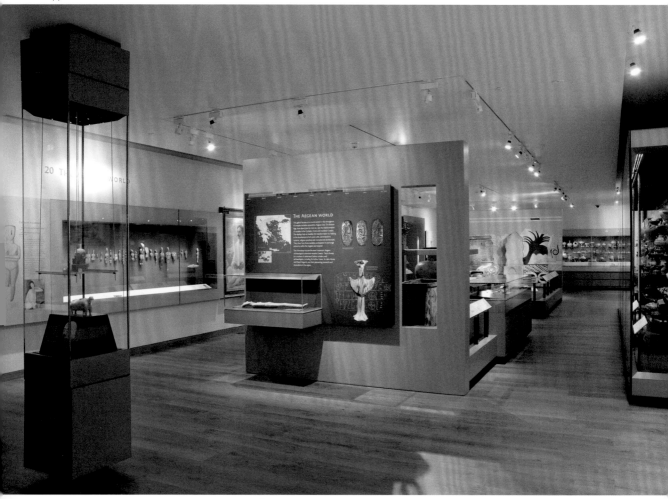

2. The Aegean World at the Ashmolean

YANNIS GALANAKIS
Lecturer in Classics (Greek Prehistory),
University of Cambridge

'The Aegean collections at the Ashmolean, taken as a whole, are the most generally representative possessed by any Museum. Athens has her magnificent Mycenaean and Cycladic antiquities, Candia her Cretan, Berlin her Trojan, and London her Cypriot. But Oxford is able to show both Cretan and Cycladic treasures of the first importance; to illustrate with abundant material the Bronze Age in Cyprus and the Aegean influence in Egypt; and to show typical Aegean products of both the European mainland and Asia Minor.'[1]

D. Hogarth, 1909

Although David Hogarth's statement may, to some extent, still echo true even after a hundred years, just 25 years before it was made the situation was quite different. When Evans (1851–1941) became the Museum's Keeper in 1884, the world's oldest public museum had only a handful of Aegean objects: a gem, not yet recognized as coming from the Aegean Bronze Age, and a few obsidian blades from the island of Melos. Following Evans's purchases, donations and gifts to the Museum from his travels and excavations, the Ashmolean today houses the largest and finest collection of Aegean antiquities outside Greece comprising around 10,000 objects (Fig. 14–15).

Apart from Evans, a number of celebrated Oxford scholars contributed to the formation of the Ashmolean's Aegean collection, most notably Sir John Linton Myres, the first Wykeham Professor of Ancient History in Oxford, and David Hogarth, who is also remembered today as the mentor of T.E. Lawrence and chief of the Arab Intelligence Bureau in World War I. The British School and the National Archaeological Museum at Athens are among the contributors to the Aegean antiquities in Oxford. What makes the collection stand out from any other outside of Greece is that for most of the objects there is unusually detailed documentation regarding their archaeological provenance, allowing us to reconstruct their 'biographies': from the time of excavation to their display in Oxford.

15



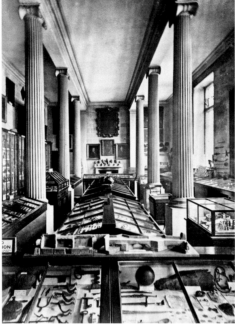

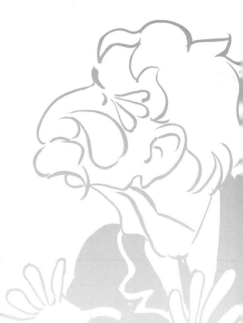

Arthur Evans's dynamic 25-year leadership of the Ashmolean (Fig. 17) ensured the successful move of the archaeological and founding collections from their elegant 17th-century quarters in Broad Street (now the Museum of the History of Science in Oxford) to Charles Cockerell's University Galleries in nearby Beaumont Street, a grand neo-classical building completed in 1845 (Figs. 12–13, 16). A new wing to house the archaeological collections was commissioned immediately to the north, and opened in 1894.[2] From their first display in the same year, the Aegean collection started to play a more prominent role in the Ashmolean's displays, not least because of Evans's own interest in the subject, and, after 1900, in association with his systematic excavations at Knossos (Fig. 18).

18

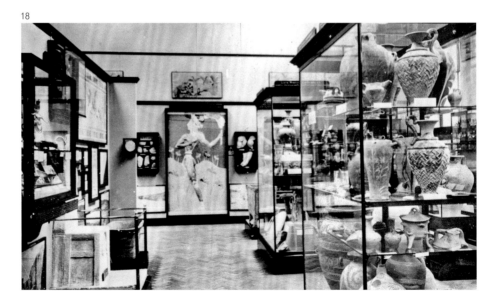

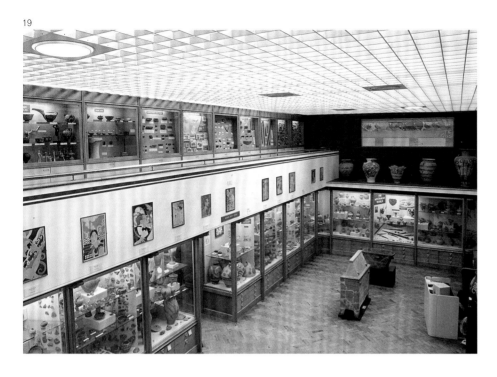

Originally displayed amongst antiquities from Egypt, the Near East, Europe and England, the Aegean collections acquired a dedicated space, the 'Minoan Room', in 1937. This space was renamed in 1951 the 'Arthur Evans Room' to honour the man who was largely responsible for its formation. Several scholars subsequently rearranged the displays in the Arthur Evans Room to a smaller or larger extent, including William Llewellyn Brown, John Boardman, Hector Catling, Michael Vickers, Ann Brown, Susan Sherratt and the present author (Fig. 19). This room along with the rest of the 1894 building and its subsequent modifications was demolished in 2005. In 2009 it was replaced with a new building designed by Rick Mather Architects[3] (Fig. 20).

20

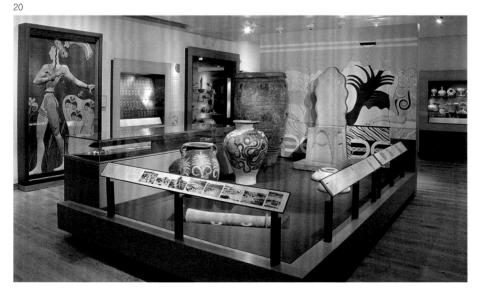

16. The archaeological collections on display in the old Ashmolean Museum, around 1870.

17. Cartoon of Arthur Evans (1851–1941) by Piet de Jong, 1920s.

18. The Aegean collections as displayed in the 'Antiquarium Room I' at the Ashmolean Museum, 1910s.

19. Gallery view of the 'Arthur Evans Room' (1983–2005).

20. Gallery view of the 'Aegean World' at the Ashmolean.

THE NEW GALLERY (SEE PLAN ON THE COVER'S FLAP)

The 2009 gallery, now entitled *The Aegean World*, occupies an area of about 160sq.m. It is equipped with 19 glass cases and two plinths. The walls are used for freestanding objects and information panels. On display are about 850 objects. Over a thousand more objects will be displayed in the numerous drawers available in the gallery, thus forming the Aegean teaching and reference collection of the University.

21

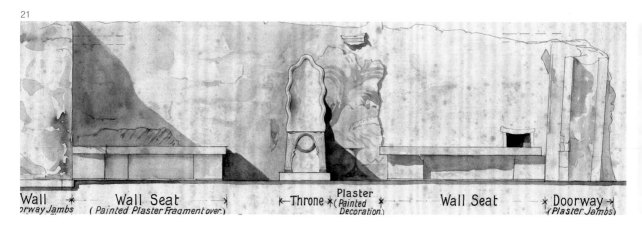

Wall ※ Wall Seat →| |←Throne ※(Painted ※ Wall Seat ※ Doorway→|
orway Jambs (Painted Plaster Fragment over.) Plaster *(Plaster Jambs)*
 Decoration.)

21. Drawing by Theodore Fyfe of the north wall of the Throne room showing painted fragments found in situ, 1901.

22. The 'Palm Fresco', one of the largest fragments of painted decoration still clinging on the walls of the palace, as found next to the gypsum throne, 1901.

23. The most recent drawing of the area next to the throne integrating information from the actual fresco fragment stored at the Herakleion Museum and the archival documentation housed at the Ashmolean. Drawing by Pepi Stephanaki.

24. View of the north wall of the throne room as was finally restored in 1930 by Evans and E. Gilliéron *fils* without taking into account the 'Palm Fresco' fragment which was by then stored in the Herakleion Museum and largely ignored.

The following chapter should be read as an illustrated introductory tour to the gallery rather than as a detailed factual archaeological analysis of the objects on display. The following chapters provide more details on particular periods and groups of objects.

The Aegean World gallery focuses on the Bronze Age (3200–1100 BC), although Neolithic material (circa 7000–3200 BC) is also included. There are three main areas in the gallery, primarily geographical but with underpinning chronological references: the Early Cyclades, Minoan Crete and Mycenaean Greece. Each area is colour-coded in an attempt to facilitate the visitor's orientation: for example greenish blue is used as the background in the Early Cyclades, the colour evoking the Aegean Sea; red is used for Minoan Crete, from the red used in Minoan painting; orange for Mycenaean Greece, representing the material of its most durable product, the humble clay pot. In addition ten panels are located throughout the gallery enhancing the visitor's experience: they provide brief information on a number of themes and are usually illustrated with a map, a timeline, pictures and graphics. Throughout the Museum, an effort was made to layer information into panels.

Significantly, the gallery challenges the visitor to explore *how we know what we know* about the Aegean Bronze Age. A large part of the Bronze Age can still be described as pre-historic and given that the later readable sources, the Linear B tablets, are specialised bureaucratic documents (**Chapter 7**), it can be argued that archaeology plays a fundamental role in shaping our understanding of the largest part of this period. Given also the Museum's strong association with Arthur Evans and his extremely influential role in shaping Minoan Crete, it was important for the Ashmolean to highlight the role of archaeologists and other related scholars in filtering and diluting what we know of the past.

To illustrate this point we focus, for example, on the changing approaches and shifting attitudes to the aesthetics of Cycladic figurines and on Evans's reconstructions, both architectural and that of objects.[4] Pride of place in this interpretative framework is reserved for the artwork showing part of the Room of the Throne at Knossos. The artwork juxtaposes Emile Gilliéron the younger's 1930 restoration of the north wall, still admired by thousands of visitors every year (the two griffins flanking the throne shown in greyscale in the gallery) with what Evans actually found in place (a palm tree

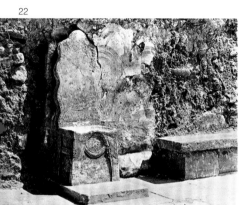

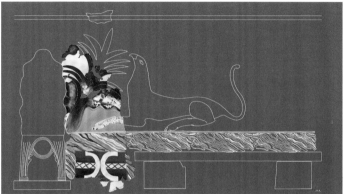

springing from the throne, ignored in the final, 1930, restoration, here shown in colour). This artwork was made possible thanks to the excavation photos and drawings from Evans's work at Knossos today archived at the Ashmolean. We are now working closely with the Archaeological Museum at Herakleion in an attempt to piece together the available material remains (the fresco fragments) and the archival documentation in order to reconstruct what Evans actually found in situ almost 110 years ago. The first results, following the conservation of the original fragment at Herakleion, have already, and quite literally, yielded fruits: we have been able to identify that this a fruit-bearing palm (Figs. 21–24).

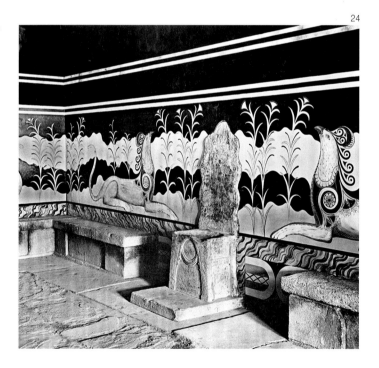

It is hoped that the new display of the Aegean World gallery will introduce visitors to the intricacies of material culture, and in particular to the process of archaeological interpretation. One of the main aims is to help visitors engage more with material remains and make archaeology and the work of archaeologists more accessible to a general audience; to inspire and spark in everyone a curiosity and enthusiasm for the intellectual richness of the Aegean collection at the Ashmolean.

EARLY CYCLADES

The section on the Early Cyclades is divided into three main themes: 'Early Cyclades 3200–2100 BC', 'Phylakopi on Melos, 2200–1100 BC' and the 'Cycladic Figurines' (see also **Chapter 4**). Marble and clay vessels, copper and bronze tools and weapons, silver ornaments, a 'frying pan', obsidian blades, stone tools, mat and basket impressions, loomweights, and the 'Kapros D assemblage', the latter said to be from a tomb on the island of Amorgos, form the bulk of the material on display in the first section. The emphasis here is on the development of seafaring, the procurement of raw materials and the circulation of ideas that kept life going and information flowing in the Early Cyclades (Fig. 26).⁵

The material from Phylakopi on Melos is perhaps the most important assemblage within the Cycladic collection at the Ashmolean. It comes from the early British excavations at the site (1896–1899). Phylakopi provided the first reasonably complete timeline for the Aegean Bronze Age and became the main reference point for Cycladic prehistory for several decades. In its different strata archaeologists found buried material from mainland Greece, the Cyclades and Crete, allowing better chronological synchronisms across the Aegean. The distribution of Melian obsidian, a hard volcanic glass used for cutting implements, to nearby lands provides the earliest evidence for long distance contacts within the Aegean and the development of seafaring – as early as 11,000 BC, based on evidence from the Franchthi Cave in the Argolid and a few other Aegean sites.

25. The display of Cycladic figurines in the 'Aegean World' gallery. This display includes some Neolithic and west Anatolian examples (left side) and a few replicas (right side) to illustrate the use of colour and painted decoration as well as the deposition of the figurines in graves. The Ashmolean has the finest collection of Cycladic figurines outside of Greece.

Almost 40 figurines are displayed in the Early Cyclades section: the largest (among the ten largest in the world) is displayed lying flat in its own case, since most of the Cycladic figurines cannot stand upright without support, while a few of the most intriguing pieces are displayed in a freestanding case – for example, the marble beaker in the shape of a female figure and the sheep *kernos* (a multi-container vessel). A number of themes are explored, including paint on Cycladic figurines and the role of women in early Cycladic societies: most of the figurines show nude female individuals at an early stage of pregnancy. The main group of figurines on display in a 3m long case consists of marble examples from the Cyclades arranged by type, although Neolithic examples and contemporary figurines from western Turkey are also displayed for comparative purposes (Fig. 25).

25

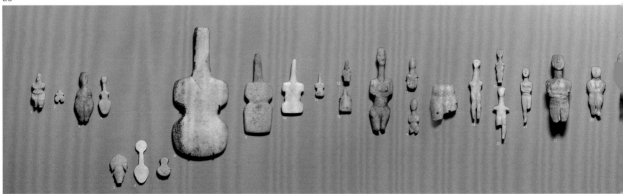

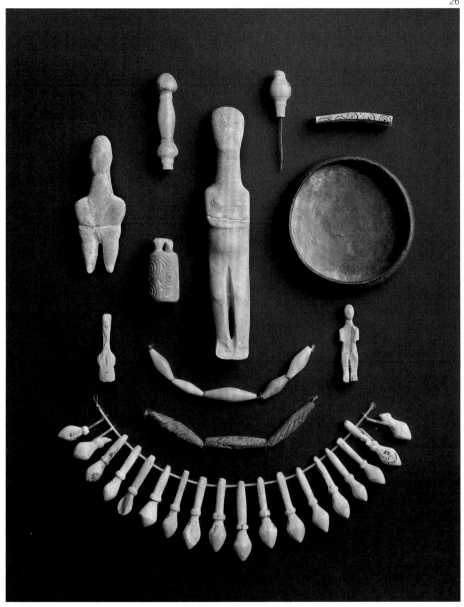

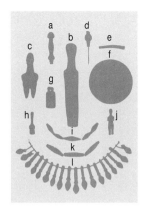

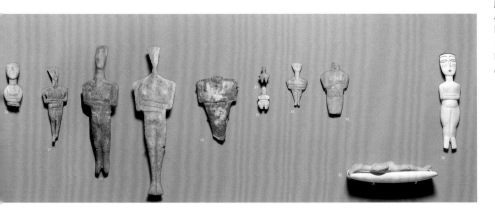

26. The 'Kapros grave D group' said to have been found in a tomb on Amorgos.

a) Green stone handle, L: 6.6 cm. AE.160 (AN1893.53); **b)** Copper needle, perhaps for tattooing, and green stone handle (modern grouping), 7.7 cm (L). AE.164 (AN1893.54), AE.161 (AN1893.51); **c)** Marble figurine, 9.5 cm (H); AE.155 (AN1893.48); **d)** Marble folded arm type figurine, 17 cm (H). AE.154 (AN1893.47); **e)** Bone object with incised compass-drawn concentric semi-circles, but possibly post-Early Cycladic in date. 1.6 (H) × 5.4 cm (L). AE.165 (AN1893.56). **f)** Shallow silver bowl, 1.6 (H) × 8.5 cm (Diam.). AE.158 (AN1893.46); **g)** Stamp cylinder seal, 4.6 (H) × 1.9 cm (Diam.). AE.159 (AN1889.307); **h)** Violin-shaped shell figurine, 4.6 cm (H). AE.157 (AN1893.49); **i)** Green and yellow-brown stone beads, 2.7–3.7 cm (L). AE.162 (AN1893.52); **j)** Shell figurine, 5.3 cm (H). AE.156 (AN1893.50); **k)** Silver beads, 4.3–4.5 cm (L). AE.163 (AN1893.54); **l)** Marble pendant beads and fragments, 4.2–5.4 cm (L). AE.166 (AN1893.55).

ARTHUR EVANS AND MINOAN CRETE (SEE ALSO CHAPTERS 3 AND 5).

A number of personal stories are told in the new Aegean World gallery, including those of Duncan Mackenzie, Piet de Jong, the Gilliérons, David Hogarth and Heinrich Schliemann. Tribute is also paid to the workers who played their own significant role in making archaeology happen, such as the 'superman among foremen' and the best 'tomb hunter of the Levant', the Cypriot Gregoris Antoniou (Fig. 27).

Yet the personality that dominates the Aegean gallery is that of Arthur Evans. His official portrait by Sir William Richmond shows him as he wanted to be remembered: a romantic doyen of Cretan archaeology (Fig. 28). This is juxtaposed to the cartoon drawn in 1924 by Piet de Jong, which captures the way people actually saw him: as an energetic monkey, even at the age of 73 when de Jong made the drawing (Fig. 30). 'For unusualness was of the essence of his being', as his half-sister, Joan Evans, wrote.[6]

Next to the portrait of Evans is a case featuring a clay conical vessel (a *rhyton*) from Palaikastro in east Crete, an object destined for use at a banquet or a religious festival. The *rhyton* is displayed in front of an archival drawing showing the 'Cup-Bearer': the first Minoan on a fresco fragment to be discovered by Evans at Knossos during the very first season of excavation at the site in 1900.[8] This case offers the opportunity to look closely at the way things were used in the past (for example the

27

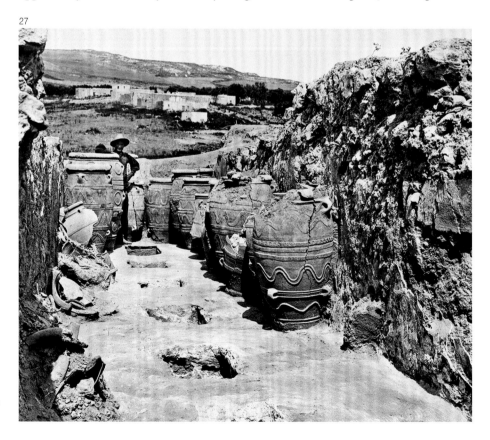

27. Grigoris Antoniou in one of the storerooms filled with storage jars (*pithoi*) at Knossos, 1901.

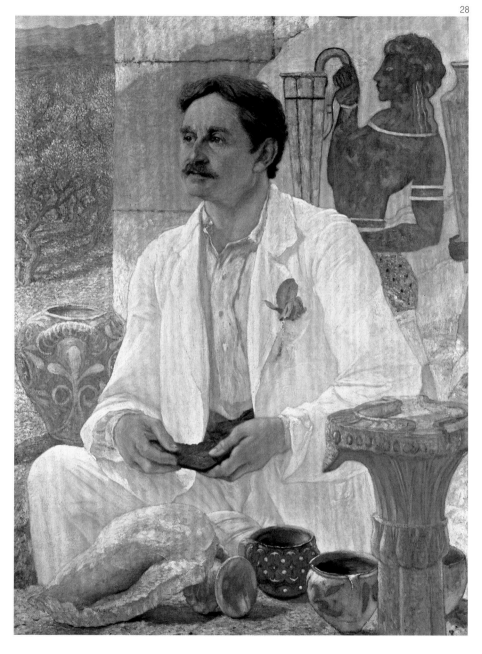

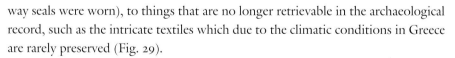

28. Sir William B. Richmond. Portrait of Arthur Evans among the ruins of Knossos, 1907. The portrait received 'mixed reviews' when it was first displayed in the National Portrait Gallery in London. It shows Evans as he wanted to be remembered – the doyen of Minoan archaeology. The reconstructed ruins in the background and the Cretan landscape take the viewer to Knossos despite the fact that it was painted exclusively in London. The objects in front of Evans are all replicas, still stored at the Ashmolean. Evans is holding the object he most longed for – a Linear B tablet. Watercolour. 152 (L) × 117 cm (W). WA 1907.2. Presented by the Society of Friends of Arthur Evans.

29. The 'Cup-Bearer' (1500–1400 BC) and the Palaikastro *rhyton*. The clay rhyton was found in Room 4, Block δ at Palaikastro. It dates to the Late Minoan IB, 1600–1450 BC. 35.4 cm (H). AE.780. British School at Athens Excavations.

way seals were worn), to things that are no longer retrievable in the archaeological record, such as the intricate textiles which due to the climatic conditions in Greece are rarely preserved (Fig. 29).

Along with the cartoon of Arthur Evans those of Mackenzie, Gilliéron and de Jong are also displayed (as printed graphics) in the gallery. The Ashmolean houses around 50 de Jong cartoons which vividly encapsulate the personalities of some of the most important protagonists in Aegean archaeology working in Greece around the time of Arthur Evans[7] (Figs. 31–35).

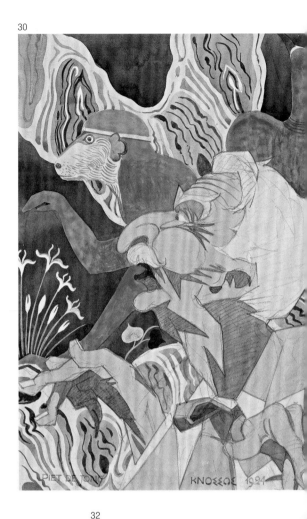

30. Piet de Jong. Cartoon of Arthur J. Evans, 1924. The cartoon conveys the impression of Evans as an energetic man even at the age of 73. De Jong paid attention to detail, including Evans's facial expression and his overgrown nail on each little finger that Evans used as a 'pocket excavator's tool'. The background is taken from the restored wall paintings from the 'House of Frescoes' at Knossos. The alignment of his head with that of the monkey may refer to Duncan Mackenzie's habit – Evans's chief archaeologist at Knossos – of referring to Evans as 'that monkey' behind his back! Painting on cartridge paper. 40.8 (L) × 29 cm (W). AN 2003.147 (1). Presented by the Knossos Trust.

31. Piet de Jong. Cartoon of Carl W. Blegen, 1925. An American archaeologist of Norwegian descent, Blegen (1887–1971) is today remembered through his outstanding work at Troy, Pylos, Prosymna (the Argive Heraion), Korakou, Zygouries, and Tsoungiza. He was Professor at the University of Cincinnati. In the cartoon, De Jong emphasizes Blegen's fascination with pottery sequence by placing pots at different levels. The serious scholarly expression underlines the efficient and industrious scholarship of Blegen. Painting cartridge paper. 47.8 (L) × 36.2 cm (W). AN 2003.147 (29). Presented by the Knossos Trust.

32. Piet de Jong. Cartoon of Alan J.B. Wace, 1920. Wace (1879–1957), a British archaeologist, is today remembered for his excavations at Mycenae in mainland Greece, his pioneering research in Thessaly, his wide-ranging interests (including textiles and anthropology) and for directing the British School at Athens. He was also the Laurence Professor of Classical Archaeology in the University of Cambridge. De Jong's cartoon is simple: in the background is a reconstructed lion from Mycenae's 'Lion Gate' and a black fill to contrast to the colourful and genially beaming face of Wace. Painting on cartridge paper. 37.5 (L) × 30.2 cm (W). AN 2003.147 (6). Presented by the Knossos Trust.

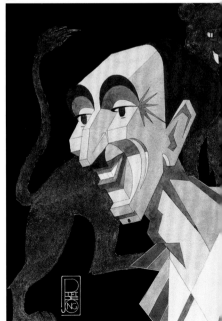

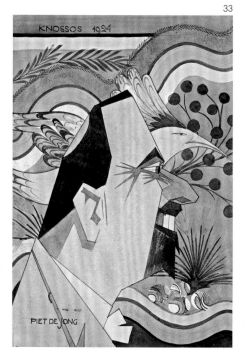

33

34

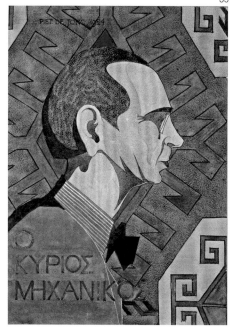

35

33. Piet de Jong. Cartoon of Émile Gilliéron *fils*, 1924. Émile Gilliéron *fils* (1885–1939) and his father, Gilliéron *père* (circa 1850–1924) were highly creative Swiss-born artists resident in Athens. Between them they were responsible for restoring and reconstructing most of the Knossos frescoes and objects under the guidance of Evans. Their vivid restorations have considerably influenced what we know (or think we know) and admire about Minoan art. Painting on cartridge paper. 40.5 (L) × 27.1cm (W). AN 2003.147 (3). Presented by the Knossos Trust.

34. Piet de Jong. Cartoon of Duncan Mackenzie, between 1922 and 1928. Duncan Mackenzie (1861–1934) was Evans's chief assistant at Knossos. His thoroughness in excavation practices and systematic approach, already from the Phylakopi excavations on the island of Melos (1896–1899), were remarkable at a time when scientific principles of excavation had not yet been fully established. Mackenzie's fundamental role in systematically documenting the Knossos excavations, a monumental undertaking in each own right as it required the supervision of more than 200 workers, is captured in this cartoon. Painting on card. 46.1 (L) × 29.2 cm (W). AN 2003.147 (2). Presented by the Knossos Trust.

35. Piet de Jong. Self-portrait of Piet de Jong, 1924. De Jong (1887–1967) was a talented British architect of Dutch origin and the most charismatic archaeological illustrator of his age. His imaginative reconstructions of the various quarters of the palaces at Knossos and Pylos have captured the imagination of many and have created an elaborate and refined view of the Greek Bronze Age. He was also influential in the reconstructions at Knossos, especially with regard to the fragmentary nature of the reconstructed ruins. The label at the bottom left reads 'Mr Engineer' in Greek. Painting on heavy weight paper. 35.1 (L) × 24.9 cm (W). AN 2003.147 (42). Presented by the Knossos Trust.

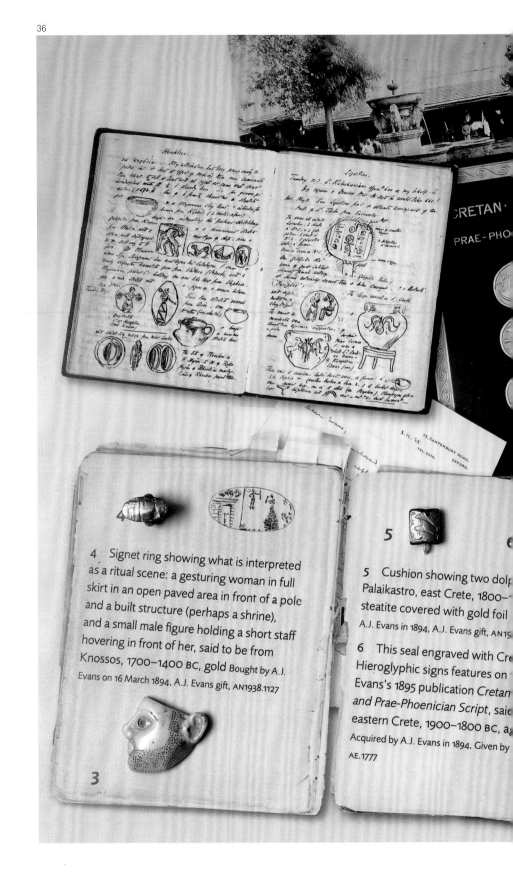

4 Signet ring showing what is interpreted as a ritual scene: a gesturing woman in full skirt in an open paved area in front of a pole and a built structure (perhaps a shrine), and a small male figure holding a short staff hovering in front of her, said to be from Knossos, 1700–1400 BC, gold Bought by A.J. Evans on 16 March 1894, A.J. Evans gift, AN1938.1127

5 Cushion showing two dolp
Palaikastro, east Crete, 1800–
steatite covered with gold foil
A.J. Evans in 1894, A.J. Evans gift, AN19

6 This seal engraved with Cre
Hieroglyphic signs features on
Evans's 1895 publication Cretan
and Prae-Phoenician Script, said
eastern Crete, 1900–1800 BC, a
Acquired by A.J. Evans in 1894. Given by
AE.1777

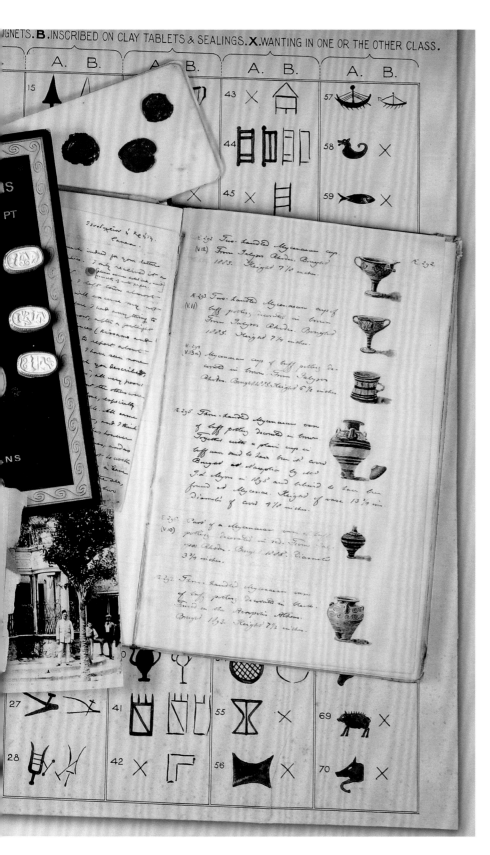

36. A display of archival material and objects relating to Evans's travels in Crete (1894–1899).

33

A table-case accompanies the information panel: the story of Evans is broken down into three major periods, echoing his favourite tripartite system of Minoan chronology ('Early', 'Middle' and 'Late'). The first period focuses on his work at the Ashmolean (1884–1908) and the Chester seal: a gem given to the Museum in 1889 by the Reverend Greville John Chester,[9] on which Evans first identified signs of a pre-alphabetic writing system (Figs. 264–271). This object is said to have sparked his interest in ascertaining the existence of pre-alphabetic writing in the Aegean. Although Evans was looking for one script to prove his theory, he managed at the end to identify three different systems of writing which he dubbed Cretan Hieroglyphic or Pictographic, Linear A and Linear B respectively (see also **Chapter 7**). While in Athens in 1893, art dealers informed Evans that most of these gems came from the island of Crete and it was there that he made his most extraordinary discoveries. The second section of this display is dedicated to his travels and explorations on Crete between 1894 and 1899[10] (Fig. 36) and the third to Evans's Knossos excavations (1900–1931) (Fig. 39).

Evans was not the first modern excavator of Knossos. This title belongs to Minos Kalokairinos, a Cretan businessman and antiquarian who investigated parts of Knossos in the late 1870s.[11] Evans was not even the only one who had a special interest in the site – many were the suitors, amongst them Heinrich Schliemann, who decided not to purchase the site because he found the price that the landowner was asking exorbitant. Yet Evans was the only one who succeeded in purchasing the entire land where the palace once stood and was the first to thoroughly bring the ruins back to life in a systematic manner (Fig. 37).

37

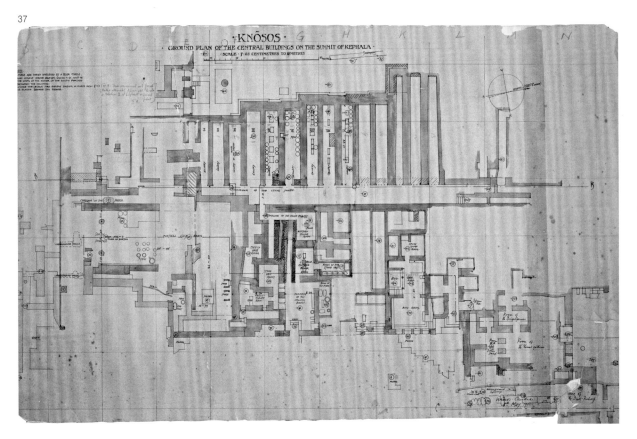

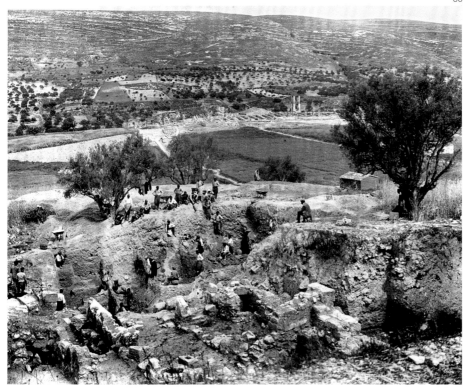

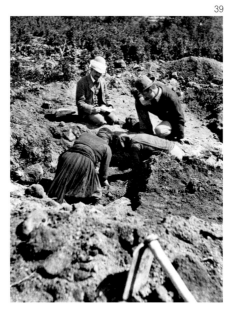

Despite several criticisms raised by modern archaeologists about the excavations at Knossos, including the fact that only one archaeologist, Evans's chief collaborator Duncan Mackenzie, was responsible for supervising often over a hundred workers and several different trenches simultaneously (Figs. 34, 38), the overall quality of archaeological documentation from Knossos is generally good by the standards of the time. Evans involved in his work professional excavators, artists, restorers, architects, conservators and photographers. His workforce comprised Christian and Muslim Cretans as well as women and children (Figs. 40–44); a complicated task made possible through his determination, stubbornness, and financial resources, most of which he inherited from his father, the famous prehistorian Sir John Evans – another major figure in the history of archaeology and the Ashmolean Museum.[12]

37. A section from the earliest full-scale ground plan of the Palace at Knossos by Theodore Fyfe (1875–1945). Possibly 1902 or early 1903. With pencilled additions. Arthur Evans Architectural Drawing GP/10.

38. Mackenzie, seen here seating on a stool, supervises work at the 'Little Palace' at Knossos, 1905. Photograph by Noel Heaton.

39. Evans, Mackenzie, Antoniou and another worker in the course of excavation, 1901.

40

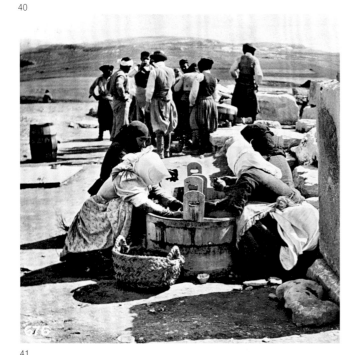

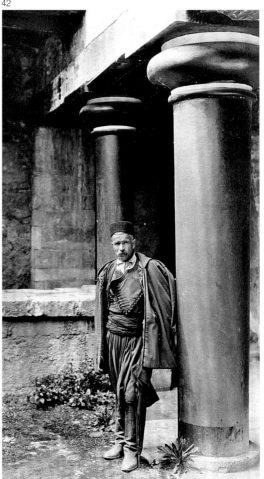
42

41

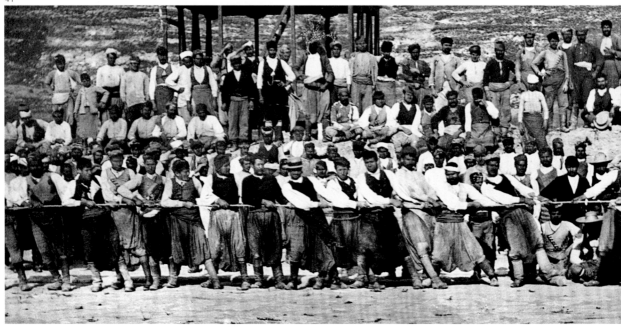

43

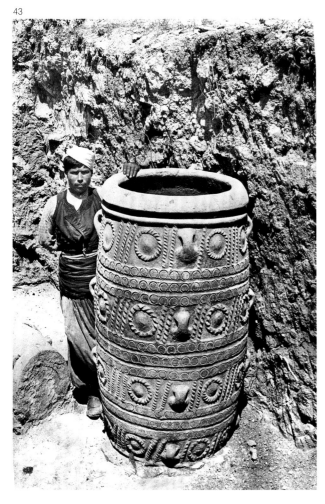

44

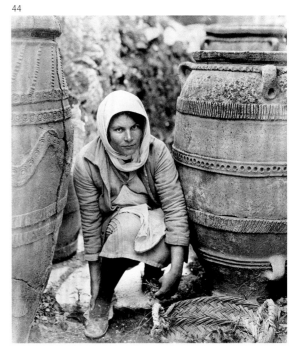

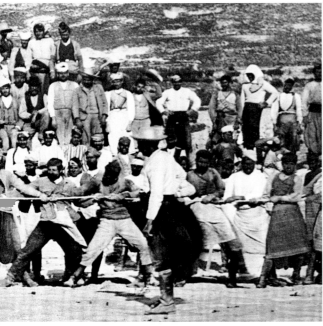

40. Women washing pottery in the Central Court by the Throne Room complex, 1901.

41. Tug-of-War in the west court of the Palace at Knossos, 1902.

42. A man dressed in traditional Cretan costume at the bottom of the reconstructed Grand Staircase, around 1910.

43. A worker and a tall storage jar, 1902.

44. Cretan girl next to jars (*pithoi*) in the storerooms ('magazine 12') in the Palace at Knossos, 1902.

45. Watercolour reconstruction drawing of the 'Priest-King' by E. Gilliéron *fils*, 1926. The relief figure of the 'Priest-King' (1700–1450 BC) is one of the most recognizable of the Knossos paintings. The fragments were found in 1901 to the south of the Central Court of the Palace at Knossos. Evans originally thought that they belonged to three male figures, perhaps part of an elaborate procession. The subsequent reconstruction of a single figure was conceived gradually in Evans's mind, in step with the development of his ideas about Minoan religion and kingship. Evans thought that the 'Priest-King' was the ruler of Knossos and adopted son on earth of the Minoan Goddess. Most scholars now argue against Evans's interpretation of the figure as a 'Priest-King'. The full-size plaster replica that is now on display in the gallery was made by William Young, the Ashmolean's first conservator.

46–48. The Ashmolean houses some romantic reconstructions of the Palace that were commissioned by Evans from a number of different artists in order to illustrate his monumental *Palace of Minos* publication and became the blueprint for his actual reconstructions at Knossos.

46. A.J. Lambert. 'Room of the Throne', Palace at Knossos, 1917. Watercolour. 56cm (L) × 38cm (W). Arthur Evans Fresco Drawing A/7.

47. Émile Gilliéron *fils*. 'Hall of the Double Axes', Palace at Knossos, before 1931. Watercolour. 36 (L) × 26cm (W). Arthur Evans Fresco Drawing T/18c.

48. Émile Gilliéron *fils*. 'Queen's Megaron', Palace at Knossos, before 1931. Watercolour. 56 (L) × 41cm (W). Arthur Evans Fresco Drawing E/4.

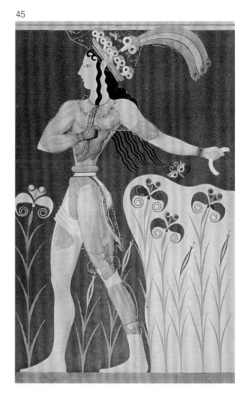

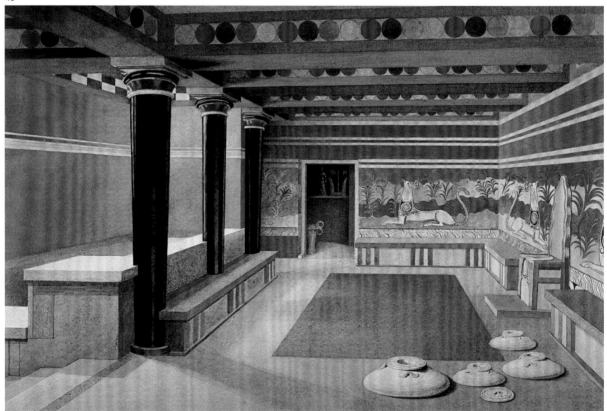

Next to the story of Evans are some romantic watercolour drawings of various rooms of the palace at Knossos along with the replica of the 'Priest-King', in one of its many versions (Fig. 45). The drawings were used in the *Palace of Minos*, Evans's monumental publication that gave a synthesis of his Knossos excavations and his vision of Minoan Crete. This was not, strictly speaking, an excavation account but a compendium of how Evans viewed the archaeology, history and art of Minoan Crete. The drawings were also used as blueprints for his restorations of various rooms at Knossos – restorations largely guided and influenced by his architects as much as by his vision of Knossos at its peak (Figs. 46–48). Within this vision, the 'Priest-King' was cherished by Evans as the ruler of Knossos. It is now thought to represent another youthful figure, probably taking part in a procession at the palace.[13]

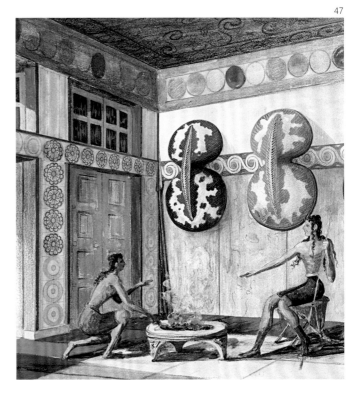

47

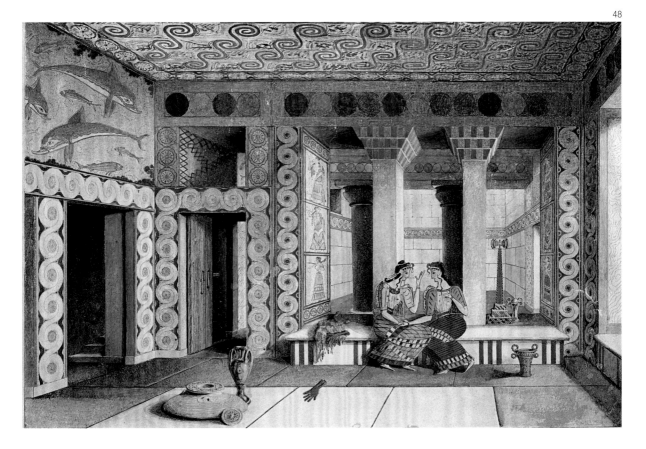

48

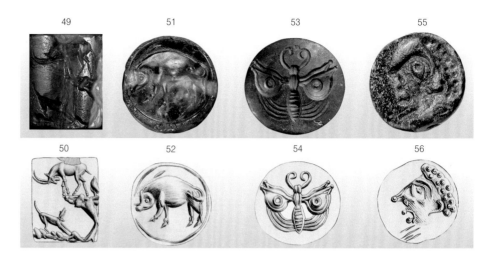

49, 50, 51, 52, 53, 54, 55, 56

49, 50. Flattened cylinder (cushion) seal, said to be from Archanes, Crete. It shows a collared dog barking at a wild goat standing on a rocky outcrop. Middle Minoan III–Late Minoan I, 1800–1450 BC. Bluish chalcedony. 1.5 (L) × 1.2 (W) × 1.65 cm (Th.). AN1938.954.

51, 52. A bi-facial discoid seal of rock crystal showing a boar. The animal's tusks, tail and feet are clearly rendered. The other side, not illustrated here, has a dog springing onto the back of a wild goat biting the base of its horns. Found at Sphaka, East Crete. Middle Minoan II-III, 1900-1700 BC. 1.8 cm (Diam.). AN1938.943.

53, 54. Haematite seal engraved with a butterfly. No provenance. Late Minoan I, 1700–1450 BC. 1.25 cm (Diam.). AN1941.1229.

55, 56. Steatite or serpentinite seal with a bearded man with open mouth. No provenance. Middle Minoan III–Late Minoan I, 1800–1450 BC. 1.4 cm (Diam.). Given by Dr A. Hamerton (ex-de Jong coll.).

A case with seals complements Evans's story and quest for pre-alphabetic writing.[14] The Ashmolean holds more than 550 gems and rings, including some of the finest known examples, purchased by Evans from local owners and art dealers[15] (Figs. 49–56). These little gems, true masterpieces in miniature, were known locally as *galopetres*: charms or amulets that ensured the flow of milk to lactating mothers. The seals, given their small size and often intricate representations and colours, are accompanied by drawings to make them more accessible to the non-specialist (see also **Chapter 8**). Despite their miniature size, the level of detail surprises the visitor as in the case of the tiny bluish chalcedony (H: 1.5cm), said to be from Archanes, that shows a collared dog barking at a wild goat that stands on a rocky outcrop – a great story that brings to mind Aesop's tale of 'the Kid and the Wolf': 'it is not you who is taunting me, but the place on which you are standing!'[16] (Fig. 49).

The side opposite the story of Arthur Evans is dominated by five large cases in a row. Four of them offer an overview of Minoan Crete from around 7000 to 1000 BC. Broad themes include the stratigraphy at Knossos, eating and drinking, warrior burials, arts and crafts and cult and ritual. Although the bulk of the material on display comes from Knossos, other Cretan sites represented include Ayia Pelagia, Phaistos, Kato Zakros, and Palaikastro.

Knossos is one of the oldest farming communities in Europe and the earliest and most complete settlement on Crete. Successive layers of occupation, of at least 9000 years, have created a man-made hill of 13 m in height. The Neolithic layers occupy the largest part of the hill (at points more than seven metres) but due to the fact that they stand under the later 'palace' they are only partially known.[17] The first permanent settlers were probably farmers who brought with them some domestic animals, such as goats, pigs and cattle, and seed for their crops. They made tools of bone and stone; spindle whorls and loomweights indicate that they knew how to spin and weave. Obsidian was imported from the island of Melos to be chipped like flint to make cutting tools. They made clay and stone figurines, whose purpose is not entirely clear, while pottery was handmade throughout the Neolithic (Fig. 57).

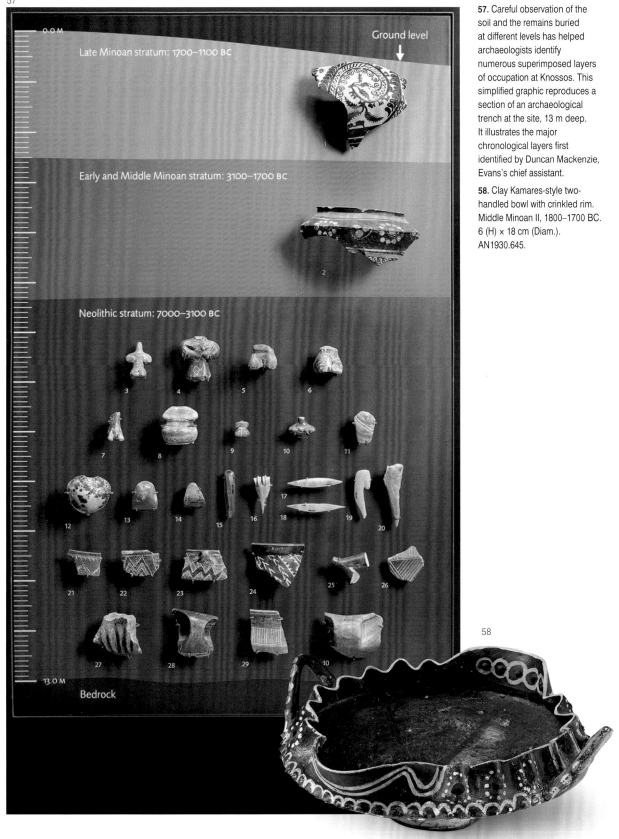

57

0.0 M

Ground level

Late Minoan stratum: 1700–1100 BC

Early and Middle Minoan stratum: 3100–1700 BC

Neolithic stratum: 7000–3100 BC

13.0 M

Bedrock

58

57. Careful observation of the soil and the remains buried at different levels has helped archaeologists identify numerous superimposed layers of occupation at Knossos. This simplified graphic reproduces a section of an archaeological trench at the site, 13 m deep. It illustrates the major chronological layers first identified by Duncan Mackenzie, Evans's chief assistant.

58. Clay Kamares-style two-handled bowl with crinkled rim. Middle Minoan II, 1800–1700 BC. 6 (H) × 18 cm (Diam.). AN1930.645.

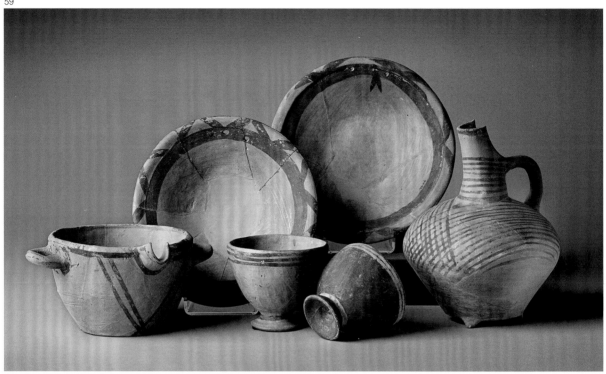

59. Group of Early Minoan pottery. Two plates with suspension holes, two cups, a spouted bowl and a jug. The jug comes from Mochlos. The other pots were part of a floor deposit from the area of the 'South Corridor', Palace at Knossos, Crete, Early Minoan II, 2700–2200 BC. Spouted bowl: 8.5 cm (H), AN1910.146; Cream-coloured pedestal cup: 7.5 cm (H), AN1910.149; Red pedestal cup: 6.5 cm (H), AN1910.151; Two plates: 18.3–19 cm (H), AN1910.152–153 (Knossos); Jug: 18.7 (H) × 15 cm (W), AN1909.340 (Mochlos).

60

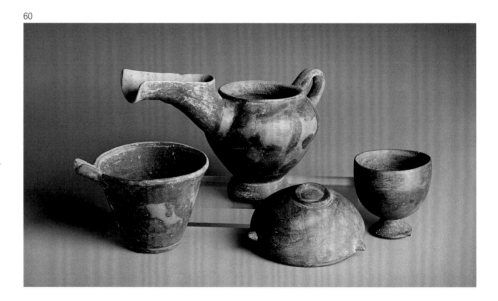

The systematic development of agriculture, seafaring, contacts between communities, craft and industrial output led to the formation of ruling groups. They formed local centres of power, consumption, production, exchange and ritual. Settlements expanded in size and architectural sophistication and the first monumental tombs marked the island's landscape as early as the 4th millennium BC. Different types of tableware attest to the establishment of more formal drinking and eating practices around that time and in the course of the 3rd millennium BC (Figs. 59–61).

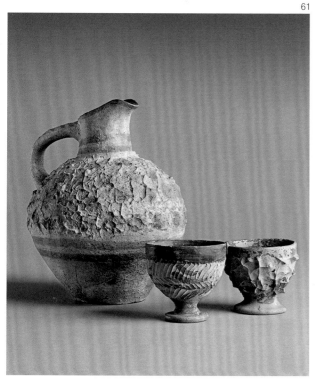

60. Four clay 'Vasiliki' pots. A beak-spouted jug ('teapot'), a bucket, a cup and a bowl. These mottled pots take their name from Vasiliki, an important Minoan village in the Isthmus of Ierapetra in East Crete. Mottling has been interpreted as imitating metal vessels, stone vases or even leather. The 'teapot' and the bucket come from Richard Seager's excavations at Vasiliki in 1904. The bowl and the cup come from Evans's excavations at Knossos. Early Minoan II, 2700–2200 BC. 'Teapot': 18.5 (H) × 30.5cm (L from spout to handle), AN1910.160; Bucket: 10.3 cm (H), AN1910.159; Cup: 8.8 (H) × 9.2 cm (Diam.), AN1910.157; Bowl: 7.5 (H) × 14 cm (Diam.), AN1938.410.

61. A jug and two cups. Their body has a flaky relief appearance called by archaeologists 'Barbotine ware'. Middle Minoan I, 2100–1900 BC. Jug: 17.5 cm (H), AN1974.310; Two cups: 5.5–6.1 cm (H), AE.930 and AN1910.161.

62. Kamares pottery from the Palace at Knossos. Forming one of the island's most distinct styles, Kamares pots are characterized by thin walls and a remarkable degree of individuality and inventiveness in design. Given the prominence of eating, drinking and storing shapes, Kamares pots appear, in some contexts, to form serving sets. Middle Minoan II, 1900–1800 BC. Clay. Angular bowl: 6.8 (H) × 11.1 cm (Diam.), AE.841; Bridge-spouted jug: 14 (H) × 9.3 cm (rim Diam.), AE.912; Large one-handled cup with decoration imitating wool: 10.4 cm (H), AE.914; Thin-walled one-handled cup: 4.1 (H with handle) × 5.7 cm (rim Diam.), AE 934+AE.1204; Tumbler decorated with rosettes within squares: 6.5 (H) × 5.8 cm (rim Diam.), AE.944; Bowl with red and white 'racquet pattern': 6.2 cm (H), AN1929.405.

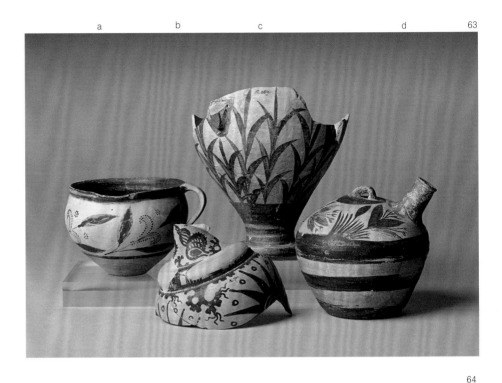

63. Neo-Palatial pottery with themes inspired by nature.
a) One of the finest examples of vase painting of the Neo-Palatial period, this one-handled clay cup from Knossos is decorated with an olive spray recalling the art of wall painting. Late Minoan IB, 1600–1450 BC. 8.9 (H) × 11.4 cm (rim Diam.). AN1938.476.
b) Part of the neck and body of a conical vessel (*rhyton*) for pouring liquids. It is decorated in the 'Marine style' with rocks and shells. Worth noticing is the murex shell on the neck of the vessel. Murex shells played an important role in the textile industry because of the purple dye they provided. House A?, Kato Zakros. 13.4 cm (H). AE.785+786. British School Excavations at Kato Zakros.
c) Base of a clay jar from Palaikastro in East Crete decorated with grass or reeds. A hole on the underside suggests that the pot might have been used either as a flowerpot or for pouring liquids. Late Minoan IA, 1700–1600 BC. 16.5 cm (H): AE.859. British School Excavations at Palaikastro.
d) A clay aromatic-oil container (*askos*) from Knossos decorated with crocuses. Late Minoan IA, 1700–1600 BC. 12.5 cm (H). AE.845.

64. Kamares style storage jar decorated with a group of three white palm trees set on a black glazed background. The leaves are outlined with red paint. The pot's metallic appearance is emphasized by the crinkled rim, the plastic 'ring' on the neck and the laid-on handles. The other half of the pot is in the Herakleion Museum (HM7691). 'Loomweight basement', Knossos. Middle Minoan IIB, 1850–1800 BC. Clay. 54.5 (H) × 21 cm (base Diam.). AE.1654.

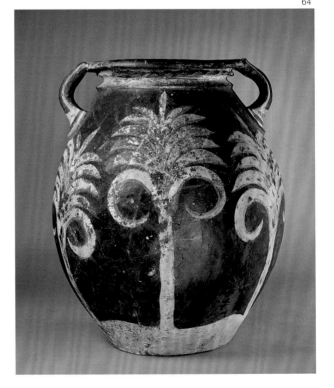

Gradually regional centres, known in modern literature as 'palaces', were formed (see also **Chapter 5**). The finds discovered in these early ('proto'-) 'palaces' display a notable degree of specialist craftsmanship and contacts from around the Aegean and the Mediterranean. Clay bars and medallions inscribed in the Cretan Hieroglyphic script and sealings (seal impressions) indicate the development of administration (see **Chapter 7**). The polychrome Kamares pots form the most distinctive pottery group of the Proto-Palatial period. They take their name from the Kamares Cave in south Crete, where in 1890 they were first discovered in great quantities (Figs. 58, 62, 64).

During the 'Neo-Palatial' period (1800–1450 BC) Cretan sites reached the peak of their prosperity. Objects, technologies and ideas spread far beyond the island. Clay tablets written in the Linear A script and sealings underline the importance of central administration. Buildings expanded and were now more elaborately built. Crafts reached a peak in production, refinement and dexterity. Artists created a colourful visual environment, inspired by nature as well as by all aspects of everyday life (Figs. 63, 65). According to one theory, the eruption of the Santorini volcano (c. 1600/1500 BC) may have contributed to the reconfiguration of power on Crete. All 'palaces' were destroyed by 1450 BC, except for Knossos that shows only limited signs of destruction.

65. E. Gilliéron *fils*. Restored 'Monkey and Papyrus' fresco scene. 'House of the Frescoes', Knossos. Between 1923 and 1928 (original: Middle Minoan III–Late Minoan IA, 1800–1600 BC). Watercolour. 64 (L) × 44 cm (W). Arthur Evans Fresco Drawings A/8.

65

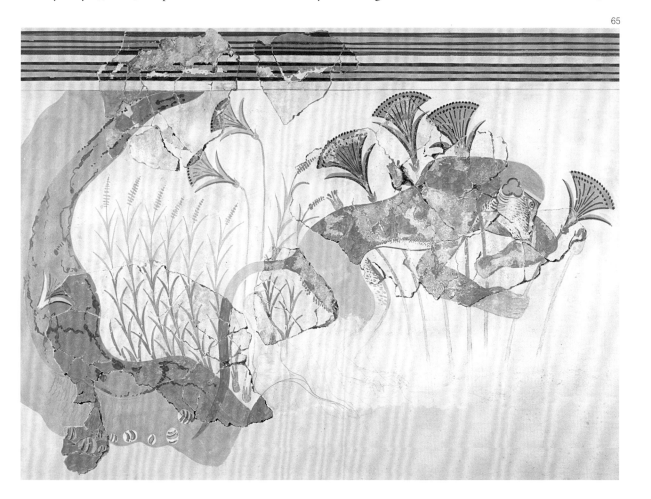

66. '66. 'Warrior graves' in Crete – bronze weapons and a serpentine pommel, 1400–1100 BC:
a) Pommel with incised decoration. Central Crete. 4 cm (H). AN1938.838.
b) Sword, originally wrapped in cloth. Zapher Papoura cemetery, pit-cave 55, Knossos. 65.8 cm (L), 364.6 gr. AE.481.
c) Sword in fragments decorated with minute spirals along the midrib and hilt flanges. Zapher Papoura, shaft grave 44, Knossos. 90 cm (L). AE.482.
d) Short sword. Zapher Papoura cemetery, Knossos. 35.2 cm (L), 299.4 gr. AE.472.
e–f) Partly restored short sword and spearhead, said to be from a tomb in the Siteia region. 34.4 cm (L), 216.4 gr. (AN1966.544); 41.9 (L) × 3.6 cm (W) (AN1966.547). Museum purchase;
g) Two arrowheads, Zapher Papoura, possibly from pit-cave 10 ('the Hunter's grave'), Knossos. 3.5–4 cm (L). AE.483, AE.484.
h) Sword, said to be from a tomb in the Siteia region. 51.3 (L) × 5.8 cm (W at shoulder). 454.2 gr. AN1966.542. Museum purchase;
i) Sword (Naue II type), said to be from a tomb in the Siteia region. 51.2 cm (L), 378.2 gr. AN1966.543. Museum purchase;
j–l) A razor and two knives, said to be from a tomb in the Siteia region. 19.5 (L) × 6.4 cm (W) (AN1966.550); 29 (L) × 2.7 cm (W) (AN1966.551); 22 (L) × 2.3 cm (W) (AN1966.552). Museum purchase;
m) Spearhead, from the 'Acropolis tomb', Knossos. 18 cm (L). AE.492.
n) Razor, Zapher Papoura cemetery, shaft grave 4, Knossos. 19.3 cm (L). AE.487.
o) Knife, Zapher Papoura cemetery, pit-cave 64, Knossos. 20.6 cm (L). AE.488.

It was around 1450 BC that a new burial practice appeared at Knossos. Men of some social importance were buried in graves alongside their weapons and a few clay pots, some perhaps filled with wine or oil. One theory is that the 'warrior ethos' reflected in the graves displays the domination of Knossos over the other Cretan 'palaces'.[18] Alternatively, they are interpreted as the result of the island's conquest by the mainland Greeks who brought with them their own burial practices. Zapher Papoura, the largest Late Bronze Age cemetery site at Knossos (1400–1200 BC) with some hundred tombs, included several 'warrior graves'. More similar graves have recently come to light at Chania in the west part of the island. The objects on display in the 'Aegean World' gallery help to visualise some of the metal objects often placed in these 'warrior graves' (Fig. 66).

66

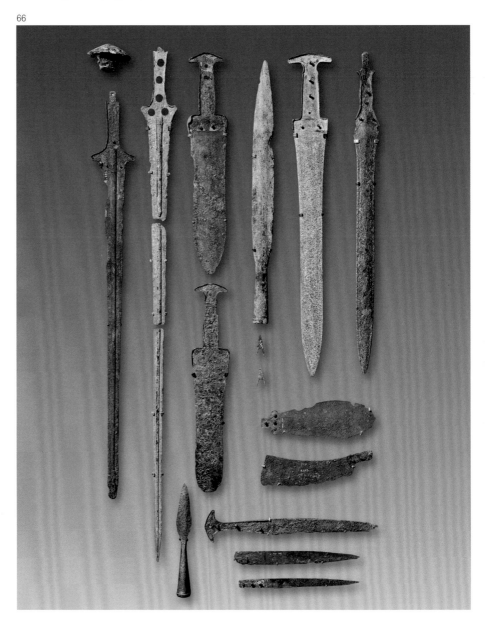

Despite some evidence of destruction around the palace, Knossos continued to be the centre of administration from 1450 to 1375 BC. Tablets written in Linear B, an early form of Greek, give evidence of how Knossos controlled almost the entire island. Knossos was probably destroyed around 1375–1350 BC (in pottery terms, early in Late Minoan IIIA2). The date of the Linear B tablets and the causes of Knossos' destruction, whether by internal strife or by conquest, are hotly debated among scholars.[19] During the following period, a number of sites probably acted as small-scale regional centres (including Chania) until their final destruction, demise or abandonment around 1250–1200 BC. In comparison to earlier periods, Late Minoan pottery (1400–1200 BC) is less inventive and experimental and more standardised (Figs. 67–69).

a b c 67

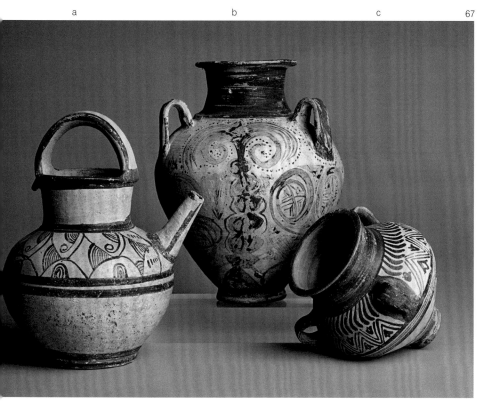

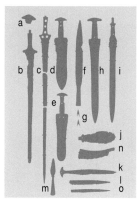

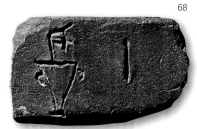

68

67. Three Late Minoan clay pots. **a)** 'Feeding bottle'. The conical spout has a narrow opening providing a steady flow of the liquid stored in the pot. Although 'feeding bottles' may be found alongside child burials, they are also attested in other contexts and the large size of some of them suggests a versatile function for this pot.
Said to be from Crete. Late Minoan IIIB, 1300–1200 BC. 22.6 (H) × 16.1 cm (body Diam.). AN1967.528. Museum purchase. **b)** Storage jar with stylised lilies. Ayia Pelagia. 23.5 cm (H). Late Minoan IIIA, 1400–1300 BC. **c)** Storage jar with linear decoration. Probably from the Palaikastro area. 14.5 (H) × 13.5 cm (Diam.). Late Minoan IIIA2, 1375–1300 BC. Museum purchase.

68. A fragment of a leaf-shaped Linear B tablet from Knossos. It records 'one' (the vertical line to the right) two-handled 'jar' (represented with an ideogram) on top of which the sign for /u/ has been inscribed. The latter stands for *u-do-ro* ('water') suggesting that this is actually a water-jar. Palace at Knossos (K 1810). Late Minoan IIIA2 early, 1375–1350 BC. Burnt clay. 4 (L) × 2 cm (W). AN1938.855.

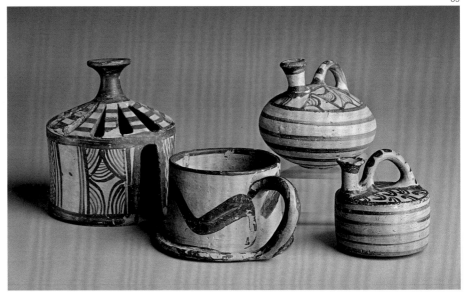

69. 'Incense burner' with perforated conical lid and two aromatic-oil containers (*askoi*). Said to come from Ta Pharangia, Sphakia, West Crete. Late Minoan IIIB, 1300–1200 BC. Clay. Incense burner: 12.6 (H) × 7.9 cm (cup Diam.), AE.282; Two *askoi*: 6.6 and 7.5 cm (H), AE.283-284.

70. Votive clay limbs. The commonest types include arms and hands, legs and feet, torsoes and heads and sections of body parts. Our understanding of prehistoric modelled body parts draws on later Greek and Roman practices to dedicate anatomically modelled body parts to Asclepius, in anticipation of or as thanks for the successful outcome of healing. Petsophas near Palaikastro, East Crete. Middle Minoan I–II, 2100–1800 BC. 10 (L) × 2 (W). AE.1016, AE.1018[1], AE.1018[2]. Excavated and presented to the Museum by John Myres in 1903.

71. Miniature clay bovid. Petsophas near Palaikastro, East Crete. Middle Minoan I–II, 2100–1800 BC. 4 cm (L). AE.1025[4]. Excavated and presented to the Museum by John Myres in 1903.

72. a and **c)** Two male figurines from the peak sanctuary of Petsophas near Palaikastro, East Crete. Dressed with a cod-piece and with the arms brought to the chest, the tallest of the two figurines is also equipped with a dagger. Middle Minoan I–II, 2100–1800 BC. Clay. 13.4 cm (H): AE.990; 13 cm (H): AE.1010. Excavated and presented to the Ashmolean by John Myres.
b) A female figurine with raised arms. The figure probably wears a bodice of some sort, perhaps a corset or a waistcoat, and a short cylindrical headdress. Said to come from the 'Shrine of the Double Axes', Palace at Knossos. Late Minoan IIIA, 1400–1300 BC. Clay. 17.1 (H) × 7 cm (base Diam.). AN1924.32.

The last case along the wall looks, admittedly rather sketchily, at 'Cult & Ritual' and 'Arts & Crafts' in Minoan Crete. The former is covered with the offerings from the peak-sanctuary at Petsophas in east Crete and replicas of some of the objects found in the 'Temple Repositories' at Knossos, while a display of stone vessels and fresco fragments presents aspects of the latter theme.

Excavations in Crete have brought to light cult sites ranging from open-air sanctuaries to settlement shrines. At peak sanctuaries and caves, offerings were made to the gods, most frequently in the form of clay and bronze human and animal figurines and possibly foodstuff. John Myres examined in 1903 the summit of Petsophas, a mountain overlooking the Minoan town of Palaikastro (Figs. 70–71). He was on a cruise in the East Mediterranean but was 'induced to exchange the luxuries of ocean travel for the privations of the excavator's lot'.[20] Myres discovered a large number of clay figurines that included whole and partial animal and human figures dating to 1900–1450 BC. The human figurines in particular reveal an expressive body language that might have played a prominent role in religious performance (Fig. 72).

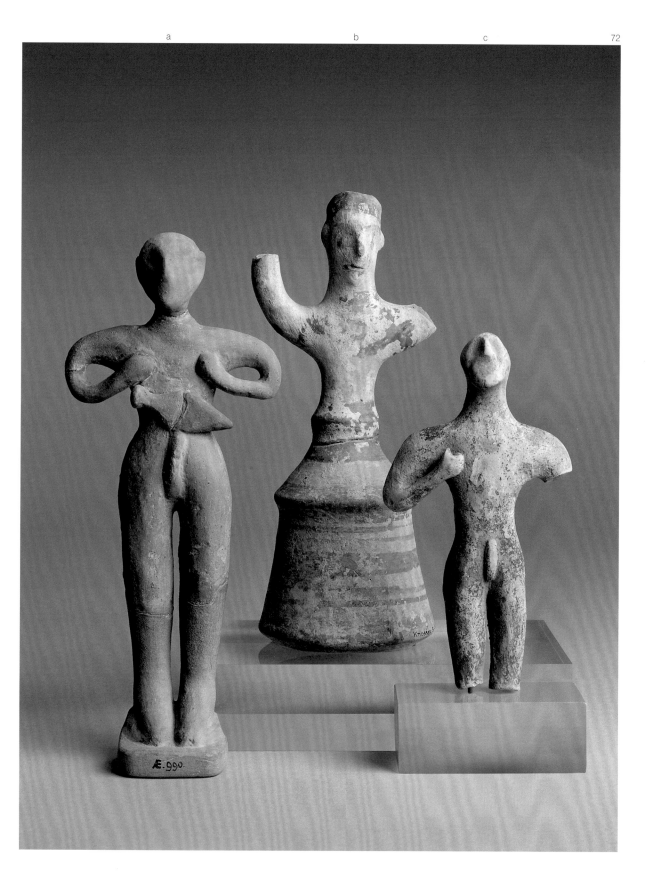

The same year as Myres's exploration at Petsophas, Evans and his team discovered two deep stone-lined cists ('Repositories') in a small room to the south of the 'Throne Room'. Pottery and 'treasures' were found in them dating to around 1700–1600 BC. Many pots closely packed together were placed in the middle layer, amongst them vases decorated with birds that had been imported to Knossos from the island of Melos. At the lowermost layer a variety of small objects were discovered, including the faience figure of a snake goddess and followers. This extraordinary group of objects is considered by some scholars a foundation deposit to ensure the longevity of the structure built above it [21] (Figs. 73–76).

73. The 'Temple Repositories', 1903. The two cists yielded an interesting mix of objects: a large number of jugs, numerous sealings, a single inscribed Linear A tablet and a variety of small objects of ivory, bone, shell and faience, including the famous faience figures of a 'snake goddess and votaries'.

74. Replicas of two 'votive robes' from the 'Temple Repositories'. The robes are decorated with crocuses and girdles. Early 20th century AD (original circa 1600 BC). Plaster casts made by Halvor Bagge (original made in faience). 16.3 and 23.7 cm (H): AE.1112 and AE.1108.

75. Finds from the 'Temple Repositories'. According to a recent interpretation, the c. 6340 shells found there should best be explained as the outcome of communal involvement in the formation of these deposits.

73

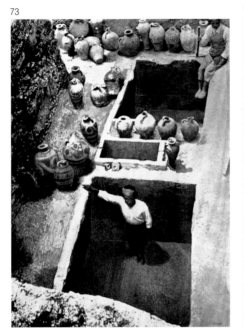

74

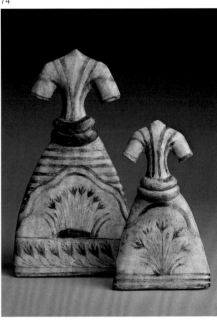

75

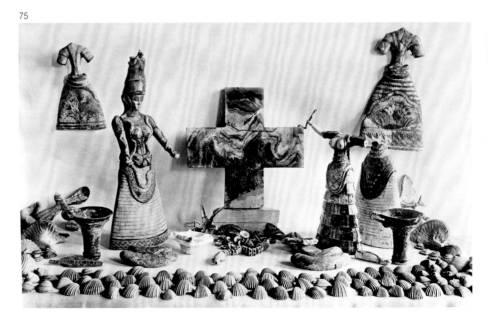

Stone working developed more systematically in the Aegean, on Crete and the Cyclades, during the 3rd millennium BC. In the 2nd millennium BC some of the most ornate stone vessels were made, including the lion and bull-headed *rhyta*, for use in ceremonies (see Figs. 197–199, 202–204, and 292). Simple stone tools, such as drills, and abrasives, such as emery, were used in the production of the stone vessels. Local materials (steatite) were used alongside imported ones: from Egypt (diorite, alabaster), mainland Greece (Spartan basalt) and the Cyclades (obsidian). After the fall of Knossos, around 1350 BC, the craft of stone carving diminished on Crete[22] (Figs. 77–82).

76

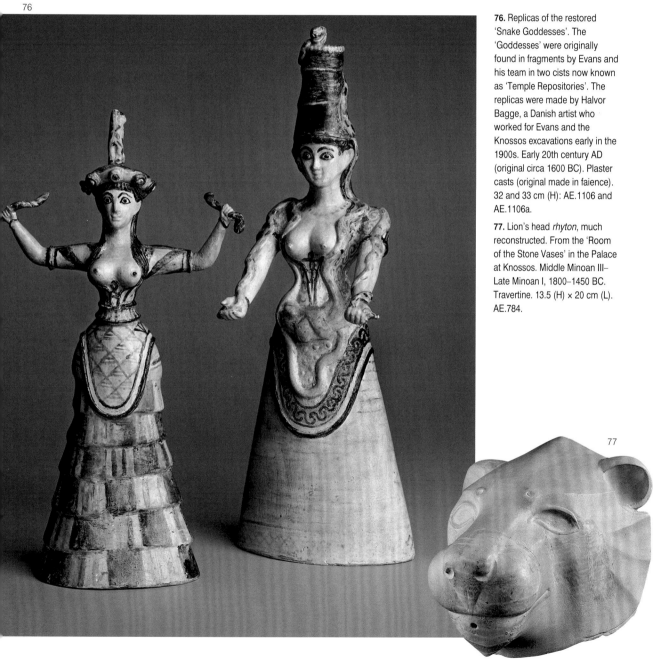

76. Replicas of the restored 'Snake Goddesses'. The 'Goddesses' were originally found in fragments by Evans and his team in two cists now known as 'Temple Repositories'. The replicas were made by Halvor Bagge, a Danish artist who worked for Evans and the Knossos excavations early in the 1900s. Early 20th century AD (original circa 1600 BC). Plaster casts (original made in faience). 32 and 33 cm (H): AE.1106 and AE.1106a.

77. Lion's head *rhyton*, much reconstructed. From the 'Room of the Stone Vases' in the Palace at Knossos. Middle Minoan III–Late Minoan I, 1800–1450 BC. Travertine. 13.5 (H) × 20 cm (L). AE.784.

77

78. Pedestal lamp. Provenance unknown. Late Minoan I, 1700–1450 BC. Blue-grey limestone. 39.5 (H) × 21.5 cm (Diam.). AN1971.840. Museum purchase (ex-Bomford coll.).

79. Bowl with two handles and decoration in the rim. 'Block X', Palaikastro, east Crete. Middle Minoan III–Late Minoan I, 1800–1450 BC. Serpentine. 6.1 cm (H). AE.890. British School at Athens Excavations.

80. Bowl with knobbed lid. Said to come from a tomb at Arvi, Crete. Early Minoan III–Middle Minoan I, 2200–1900 BC. Serpentine. 8.2cm (H) × 9.8 cm (max. Diam.). AE.210 (AN1899.99).

81. Blossom bowl. Late Minoan I, 1700–1450 BC. Serpentine. 6.1 (H) × 10.2 cm (max. Diam.). AN1938.618.

82. Frieze fragment with a half-rosette pattern in relief originally probably decorating the lower part of a wall. 'Northwest Hall', Palace at Knossos. Late Minoan II–IIIA2, 1450–1300 BC. Bluish-grey stone. 16 (H) × 28 cm (L). AE.791.

Large-scale painting in the Aegean probably first developed on Crete. Inspired by nature and aspects of everyday life, painters created a colourful and vivid visual environment (Figs. 83–84, 141, 196–197, 208, 210).[23] Although aspects of the painting process are still unclear, it is generally thought that painters worked on moist plaster (*buon fresco* technique). Should the plaster have dried out, though not completely, lime-water might have been used as a vehicle for the paint in place of water (*secco fresco* technique). Paintings decorated floors, ceilings and walls, as in the case of the bull-leapers which formed part of a larger composition that probably decorated the wall of a first floor apartment in the Palace at Knossos. It consisted of a series of panels, each depicting a scene from the bull-games.

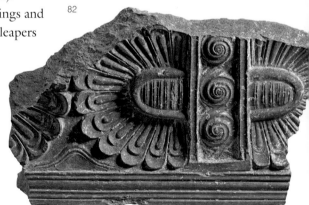

From the art and archaeology of Minoan Crete, the visitor is subsequently introduced to the Cave of Psychro in the Lasithi Plateau[24] (Fig. 85–86). One of the island's most famous cave sanctuaries, the Psychro attracted the attention of antiquarians and archaeologists already in the 19th century. Evans and Hogarth both conducted excavations there. 'To Psychro I betook myself with a few trained men, some stone-hammers, mining-bars, blasting powder, and the rest of a cave-digger's plant.'[25] This famous quote by Hogarth highlights the dramatic changes in archaeological practice between the 19th and the 21st century, and so does the following: 'in hope of the reward, which I gave for the better objects, and in the excitement of so curious a search, which, in their earlier illicit digging, it had not occurred to them to attempt, the villagers, both men and women, worked with frantic energy…a grotesque sight, without precedent in an archaeologist's experience.'[26] (Figs. 85–92).

83

84

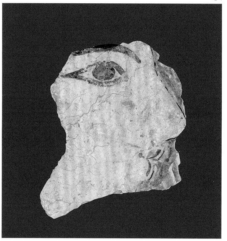

83. Flowering olive sprays. 'Gallery of the Jewel Fresco', Palace at Knossos. Middle Minoan III, 1800–1700 BC. 5.5 cm (H). AE.1711.

84. Woman's face in profile. Palace at Knossos. Late Minoan I, 1700–1450 BC. 7.5 cm (H). AE.1706.

85. The Ashmolean holds a large collection of objects from the Psychro Cave high up on the Lasithi plateau in east-central Crete. The cave, which was excavated at various times between 1886 and 1900 (including by Arthur Evans in 1895–1896), was associated by early research with the Dictaean Cave, the birthplace of Zeus, the senior divinity of the Greek pantheon. This association has lost ground in recent years. Lithograph based on a photo showing the 1890s excavations in the upper chamber, just before the main entrance to the Cave of Psychro.

85

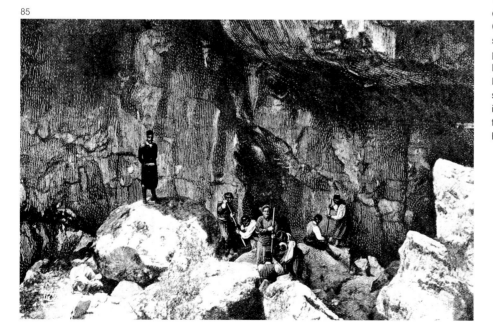

86. The Psychro cave's spectacular lower interior with stalagmites, stalactices and the 'sacred pool'.

87. Bronze male figurines from Psychro. The variety of gestures observed in these figurines appears to suggest an elaborate ritual language based on bodily expressions. *From left to right:* A fine figurine with long apron and hand to the forehead. Middle Minoan III–Late Minoan I, 1800–1450 BC. 9.3 cm (H). AE.23; A man with loincloth and hand to the forehead. Middle Minoan III–Late Minoan I, 1800–1450 BC. 12.5 cm (H). AE.595; A man wearing armlets and a belted loincloth, Late Minoan, 1700–1100 BC. 7.7 cm (H). AE.19; A belted man with arm to the forehead. Late Minoan, 1700–1100 BC. 8.5 cm (H). AE.20.

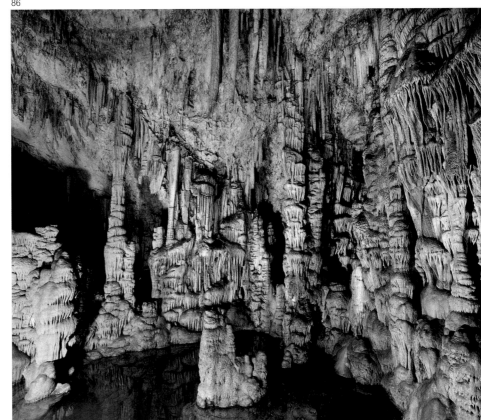

86

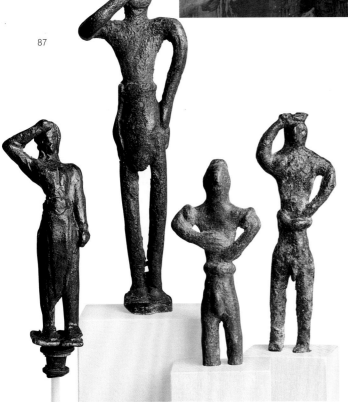

87

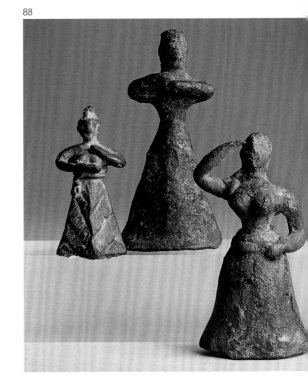

88

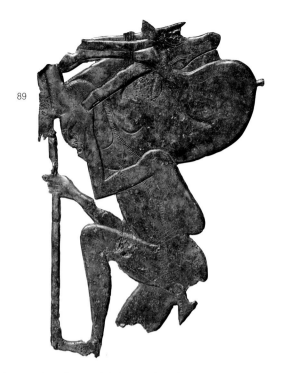

89

Cold, dark and damp, the cave's lower chamber, with its pool and spectacular stalagmite and stalactite pillars (Fig. 86), was visited for more than a thousand years by worshippers who pressed votive offerings into and between these formations, including engraved gems, metal figurines, knives, tweezers, jewellery and double-axes. The bronze inlay plaque of a man with a stick kneeling by the weight of the wild goat that he carries on his shoulder (circa 650 BC) best summarises the efforts of thousands of dedicators to reach the cave, present their offerings and experience the cave's majestic setting and interior[27] (Fig. 89).

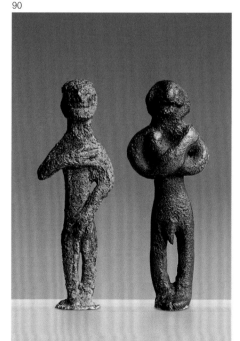

90

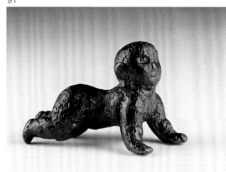

91

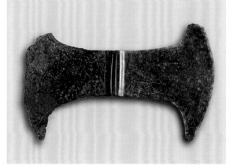

92

88. Bronze female figurines from Psychro. *From left to right:* Figure with flounced skirt and arms to the chest before bare breasts. Middle Minoan III–Late Minoan I, 1800–1450 BC. 5.3 cm (H). AE.597; Figure with flounced skirt and arms to the chest. Late Minoan, 1800–1100 BC. AE.22; Figure with her right hand to the forehead and her left arm bent at the side. She has a very narrow waist that places even more emphasis on the exaggerated protruding chest and large bosom. Middle Minoan III–Late Minoan I, 1800–1450 BC. 7.2 (H) × 4.7 cm (W). AE.596.

89. Bronze plaque showing a man carrying a goat. Psychro Cave. Archaic (circa 650 BC). 10.4 (H) × 7.3 cm (W). G.438. Bought by Arthur Evans. Presented to the Museum in 1897.

90. Two bronze figurines from Crete. *From left to right:* 6.1 cm (H). Early Iron Age, possibly 900–700 BC: G.392 (unknown provenance); 7.3 cm (H). Late Minoan III or Early Iron Age, 1400–700 BC: AE.600 (Psychro).

91. The figure of the baby with a chubby body and crawling movement is remarkably naturalistic. Psychro Cave, Crete. Possibly Late Minoan I, 1700–1450 BC? Bronze. 2.8 (H) × 4.8 cm (L). AN1938.1162. Purchased by Arthur Evans in 1908.

92. Bronze double axe. This large axe, consisting of two separate thin bronze sheets riveted together, is still covered with green patina and decorated with linear ornaments on both faces. The thinness of the sheets prevents it from any practical use. Such non-functional axes also exist in precious metals (gold, silver and bronze) and clay and are found in caves, peak sanctuaries, settlements and tombs. Crete (provenance unknown). Middle Minoan III–Late Minoan I, 1800–1450 BC. 19 (H) × 31.5 cm (W). AN1971.849. Museum purchase (ex-Bomford coll.)

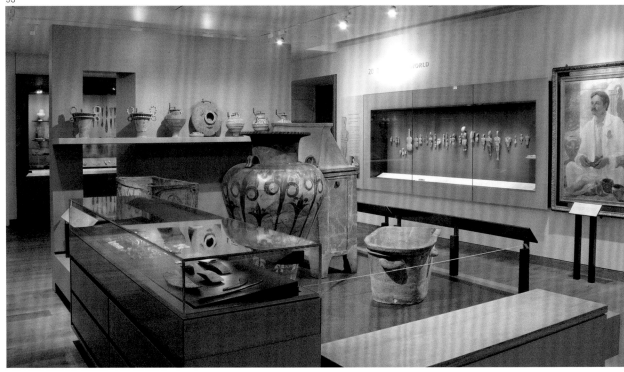

93. View of the 'Power in Death' plinth in the 'Aegean World' gallery.

94. Excavating the cemetery at Mavrospilio (the 'Black Cave') on the slopes to the east of the Palace at Knossos, 1927. Chamber tomb XVII with the coffins (*larnakes*) still in place.

In the middle of the gallery are two plinths dedicated to 'Power in Minoan Crete'. The east plinth focuses on 'Power in Death' (Fig. 93): a number of clay coffins (*larnakes*) are on display along with pottery found by Evans in the Knossos tombs (Figs. 95–98). Labels help visitors familiarise themselves with the burial practices of the people at Knossos, especially during the later stages of the Late Bronze Age (1450–1200 BC) (Fig. 94), while a table-case displays jewellery worn in life and death and presents objects associated with craftsmanship, such as bronze tools used in building and agriculture and stone moulds for the production of beads and ornaments (Figs. 101–105).

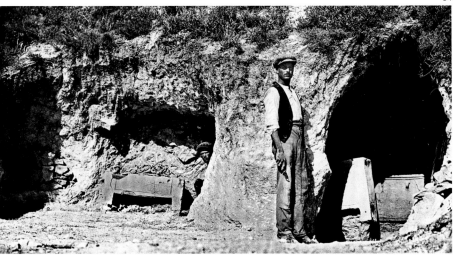

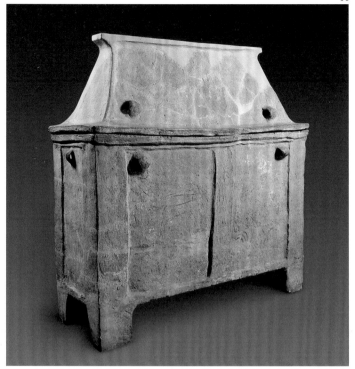

95

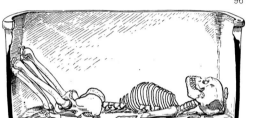

96

95-97. Two clay coffins (*larnakes*) from the Zapher Papoura cemetery near Knossos (Chamber tombs 9 and 100). The accompanying drawing shows the deposition of the body inside a *larnax*. Late Minoan IIIA2–B, 1375–1300 BC. Clay. AE.1128 (**95**): 113 (L) × 120 (H) × 41 cm (W); AE.583 (**97**): 106 (L) × 68 (H) × 43 cm (W). Both excavated in 1904 and given to the Museum by Arthur Evans.

97

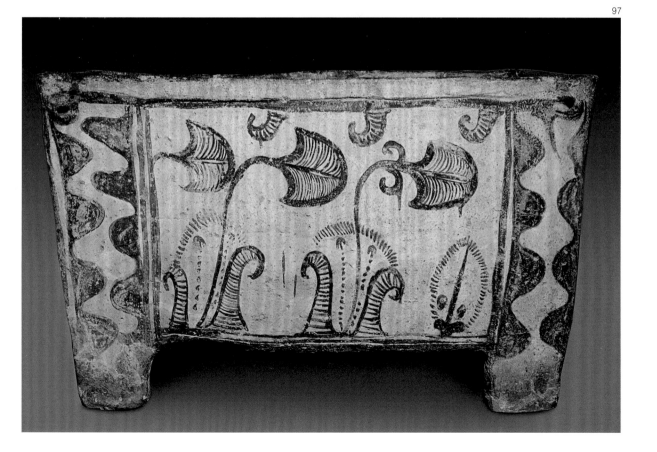

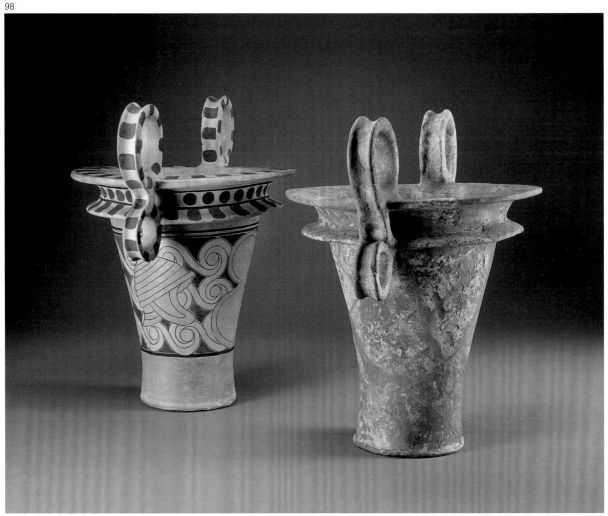

98. Clay jar with scissor (double coiled) handles and replica made by William Young. The jar is decorated with figure-of-eight shields and helmets set against a sea of spirals. Original from chamber tomb 5 at Isopata, north of Knossos. Late Minoan II, 1450–1400 BC. 22.8 (H to rim level) × 22.5 cm (max. Diam.). AN 1911.609 (original) and AE.2393 (replica).

99-100. Reading a Linear B tablet. For a commentary on this particular tablet see Chapter 7.

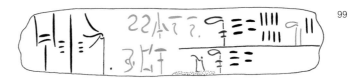

99

a-te-mo: the 'shepherd' Artemos or Anthemon

we-we-si-jo-jo: perhaps the owner of the flock

ku-ta-to: the place in Crete where the sheep are herded

100

male sheep

female sheep

o: an abbreviation for the word 'ophelos', 'owed' in Greek

the 'male sheep' is here used as the default sign which may include males, wethers and ewes

101
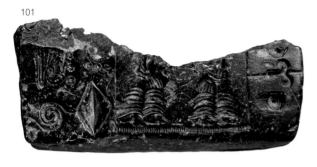

102

The west plinth focuses on 'Power in Life': (Fig. 108): a table-case looks at Aegean scripts and administration. The display is conveniently placed close to the Evans story and the seals display. Visitors are invited to read two Linear B tablets with the aid of graphics: a page-shaped tablet recording women workers and their children at the palace of Knossos, first interpreted by Evans as a list of 'Royal concubines', and a leaf-shaped tablet that records sheep herded at *ku-ta-to*, probably a coastal site in northern Crete (see **Commentary after Chapter 7**) (Figs. 99–100). Clay sealings (seal impressions on lumps of clay, some of which acted as 'receipts' for goods delivered to the 'palace') are also displayed to illustrate the basic steps of administration on the island, especially around the period of the Linear B tablets, about 1375 BC (see also **Chapter 7**).

101-102. Two-sided open mould used in the production of gold and especially glass beads and ornaments. Ten different ornaments are preserved in both faces of the partly broken mould, including the bracket or curled leaf on one side and on the other two women with flounced skirts. From the Palace at Knossos. Late Minoan II–IIIA1, 1450–1375 BC. Steatite. 10.7 (L) × 1.5 (W) × 4.2 cm (H). AN1910.522.

103. Rock-crystal, amethyst, steatite, cornelian, amber beads and conuli. Said to have been found in a tomb at Arvi, south Crete. Late Minoan, 1600–1300 BC. 1–2 cm (L). AE.313a–e, g–h, i, j, k.

104. Necklace made of cornelian beads. Said to come from a chamber tomb at Ayia Pelagia. Late Minoan IIIA-B, 1400–1200 BC. 2.6 (central bead L) × 2.2 cm (central bead W). AE.1240.

105. Bull's head pendant. Probably from Crete. Late Minoan IIIA–B, 1400–1200 BC. Rock crystal. 2.2 (L) × 1.9 cm (W). AN1941.191.

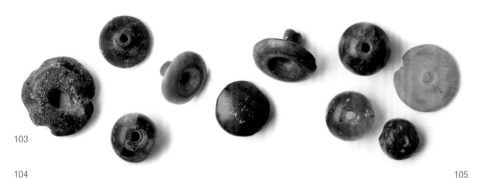
103

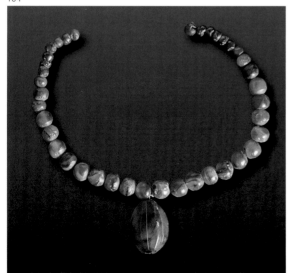
104

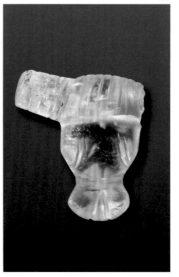
105

106. Large storage jar (*pithos*) from 'Magazine X', Palace at Knossos. It has three rows of handles and is decorated with appliqué, incised and painted decoration. It has a capacity of around 550 litres revealing the grand scale of storage provided by the west magazines at Knossos, most of which were found filled with these large *pithoi*. The first *pithoi* at Knossos came to light during the excavation of Minos Kalokairinos (1843–1907) in the 1870s. Due to their discovery the site was known, until Evans's excavations, as '*στα πιθάρια*' ('at the pithoi'). Late Minoan I–II, 1600–1400 BC. Clay. 143 (H) × 72 (rim Diam.) × 42 cm (base Diam.). AE.1126.

On the west plinth are displayed a drain pipe from Knossos, the large storage jar (*pithos*) from one of the storerooms (Fig. 106), the famous six-tentacled octopus jar (Fig. 221) and the artwork showing the partial reconstruction of the north wall of the 'Throne Room', with two *alabastra* and a replica of the throne (Figs. 107–108). The process of excavating, reconstructing and interpreting this particular room is narrated along the lecterns, while images help present the different phases of architectural reconstructions at Knossos by Evans and his architects – perhaps the most popular and heavily criticised aspect of Evans's work at Knossos as it went beyond the need to protect the ruins from the natural elements (Figs. 109–113). Evans's reconstructions blend different architectural phases together. Although some are more successful than others, they can confuse and blur the visitor's experience of the site's complex architectural past. At the same time, however, they concretely represent Evans's vision of the Minoan past forming an everlasting testimony of his efforts to make things 'intelligible to other people', as mentioned by his half-sister Joan Evans[28] (see also **Chapter 3**).

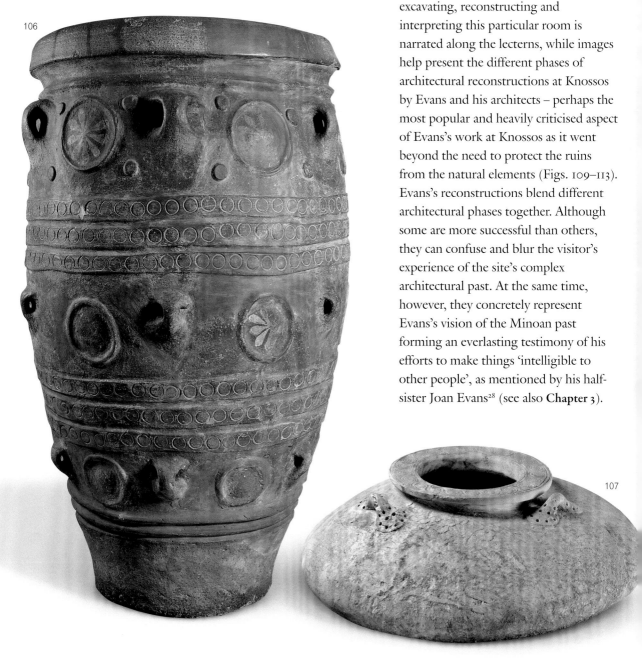

106

107

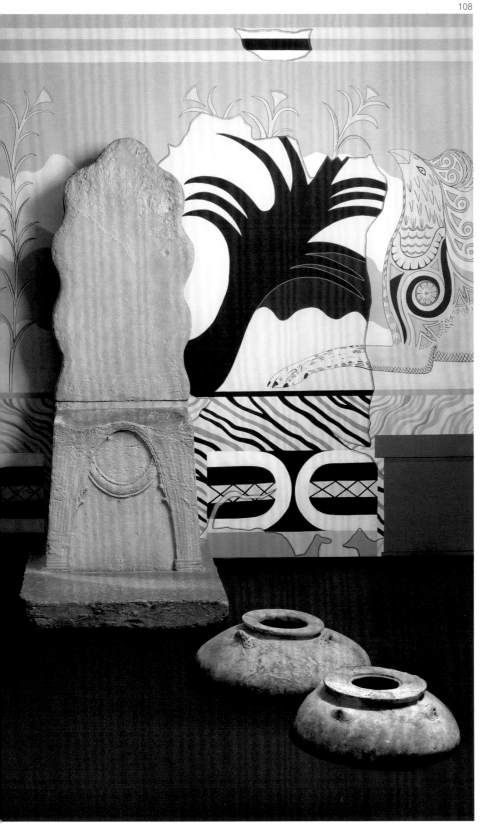

107. A flat *alabastron* (container) with elaborately carved rim (spirals) and figure-of-eight handles. At least a dozen *alabastra* were found in the 'Throne Room', the largest concentration of this rare stone vessel type. Its clay counterpart is more frequently attested in Mainland Greece than on Crete. Some of the *alabastra* from the 'Throne Room' were found close to a broken *pithos* set next to the throne. Evans believed that the *pithos* was used to fill the alabastra with aromatic oil. This vessel type is particularly convenient for the mixing of perfume and oil, perhaps for the creation of a viscous unguent. 'Throne Room', Palace at Knossos. Late Minoan II–IIIA, 1450–1375 BC. Gypsum. 12.9 (H) × 46.5 (Diam.) × 21 cm (rim Diam.). AN1911.611.

108. View of the 'Throne Room' plinth in the 'Aegean World' gallery. The replica throne was made in 1902 for the first ever Minoan exhibition which took place in Oxford as part of the festivities for the tercentenary celebrations of the Bodleian Library. 139 (H) × 50 (max. W) × 45 (seat's W) × 32 cm (seat's L). AE.2396a-b. The painted artwork at the back of the Throne is by Matthew Potter.

109

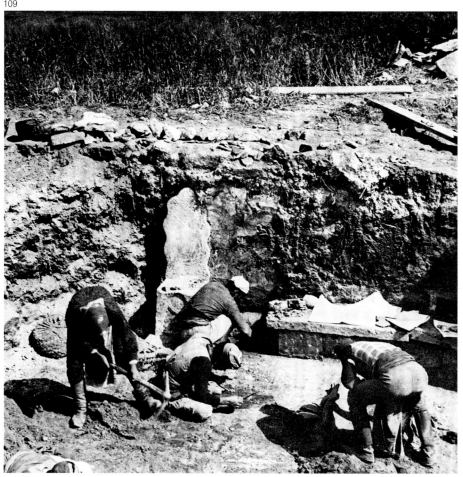

110

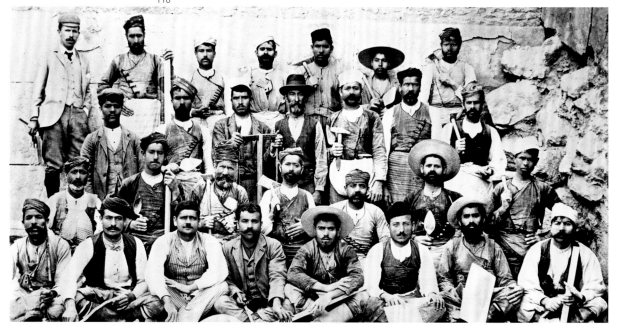

The reconstructions at Knossos could be listed among the earliest attempts to create and curate open-air sites as museums that offer a new experience to the visitor with the romantically fragmented presentation of the ruins. This fragmented ruinous landscape took shape in the 1920s, during the final stages of the Knossos restorations, and was influenced by the work of Piet de Jong – the talented architect and illustrator working for Evans at the time. In addition, Evans's interest in transforming Knossos might have developed alongside his work at the Ashmolean, which he managed to turn into a first-rate museum of archaeology and art.[29]

111

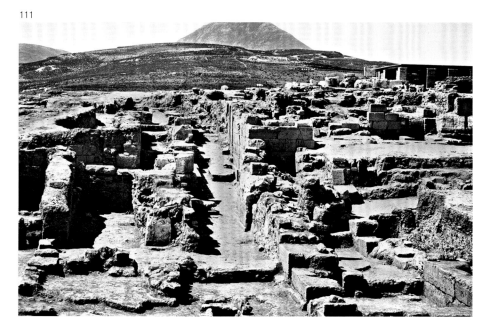

109. Excavating the 'Throne Room', April 1900.

110. Theodore Fyfe and workmen in the Hall of the Double Axes, 1901.

111–113. The reconstruction of the 'North Entrance Passage' at Knossos: **111)** 1901; **112)** 1929; **113)** 1930.

112

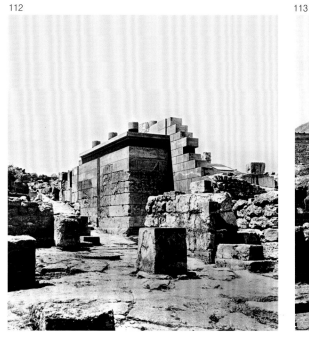

113

MYCENAEAN GREECE

In contrast to the policy of a number of museums, we decided to put on display a number of replicas, not least because they played, and continue to play a fundamental teaching role in the University of Oxford. At the same time, replicas have a value of their own being historic objects commissioned by Arthur Evans from the creative Swiss artists Emile Gilliéron, father and son.[30] The replicas of the Mycenae shaft graves and other early Mycenaean tombs, such as the Vapheio and Dendra tholos tombs, introduce visitors to this period and the systematic exploration of the Aegean's rich pre-classical past following Heinrich Schliemann's tantalizing discoveries at Troy and Mycenae in the 1870s. Objects from Troy, some still bearing their original labels, were donated by Schliemann himself to the University of Oxford in the 1880s (Fig. 114).

A wall case provides a representative sample of Mycenaean pots, including the Kareas chamber tomb assemblage dating to around 1350–1250 BC and sold to Evans by the Professor of Archaeology in the University of Athens and prolific art dealer,

114

114. A small group of handmade clay objects given by Heinrich Schliemann to the University of Oxford early in the 1880s. Later they were transferred to the Ashmolean. Some of them still bear Schliemann's original labels. Most date to 2600–2450 BC (Troy II), a period during which imposing buildings, protected by fortifications with gates and towers, stood at the centre of Troy. Around 2450 BC, Troy was destroyed by fire. In and on the burnt debris over twenty 'treasures' (buried collections of objects) were found, including the so-called 'Treasure of Priam'. A tall cup with two handles ('depas amphikypellon'), a mug, a cup, a jug and a bowl, circa 2500–2000 BC. Depas: 20.5 cm (H), AE.349; Jug: 15.3 cm (H), AE.351; Cup: 7.6 cm (H), AE.353; Bowl: 7.3 cm (H), AE.365; Mug: 11.1 cm (H), AE.366; Clay spindle whorls with incised decoration. The estimated 10,000 clay whorls from Troy II alone (2600–2450 BC) suggest the existence of a major textile industry there. 2500–2300 BC. AE.361, AE.374. Given by Heinrich Schliemann.

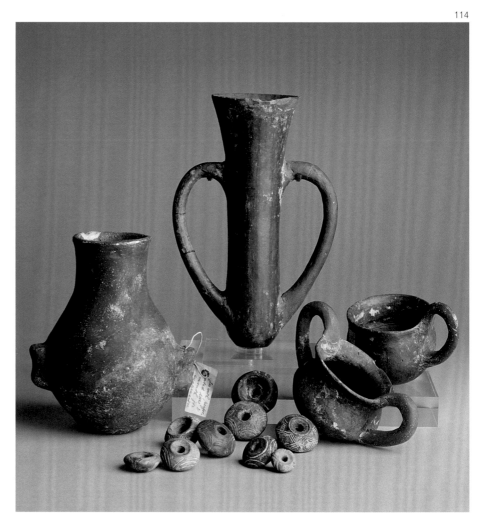

Athanasios Rhousopoulos[31] (Fig. 115). A few Mycenaean pots from Rhodes, Athens and Aegina along with clay figurines and the fox- or swine-headed vessel (*rhyton*), allegedly from Tiryns, are also on display. A panel accompanying this case offers a brief introduction to the Mycenaean world – from its early rich graves to the formation of the palaces and the adoption of an administrative system using Linear B (see also **Chapters 6 and 7**) (Figs. 116–119).

Opposite the Schliemann story, there is a case focusing on contacts between the Aegean and the East Mediterranean during the Late Bronze Age (1600–1100 BC). This is a partially transparent case shared between the 'Aegean World' and the 'Ancient Near East' gallery. On display are Aegean and Aegeanizing pottery not found in the Aegean; Cypriot pots discovered outside Cyprus; and Egyptianizing and Levantine vessels popular across the East Mediterranean and the Aegean, underlining contacts across distant lands. The story of the Uluburun wreck (around 1300 BC), the most famous of the Late Bronze Age shipwrecks, helps illustrate these contacts[32] (see Figs. 238–240) which extended to Cyprus, Egypt and beyond (Figs. 120–121).

115. The 'Kareas assemblage': pots, figurines, buttons or whorls, and beads. They are said to have been discovered in 1893 in a chamber tomb at Kareas on the slopes of Mt. Hymettos near Athens. A destroyed skeleton and bones were found in the passageway (*dromos*) leading to the chamber, while a charnel pit with human bones, was found on the chamber floor. Late Helladic IIIA2–B, 1375–1200 BC. Bowl: 13.2 cm (Diam.), AE.306; Stirrup jar: 10.2 cm (H), AE.308; Figurine (transitional type): 12.7 cm (H), AE.309; Psi-type figurine: 10.3 cm (H), AE.310; Phi-type figurine: 9.5 cm (H), AE.311; Beads: 1.1–3 cm, AE.312a and c-g. Purchased for the Museum by Arthur Evans from Athanasios Rhousopoulos.

115

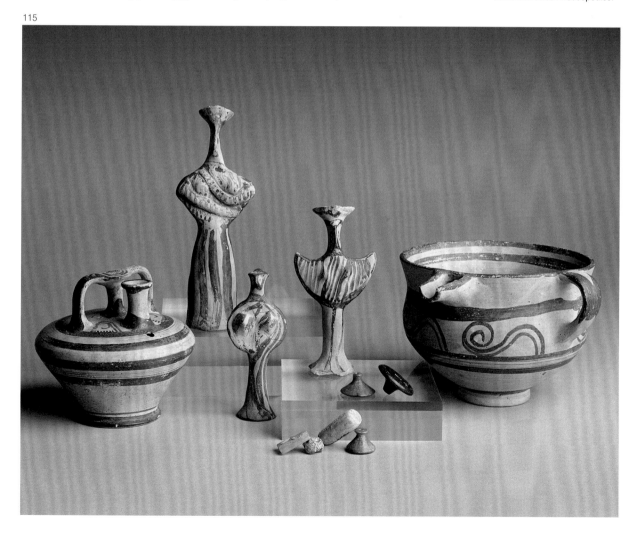

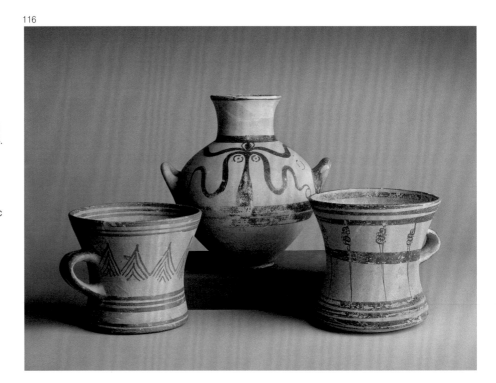

116. Mycenaean pots from Ialysos on Rhodes: a jug decorated with a stylised cuttlefish and two mugs ('tankards') with chevrons and murex shells. Late Helladic IIIA2–B, 1375–1200 BC. Jug: 25 cm (H), AE.289; Mugs: 14.7 and 16.4 cm (H), AE.291 and AE.294. Ex-Biliotti coll.

117. Mycenaean pots: two jugs and a single-handled stemmed cup. The jug on the right has a stylised floral motif. Late Helladic IIIA2–B. 1375–1200 BC. Clay. Jugs: 23.2 and 22 cm (H), AN1964.485 and AN1972.918; Cup: 11.4 cm (H), AN1983.193. No provenance. Museum purchase.

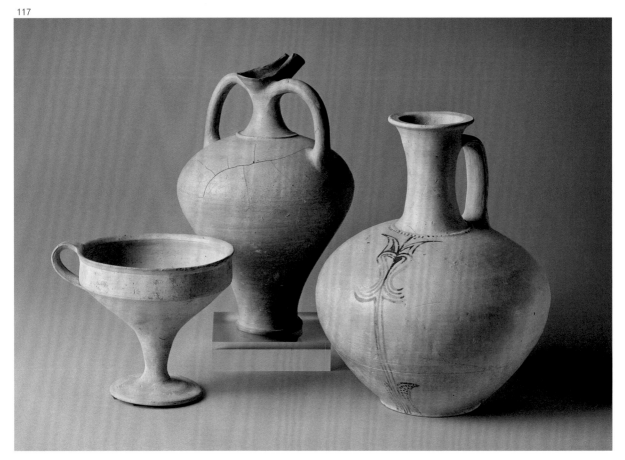

118. Fox -or swine-headed rhyton. Said to have been found at Tiryns. Late Helladic IIIB, 1300–1200 BC. The elongated muzzle, a modern restoration, makes the *rhyton* look more like a fox or dog than a swine, but the identity of the animal remains puzzling. *Rhyta* in the Aegean took the shape of various animals, including that of bulls, lions, pigs and rams. Used for pouring liquids, the most extravagant of these ceremonial objects are made in precious metals. Clay. 16.8 cm (restored length). AE.298. Bought by Arthur Evans for the Museum in 1894.

119. Late Bronze Age clay pots, including the typical Mycenaean drinking cup – the *kylix*. Late Helladic IIIA2, 1375–1300 BC. *Kylix* with plain floral decoration from Ialysos, Rhodes: 18 (H) × 16 cm (Diam.), AN1924.68; *Kylix* with rosettes, probably from Crete: 15.8 (H) × 22 cm (Diam.), AN1961.530. Cup, possibly from Rhodes or Cyprus: 7.6 (H) × 16 cm (Diam.), AN1952.177. Museum purchase, except for AN1924.68, which was given to the Museum by Sir John Beazley.

118

119

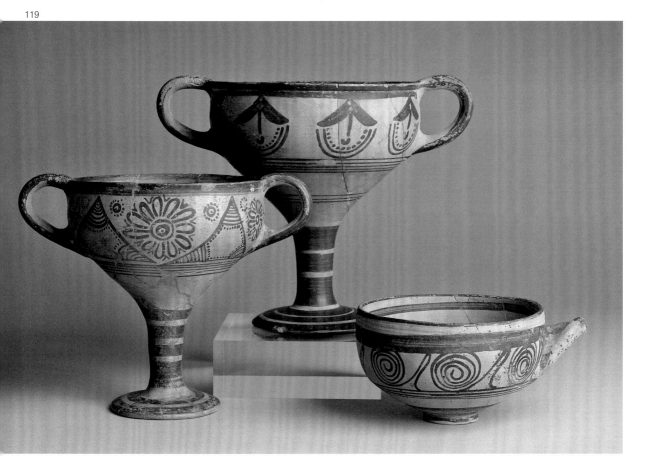

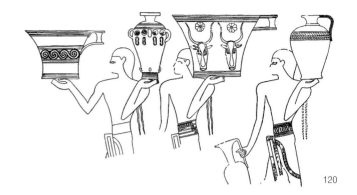

120. Fragmentary scene of people from Keftiu (Crete) carrying Aegean-looking precious metal vessels. Tomb of Senenmut, Egypt. Circa 1473–1458 BC.

121. A distribution map focusing on contacts across the East Mediterranean during the 'International Age' (1600–1100 BC). Contacts across the Mediterranean in the Late Bronze Age resulted in the transfer of goods and ideas. The distribution map presents objects that travelled around or were inspired by the interaction with other regions of the East Mediterranean.

122. Attic red-figure cup (*kylix*) showing Theseus slaying the Minotaur. The inscription in red paint inside the cup reads 'ΗΟ ΠΑΙΣ ΚΑΛΟΣ' ('the boy is beautiful') – a formulaic erotic expression, often found on drinking cups of the late 6th and early 5th centuries BC. From Chiusi, Italy. About 500 BC. Clay. 20 (rim Diam.) × 11.4 (tondo Diam.) × 8.1 cm (H). G.261. Purchased at an auction in 1892 (ex-Van Branteghem coll.).

A final case looks at the reception of Bronze Age Greece from antiquity to present day: the fascination of the public as well as the archaeological confusion sparked by epic tales, myths and legends and the attempts of various scholars, including Schliemann and Evans, to verify them. The myth of the half-man, half-bull monster (*Minotaur*) is also explored here along with the use of the past in forging and maintaining identities, both ancient and modern (Fig. 122). An object identified by Evans's worker as 'Ariadne's thread box' and the 'boy-God', a modern forgery, help highlight further the theme of this display (Figs. 139–140). Graphics illustrate the use of the Aegean Bronze Age in popular imagination, as a spectacle and as part of modern consumerism.[33] As remarked by Oliver Dickinson, an eminent Aegean archaeologist: 'No epic is a realistic presentation of a society or age; it is a fantasy, but a fantasy in which . . . reality keeps breaking through'.[34]

122

123-124. Drachma. Knossos. 300–200 BC. Cretan cities like Knossos, Phaistos and Gortyn, made use of myths associated with them as early as the 5th century BC. Knossos chose the Labyrinth and the Minotaur, while Phaistos and Gortyn chose to depict various episodes of the story of Europa and the bull. Silver. 2 cm (Diam.). Weight: 5.3 gr. Obverse: head of Hera wearing a garland decorated with floral ornaments. No obverse legend. Reverse: square labyrinth. Reverse Legend: A / P (magistrate?) – ΚΝΩΣΙ (ethnic standing for 'of the Knossians'). HCR 4581. Bought at the Lincoln sale 22/05/1889 (formerly in the Keble College collection).

123

124

An attempt was made to discuss how remnants of the Bronze Age may have provided a source of inspiration and a setting for a number of myths and legends of classical Greece (Figs. 123–124). Fighting together for the first time against a common enemy, as described in the *Iliad*, helped the Greeks to create a shared heroic past. Thereafter, this shared 'history' became a vital component of Greek identity and a popular theme in art and literature. It is hoped that a further showcase will be added to the south-west wall of the Aegean World Gallery to display some of the Ashmolean's holdings from the Geometric Period.

AEGEAN ARCHIVES AT THE ASHMOLEAN

Perhaps the single most important aspect of the Aegean collection at the Ashmolean is its rich archival documentation (Fig. 125). The Knossos Excavation Archive, the largest and most important component of the Sir Arthur Evans Archive, is the most extensive and complete resource of its kind from that very early era of archaeological exploration in the Aegean and the East Mediterranean as a whole. For this reason, it has become a source and a laboratory for understanding the development of archaeology and more importantly of how we make sense and interpret the past. The archive comprises hundreds of letters, thousands of drawings (Figs. 126–128) and photographs, newspaper cuttings, excavation notebooks, travel and sketch books, offprints, notes, pull-outs and drafts. It is the most important surviving resource for understanding and re-interpreting Evans's excavations at Knossos.

125

126

127

The Sir John Linton Myres Archive also contains a remarkable collection of letters and papers associated with the pre-decipherment phase of Linear B (see Figs. 272–276). Myres was the executor of Evans's will. Among the things entrusted to him was the publication of the Linear B tablets from Knossos (*Scripta Minoa* II, published after Evans's death in 1952, a few months before the announcement of the decipherment by Michael Ventris on 1 July 1952). The correspondence in the Myres archive highlights his contribution to the decipherment of Linear B by creating a network of scholars. These scholars, working in close collaboration, paved the way for Ventris's brilliant decipherment (see also **Chapter 7**). Apart from Ventris, this network of intelligent minds included Alice Kober and Emmett Bennett, pioneers in the study of this script. It is hoped that the pre-decipherment component of the Myres Archive will one day become available online.

125. Two pages from Evans's 1896 diary with notes and drawings of antiquities he saw at Herakleion and Ligortino, Crete.

126-127. Watercolour reconstruction drawings by Christian Doll (1880–1955) of the Grand Staircase at Knossos showing use of timber and bricks. Original ink. 1905. Arthur Evans Architectural Drawing GS/4.

128. The 'Bluebird' fresco as restored by E. Gilliéron *fils*. 'House of Frescoes', Knossos. Between 1923 and 1928 (original: Middle Minoan III–Late Minoan IA, 1800–1600 BC). Watercolour. 810 (W) × 600 cm (H). Arthur Evans Fresco Drawing C/12.

128

3. Arthur Evans and Minoan Crete

LESLEY FITTON
Keeper of the Department of Greece and Rome, British Museum

Arthur Evans dominated the world of Minoan archaeology for the first part of the twentieth century (Fig. 129). His excavations at Knossos brought him both scholarly and popular fame (Fig. 130). His definition and characterisation of the 'Minoan culture' of Bronze Age Crete became a cornerstone of understanding the ancient world of the eastern Mediterranean. His stream of publications, culminating in the great four-volume compendium of information that is *The Palace of Minos at Knossos*, bore witness to his immense and detailed labours.[1] Though physically slight he was in many ways a colossus, and bestrode his world very influentially. His legacy lives on.

But how should this legacy now be evaluated? Before considering the question, we must look at the background against which Evans began his excavations at Knossos in 1900 and give a brief account of his achievements there.

129. Arthur Evans holding a stone *rhyton* from the Hall of the Double Axes. Knossos, 1901.

130. The Room of the Throne in the course of excavation, April 1900.

130

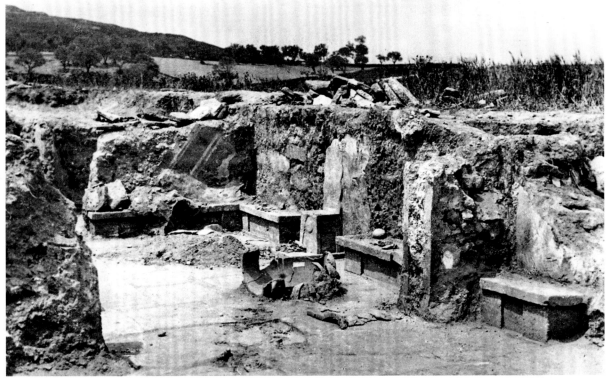

BEGINNINGS

Archaeology has always attracted the interest and attention of a wide public, but some aspects of the past capture the popular imagination more than others (Figs. 131–132). The discovery of the Greek Bronze Age attracted particular attention in the West, because in the early days of Heinrich Schliemann's work at Troy and Mycenae, between 1870 and 1890, it seemed that the world of Greek mythology, and particularly of Homer's heroes, was being revealed. Such was Schliemann's aim. The sites, for him, were not merely Troy and Mycenae, they were Priam's Troy and Agamemnon's Mycenae – and so they were for the press reporters and the public at large, even though it rapidly became apparent that the named heroes from the myths could not be summoned by the archaeologist's spade (see also **Chapter 6**).

These heroes were well-known, and indeed more widely known in the 19th century than they are today, because the study of the Greek and Latin texts that preserved their stories was then a cornerstone of education. There can be no doubt that the very great interest excited by Schliemann's work was partly due not just to familiarity with the myths themselves, but also to a sense that he was illuminating the ancestry of Western culture: the beginnings of a European tradition inherited by the contemporary world through the legacy of Greece and Rome.

We might say in passing that there is, of course, a paradox here. The site of Troy is in modern Turkey, and although it had contacts with Greece in the Bronze Age, its material culture is Anatolian through and through. The current excavators have worked hard to gain recognition of this fact, and to wrest Troy away from the distortion of Greek-coloured spectacles through which it was for so long viewed – but that is perhaps another story.

Schliemann's work on the Greek mainland, most famously at Mycenae but also at Tiryns and Orchomenos, did, of course, reveal a culture that was truly Greek. This Late Bronze Age culture became known as 'Mycenaean', and after Schliemann's death in 1890 excavations by his successors continued to reveal the Mycenaean world in more depth and more detail. So it was that as early as 1893 the Greek archaeologist Christos Tsountas was able to write an influential overview, published in English with the collaboration of J.I. Manatt in 1897 and called *Mycenae and the Mycenaean Age*.[2] He was able to date the 'Mycenaean Age' fairly accurately, using synchronisms with the better-recorded Egyptian chronology, and he discussed various themes such as dress, burial customs, religion and literacy.[3] While still fascinated by the relationship of the Mycenaean world and that of Homer, Tsountas moved beyond the overly-simplistic identification of the two, reflecting the more measured reaction of the scholarly world of his time.

131. A depiction of the Lion Gate at the citadel of Mycenae, to illustrate the article 'Antiquarian Discoveries in Greece.' Engraving from *The Illustrated London News* (3 February 1877).

132. Heinrich Schliemann giving an account of his discoveries at Mycenae to the members of the Society of Antiquaries in London (1877). Engraving from *The Illustrated London News* (31 March 1877).

131

132

30 *Dr. Schliemann giving an account of his discoveries at Mycenae before the Society of Antiquaries*

ARTHUR EVANS (1851–1941)

This, in brief, sets the stage for Arthur Evans and his work on Crete. But in fact Evans's life ran in tandem with all of the above. He was born in 1851, into doubly privileged circumstances, because his father, John Evans, was not only a rich man but also a noted antiquarian and scholar. A career in archaeology seemed predetermined for Arthur, who shared his father's interests. Many doors were opened for him because of his family connections, but as a young man of strong and indeed rather opinionated character he travelled in the Balkans in a somewhat restless quest for a field of study that he could make his own. It had to be archaeology, but preferably non-Classical archaeology – he rebelled against what he saw as the stranglehold exerted by Classical archaeologists on the discipline, and felt they were narrow-minded in their pursuit of the 'golden age' of Classical Greece.

Arthur Evans's early travels and work in the Balkans have been documented elsewhere,[4] but we must pause to acknowledge his remarkable achievements as the Keeper of the Ashmolean Museum in Oxford (see also **Chapter 2**). He took up this post in 1884, when the museum was a neglected and ailing institution. Within ten years, Evans had turned its fortunes around, almost doubling the collections, displaying them well, and creating a great centre of learning of which the University of Oxford could justly be proud. This would in itself have been a worthy lifetime's achievement for many men, but for Evans it was a precursor. He never lost his close links with the Ashmolean, only formally resigning the Keepership in 1908. But by this time his heart and mind were filled by his work in Crete (Fig. 133).

133. View of the west magazines and of the throne room area, 1901.

133

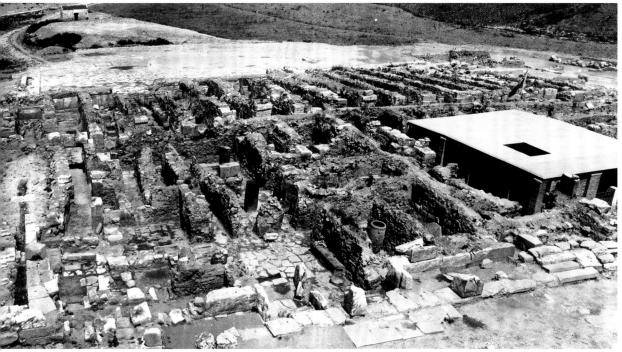

ARTHUR EVANS IN CRETE

A number of factors had led Evans to Crete. In 1883 he had made a protracted visit to Greece, during which he visited Heinrich Schliemann – already an acquaintance through his father – and discussed his finds. He had always followed Schliemann's work with interest, and was naturally drawn to the pursuit of the history of Greece before the Classical period. Evans seems to have had an instinct that some even earlier, pre-Mycenaean, stage of culture remained to be found. In 1892 he met the Italian scholar Federico Halbherr in Rome, and heard from him of his travels in Crete and the traces there of an early civilisation. Above all Evans had become interested in seal-stones. He had seen small, semi-precious stones engraved with various figures, scenes and symbols in several collections, including those of the Ashmolean (Figs. 264–271), and knew many of them were said to be from Crete (Fig. 134). He became fascinated with early traces of writing on such stones and decided to pursue them to their island home (see also **Chapters 7 and 8**).

134. Cornelian amygdaloid seal with a chariot scene drawn by two horses, from Knossos, Late Minoan II–IIIA, 1450–1300 BC. 3.3 × 2.1 cm. Given to the British Museum by A.W. Franks in 1880. An early find from Knossos before Evans's excavations. (GR 1880.4–28.1).

135. Clay storage jar (*pithos*), from Knossos, Late Minoan II, 1450–1400 BC. 113 cm (H). Excavated by Minos Kalokairinos in 1878 and given to the British Museum in 1884. (BM Cat. Vases A739).

And then, there was Knossos. Legendary home of King Minos, location of Daedalos's labyrinth with the monstrous Minotaur lurking at its heart – the myths placed Knossos firmly at the centre of tales concerning ancient Crete. Travellers had long noted the presence of intriguing remains in the area, and archaeologists before Evans had begun to pay attention to a specific site in the Knossos valley: a low hill known as Kephala.

The locals called it 'στα πιθάρια' (the place of the jars), after an Herakleion antiquary, the aptly-named Minos Kalokairinos, revealed in 1878 and in the course of his excavation at the site a number of *pithoi* (giant storage jars). He sent these to various museums abroad, including the British Museum (Fig. 135). In 1886 Schliemann had visited and tried to buy the site, without success. It has been said that the Muslim Cretan owner tried to claim compensation for a larger number of olive trees than actually grew there, but that was probably only part of the story. In fact a consensus had arisen, amongst both Cretan and foreign scholars, that the Kephala site probably concealed a 'Mycenaean' palace. But many of them felt that excavations should not begin while Crete was under Ottoman domination, for fear that the finds would be taken to Constantinople, where the Imperial Museum was taking shape at the time.

Arthur Evans made his first visit to Crete in 1894, and had the great advantage of being in the right place at the right time. He seized the opportunity. He travelled, he collected gems, and, most importantly, he managed to buy one quarter of the Kephala site under Ottoman law. He visited Crete again in 1895, but then the fighting broke out that would see the island shake off the Ottoman Turkish domination. Hostilities meant that he could not go back until 1898, but at that stage he firmly took the islanders' part against the final atrocities of the departing Ottoman troops. So it was eventually the new Cretan authorities that looked kindly on his long-laid plans for Knossos. Finally, on 23rd March of 1900, a few weeks after Evans's final purchase of the hill, digging there could begin.

Six seasons of intensive excavation followed, revealing not only the extensive palace at Knossos but also some of the adjacent buildings in the Minoan town. The search for scripts by Evans was rewarded by the discovery of not one but three systems of writing. Fine works of craftsmanship in many different materials poured from the site, including quantities of decorated pottery that Evans and his assistant Duncan Mackenzie used as the basis for their explanation of Minoan chronology. In many places colourful frescoes were found, some still adhering to the walls (see also **Chapter 5**).

The scope of this chapter will not allow even a summary of all that was found: the reader is referred to the main body of this companion guide for a glimpse into the rich nature of Evans's finds and the world from which they sprang. Evans called the Palace 'the find of a lifetime', and indeed its exploration and publication would keep him fully occupied until the end of his long life. He was knighted for his achievements in archaeology by King George V in the coronation honours of 1911 and died in 1941.

For Evans, explanation and interpretation were just as important as exploration: as his half-sister Joan says in her biography, 'Time and Chance had made him the discoverer of a new civilisation, and he had to make it intelligible to other men.'[5] This strongly didactic streak found expression not only via the conventional routes of lectures, exhibitions and publications. It also took concrete form, in both senses of the word, in Evans's extensive programme of reconstruction at Knossos. While the excavations were still in their infancy Evans was beginning to put in place what the world would inherit as his legacy. It is to the question of this legacy that we must now turn.

135

THE LEGACY OF ARTHUR EVANS

We might start this brief look at Evans's legacy with nomenclature. Evans chose to refer to the civilisation of Bronze Age Crete as 'Minoan'. The term was not new,[6] but became thoroughly established and is still widely used, though some modern scholars distance themselves from its artificiality by habitually using inverted commas around it. It could certainly be argued that the use of a name deriving from the legendary King Minos is not helpful to the aim of seeing the Bronze Age of Crete in its own terms – the 'Minoans' were not Greek, and the stories told about them in Greek mythology have no doubt picked up Greek cultural values in their transmission. Nonetheless, we do not know what the Minoans called themselves, though the 'Keftiu' of Egyptian texts or the 'Caphtor' of the Bible may give some clue. In the absence of this information 'Minoans' remains a convenient (albeit controversial and sometimes confusing) term.

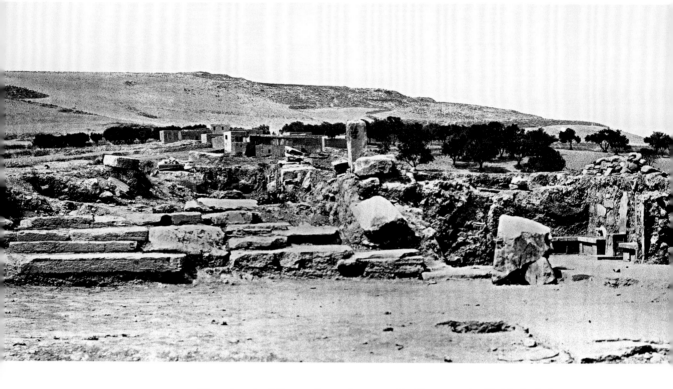

The tripartite Minoan chronology used by Evans to classify his finds from Knossos, and by extension from the rest of Crete, has equally become embedded, though again its failings have often been lamented. The thinking behind his tripartite chronology of 'Early', 'Middle' and 'Late' Minoan periods, each itself divided into three sub-periods, derived from a variety of sources, ranging from analogy with natural cycles of growth, maturity and decay to the desire to tie in his finds with the Old, Middle and New Kingdom of Egypt. Refinements in the definition of Evans's phases have been a continuous theme in Minoan archaeology as new discoveries have been made. But even in Evans's own time it was recognised that the scheme had its limitations. As John Pendlebury, Evans's younger contemporary, joked in his *Handbook to the Palace of Minos*, 'It is not reported that Minos declared, *I'm tired of Middle Minoan III, let Late Minoan I begin!*'[7]

While these matters of terminology and nomenclature exercise archaeologists, there can be no doubt that the aspect of Evans's legacy most visible in the public eye is his extensive restoration of the palace of Knossos. This above all has led to the feeling that Evans partly created Minoan culture as we perceive it, imposing his own preconceptions – those of one born and bred as the archetypal Victorian gentleman – and allowing free rein to the Art Deco sensibilities of his fresco restorers, particularly the Gilliéron team of father and son.[8]

The literature contains both examples of restorations that are questionable or wrong and defences of Evans – the latter usually on the two main grounds that he himself would have given.[9] The first was practical necessity. Certain parts of the palace, particularly on the east side, needed shoring-up so that the various levels could be revealed and preserved.

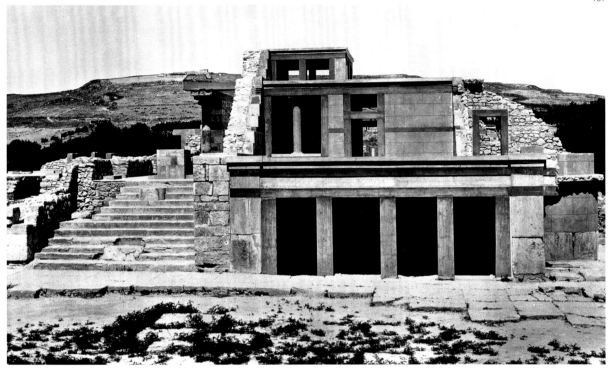

Elsewhere the building needed to be protected from the elements. But this practical necessity did not demand the particular approach that Evans adopted when he tried to recreate some aspects of the ancient reality of the palace as he saw it. This was prompted by the didactic streak in his nature – the attempt to make Knossos 'intelligible to other men'. This was his second argument for restoration. He wanted to share his vision (see also **Chapter 2**) (Figs. 136–137).

The result is a remarkable building in which Minoan architecture meets iron girders, concrete pilasters and gaudy paint. In the Bronze Age the Palace was built, destroyed, re-built and changed over many centuries. Now Evans's reconstructions are themselves old enough to have needed conservation work by the Archaeological Service of Greece, as the Palace enters the twenty-first century as one of the most-visited sites in Greece. Whatever view one takes of the reconstructions, it is undeniable that Evans has left his mark for visitors to see. Like the other Minoan palaces, Knossos is a palimpsest – a multilayered site with preserved remains that simultaneously reveal different phases of construction and use. The difference is that, at Knossos, there is a final building phase, dating to the early twentieth century AD. A comparison of the visual impact of Knossos with that of the other Minoan palaces at Mallia, Phaistos and Zakros makes the 'Evans effect' very plain.

Evans was confident in his approach, and indeed this confidence led to his remarkable domination of the reception of the Minoan world in his lifetime. Knossos was not the whole story – far from it. Other scholars, Greek and foreign, were quick to take

136–137. The west side of the Central Court at Knossos with the Throne Room complex, before (1900) and after reconstruction (1930).

advantage of the new possibilities for archaeology in Crete after the end of the Ottoman rule (Fig. 138). At the same time as Evans was working at Knossos, excavations were going on at Phaistos and Mallia, at Tylissos and Ayia Triada, at Gournia and in the Mesara tholos tombs and so on. Knossos may have been the biggest site, but it certainly did not have the monopoly on remarkable and impressive finds.

Yet still Evans had the most influential voice. The 'Minoan' terminology as developed by him was adopted across the island, as were his Knossos-based chronological divisions, even though it rapidly became apparent that pottery styles were not, in fact, the same throughout the whole of Crete and did not develop in exactly the same way. Weaknesses in the logic of the system soon appeared, and some of his colleagues

138

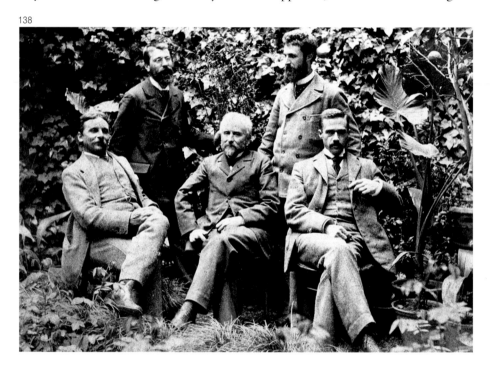

in the field dared to point this out. Evans liked to engage in lengthy discussions on points of detail, but he did not ultimately like to be crossed – a facet of his character that, perhaps unsurprisingly, became more marked as time went on. Nonetheless, he was admired, respected, almost revered – many would have agreed with the young American scholar Richard Seager who called him 'the doyen of Cretan excavators'.[10]

But even his staunchest supporters would have to admit that Evans was only human, and got some things wrong. This emerges in an intriguing aspect of his thinking that has only recently become the focus of attention.[11] The fact is that, when it came to forgeries of Minoan artefacts, even the great Sir Arthur could be fooled.

By definition the vast majority of the objects that he dealt with were genuine, since they came from his own excavations. But he nonetheless accepted as genuine certain objects

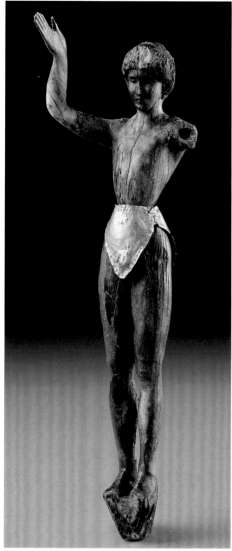
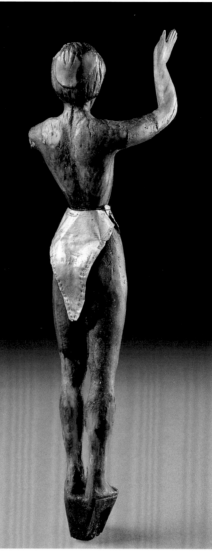

139 140

139–140. Artist unknown. The 'boy-God'. This figurine, showing a youthful standing male with raised fitted arms, a removable gold loin cloth, and a hat on the back of his head, displayed, according to Evans, an 'artistic skill...worthy of the Italian Renaissance'. Recent analyses conducted by the Radiocarbon Accelerator Unit of the Research Laboratory for Archaeology and History of Art at the University of Oxford have shown that the ivory used in the manufacture of the figurine was 230±50 years old. By the time the forgery was made, in the 1920s, the raw material used was already a hundred years old, showing the sophistication of forgers in Evans's day. Early 20th century AD. Ivory and gold. 12.5 cm (H). AN1938.692.

that the world now unanimously condemns as fake. These emerged in a shadowy way, in various different places and various different hands. The total number of such objects is not huge, but it comes as no surprise to find that they include relatively small and portable but potentially very valuable items. Gold rings and chryselephantine figurines are the two most prominent categories. In some cases Evans simply gave them his imprimatur, in others he actually bought them and added them to his own collection. The so-called 'boy-God', an ivory figurine with gold embellishments, comes into the latter category (Figs. 139–140).

Why did his eye sometimes fail him? It must surely partly be explicable in simple terms of wanting to believe. The 'boy-God', for example, seemed to bear out some of his cherished notions on Minoan religion, and his interpretation of the piece as both boy and god perhaps took the forger by surprise – as it seems very likely that a bull-jumper, such as those on the famous frescoes from Knossos, was what had really been intended.

Of course, Evans had the problems of any pioneer: he was finding genuine artefacts that were unique and remarkable and could not know what limitations should be set on the potential achievements of the Minoan craftsmen. A third factor comes into the equation with the realisation that some forgeries were probably being made in Crete by people very close to the Knossos excavations, who were intimately acquainted with the newly-found repertoire of Minoan art. Others besides Evans were taken in, and many museums have pieces now in their reserve collections that were once exhibited as genuine works of a Minoan Cretan hand. Some may indeed be Cretan – but of a more recent vintage.[12]

CONCLUDING REMARKS

141. Watercolour restoration of the miniature 'Grandstand and Temple' painting. 'Room of the Spiral Cornice', Palace of Knossos. Late Minoan I–II, 1700–1400 BC. 115 (W) × 50 cm (H). Arthur Evans Fresco Drawing J/4.

142. Chattering ladies (detail from fig. 48, p. 39).

No brief essay can hope to sum up the life and work of Arthur Evans, and biographies exist for the reader interested in obtaining a fuller view.[13] Interestingly, these have had a history very similar to that of biographical writings about Heinrich Schliemann. In both cases there was an early tendency to glorification – in Evans's case provided by his half-sister, Joan Evans, and in Schliemann's case, typically, provided by himself – and this has been followed in recent times by more critical, even harsh, revisionist accounts. Perhaps a combination of the two allows some of the main facts and the major truths to emerge.

141

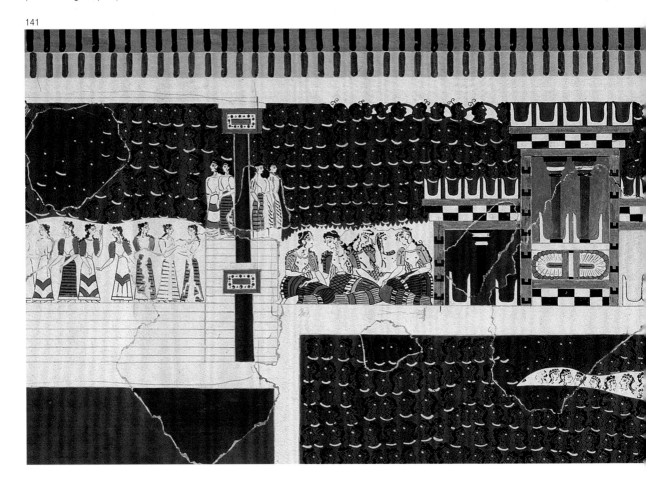

The place of biographies in archaeological literature is, though, an important one, in light of growing awareness that prehistory can become a background onto which ostensibly detached observers unconsciously project their own picture. This picture is often grounded in the reality of their own life and times and involving certain unquestioned assumptions. It has often been suggested, for example, that Arthur Evans was prone to see evidence for a Minoan monarchy and the Minoan thalassocracy (rule of the sea), because of familiarity with a British monarchy and British naval power.[14] The case can be overstated, but there are small, telling moments when he rather engagingly comes across as a creature of his time. In commenting on the chattering ladies in the Grandstand fresco (Figs. 141–142), for example, he says of one pair, 'May we venture to suppose that we have here a mother giving social advice to a debutante daughter?'.[15]

We might smile, perhaps – but nonetheless with respect. His voice emerges through his writings, and it is informed, engaged, inquisitive and energetic, ranging broadly over all Minoan matters. Approaches and interpretations may change, but the achievement of Sir Arthur Evans is breathtaking in its scale and is generally recognised as such by his successors in the field.

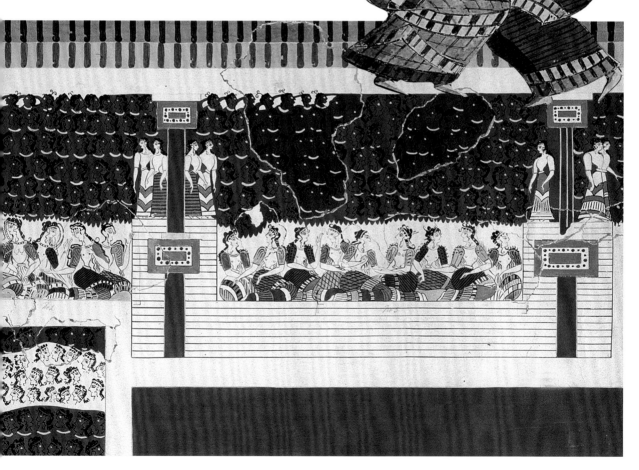

142

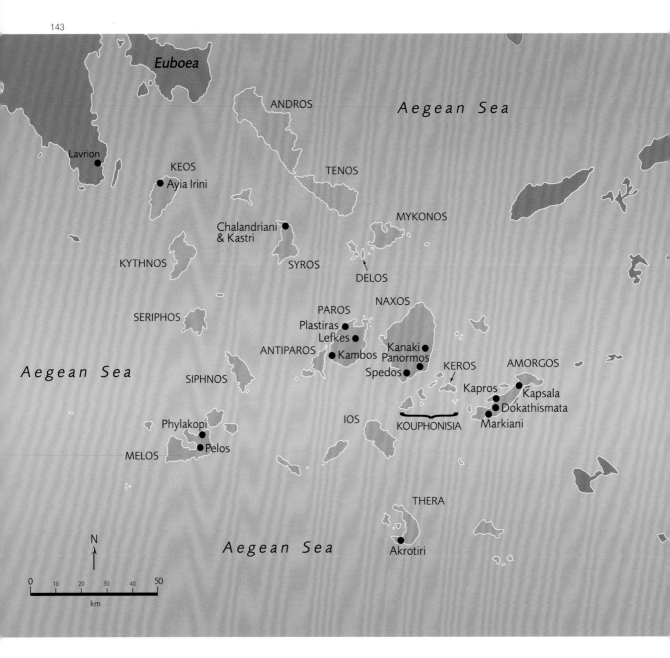

143

Euboea

Aegean Sea

ANDROS

TENOS

Lavrion

KEOS

Ayia Irini

MYKONOS

Chalandriani
& Kastri

KYTHNOS

SYROS

DELOS

NAXOS

PAROS

SERIPHOS

Plastiras

Lefkes

Kanaki

ANTIPAROS

Kambos

Panormos

AMORGOS

SIPHNOS

Spedos

KEROS

Kapros

Kapsala

Dokathismata

KOUPHONISIA

Markiani

Phylakopi

IOS

Pelos

MELOS

THERA

N

Aegean Sea

Akrotiri

Aegean Sea

0 10 20 30 40 50

km

4. The Cyclades in the Early Bronze Age

SUSAN SHERRATT
Lecturer in Archaeology, University of Sheffield

The Ashmolean contains one of the best and most representative collections of Bronze
Age Cycladic antiquities outside Greece. Much of this was acquired by purchase or gift in
the late nineteenth and early twentieth centuries through the interest of Sir Arthur Evans,
at that time Keeper of the Museum.

SPACE AND TIME

The Cyclades, from the Greek word *kyklos* meaning 'circle', was the name given by the
historical Greeks to the dense scatter of islands in the centre of the Aegean Sea, between
what is now mainland Greece and Turkey (Fig. 143). Including Andros, Keos, Kythnos,
Siphnos, Melos, Thera, Ios, Kouphonisia, Amorgos, Naxos, Paros, Mykonos, Syros,
Tenos and numerous other islands, they form a rough circle round Delos which the
Greeks of Classical times regarded as the sacred birthplace of Apollo. They provide a sea-
dominated environment, which is reflected in various aspects of their history and
prehistory. Some of them are also rich in certain mineral resources, such as silver on
Siphnos, copper on Kythnos, marble on Naxos and Paros, and obsidian – a type of hard,
translucent volcanic glass, greatly prized in very early periods for making stone cutting
tools – on the island of Melos.

Although it is still not clear precisely when the islands were first permanently inhabited,
we do know that Melian obsidian was being used by people living several hundred
kilometres away on the Greek mainland at least as early as 11,000 BC, which implies the
use of some form of boats to travel to, from and around the Cyclades. The first extensive
signs of settlement on a number of the islands belong to the advanced Neolithic period
(Late Stone Age), and date from around 5500 BC onwards. The first regular use of metal
for tools and small ornaments, including copper and, later, silver, occurs between
approximately 4500 and 3200 BC, in a period conventionally – and somewhat misleadingly
– termed the Final Neolithic. This is followed, from roughly 3200 to 2000 BC, by what is
conventionally called the Early Cycladic period or Early Bronze Age – an equally
misleading term, since it is not until around 2300 BC that bronze, in the sense of copper
alloyed with tin, first appears in the Cyclades.[1] Before that, copper-arsenic alloys were
used, often deliberately, in order to obtain a shiny silvery surface on items like daggers.

143. Map of the Cyclades
showing the location of sites
mentioned in the text.

A SEA-CENTRED CULTURE

During the Early Cycladic period, and particularly before the first appearance of sailing ships in the Aegean from around 2300 BC, the islands display a distinct material culture of their own (reflected in the term 'Cycladic'), which shows certain clear differences from those of surrounding areas – the Greek mainland to the west, Crete to the south, the islands of the eastern Aegean to the east and the Turkish mainland and coasts – though it overlaps with and impinges on the fringes of all these areas. The reason for this is the role of the Cyclades at this time as an important node of maritime activity, forming the main communication link between the coast of modern Turkey (and, beyond that, the already urbanised centres of south-east Turkey and Syria) and the Aegean regions in general, and through which ideas, materials and objects increasingly flowed in different directions as the period progressed. That before 2300 BC these were carried mainly on Cycladic paddle-powered longboats seems more than likely in view of the prominence of representations of these on the so-called 'frying pans' of clay (Figs. 144–145) and on engraved stone plaques and rock engravings from the islands. Indeed, so striking was the longboat imagery in the Early Bronze Age material uncovered from the cemetery at Chalandriani on Syros in the 1890s that it may have inspired someone in the early 20th century to attempt to produce three-dimensional versions of these in lead (Fig. 146). The Ashmolean boat illustrated here is one of only four lead models of identical design, all sold by the same dealer in Athens in 1907, and of rather obscure provenance. The model-maker, however, appears to have misunderstood the two-dimensional representations, and transformed the high stern with its squared stern-post and wind sock (in the shape of a fish emblem) at the top into a curved bow, and the other end, with its horizontal spur (or cutwater) projecting from the bottom of the hull, into a curious and unlikely raisable 'tailgate' contraption.[2]

GRAVES, THEIR CONTENTS AND THE EARLY CYCLADIC IMAGE

With a few exceptions, the majority of the objects from the Cyclades mentioned in this guide belong to the Early Cycladic period, and, though details of their findspots and find contexts have not for the most part been recorded, almost all of these are likely to have come from graves.[3] Many of them were either bought in the late 19th and early 20th centuries from dealers in Athens or acquired elsewhere in Greece on behalf of the Ashmolean by Arthur Evans. Other objects were given or sold to the Museum by Evans and his friends and contemporaries, such as Richard Dawkins, Duncan Mackenzie and Richard Bosanquet. Objects from graves in the Cyclades, often illicitly excavated, began to attract the attention of European (and later American) antiquarian collectors from the mid-19th century. Among them were obsidian artefacts, like the fine core left from the manufacture of long blades for ritual funerary use, which reached the Ashmolean in 1880 (Fig. 153). Although the function of the curious clay *kernoi* (multiple-vessel containers: Fig. 147) eludes us, one of them seems to have found an earlier use as a container for flower arrangements in a 19th-century English stately

144. 'Frying pan' with incised representation of a longboat in a sea of spirals. From a grave at Chalandriani on Syros excavated by Christos Tsountas. Early Cycladic II, 2800–2300 BC. National Archaeological Museum, Athens, No. 6184.

145. 'Frying pan' incised with circles and a boat. No provenance. Early Cycladic II, 2800–2300 BC. Clay. 1.6 (H) × 18.3 (Diam. of decorated face) × 14.7 cm (Diam. of inner rim). AN1971.842. Ex-Bomford coll.

146. Boat model. Said to have been found on Naxos. Early Cycladic II, 2800–2300 BC (if genuine). Lead. 3.5 (H) × 40 cm (L). Weight: 610.3 gr. AN1929.26. Purchased in Athens about 1907 by R.M. Dawkins and presented to the Museum in 1929.

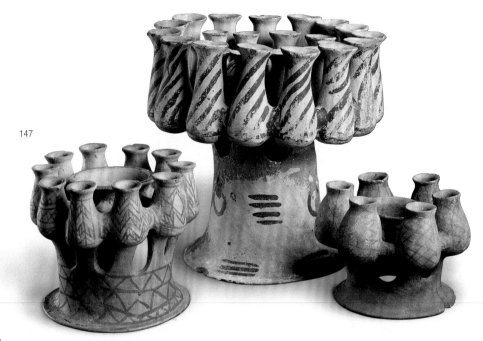

147

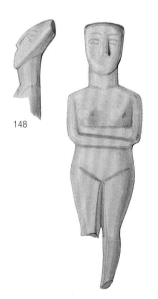

148

home. As the century wore on, the naturalistic marble figurines lost their reputation for coarseness and ugliness as seen through the eyes, for example, of Thomas Burgon in 1809 (Fig. 148), and gained an increasing aesthetic appeal as 'archaic figures of Aphrodite' – in other words, as early ancestors of the Venus de Milo.[4]

Early Cycladic graves, which typically also contain marble vessels and distinctive varieties of clay pots, as well as (in some cases) copper and silver objects and personal ornaments, have always been relatively easy to identify and excavate – whether legally or otherwise – since they generally lie near the surface of the ground in clusters.

One of the first systematic and scientific excavations to be undertaken was that of the very large cemetery at Chalandriani on the island of Syros, by Christos Tsountas in the 1890s (Fig. 149), but looting of graves, in the search for highly saleable objects such as figurines, has continued to be a problem down to recent years. Although some settlement sites have been excavated over the years,[5] it remains the case that the cemeteries of slab-lined cist graves (the most common generic type throughout the islands), corbel-vaulted cists (as on Syros) and rock-cut chambers (as on Ano Kouphonisi), which could be used for single or multiple burials, still constitute a large part of what we know about the archaeology of the Cyclades for much of the Early Bronze Age. What they make clear is that the assembly and deposition of grave goods, along with grave architecture and burial rituals, played a distinct and important part in the culture of Early Cycladic communities, reflected also in the relative prominence and visibility of their cemeteries.

Through the grave goods, as has been pointed out,[6] we are often able to glimpse the relatively clear image of some of their inhabitants which they themselves wished to

convey, particularly in the Early Cycladic II period (circa 2800–2300 BC): swaggering longboat crewmen, perhaps clean-shaven and possibly tattooed with bright colours, and equipped with glittering daggers and wine-drinking equipment. It is a predominantly male image, to which the marble figurines of naturalistic female form may, paradoxically, have contributed. Fortified settlements, such as those at Markiani on Amorgos, Kastri on Syros and Panormos on Naxos, add to a picture in which relations between communities might well be envisaged as characterised by competition and possibly even by active predation. They tend to be set on coastal hilltops, close to small, sheltered bays, and most of them would make excellent pirate strongholds.

Aspects of this image are well illustrated by items in the guide. Apart from the longboat representation on one of the mysterious clay 'frying pans' (whose use, whether practical or symbolic, is still disputed), the obsidian core (Fig. 153) represents what was left after a series of long sharp-sided blades had been flaked off, possibly by a graveside. These blades would have been particularly suitable for use as razors, and suggest that shaving or hair-cutting – of the dead or the living – may have been a feature of funerary rituals. The red pigment which still stains the inside of a marble chalice

152. Incised bone tube with blue pigment. From Naxos (Tomb 18). 10.2 cm. Early Cycladic II, 2800–2300 BC. National Archaeological Museum, Athens, no. 8818.

153. Obsidian core and blades. This fine core of Melian obsidian with thirteen blade scars remaining, appears to be exhausted. Said to be from Melos. Early Cycladic I–II, 3200–2300 BC. Core: 7.7 (L) × 2.3 cm (W); Blades: 5.5 cm (L). AN1880.123-125. Presented by Greville John Chester in 1880.

154. Two 'palettes'. Said to be from Amorgos. Early Cycladic I–II, 3200–2300 BC. Marble. 2.5 (H) × 18.2 (L) × 5.8 cm (W): AE.181 (1893.67); 0.7 (H) × 9.3 (L) × 4.5 cm (W). AE.182 (1893.66).

149

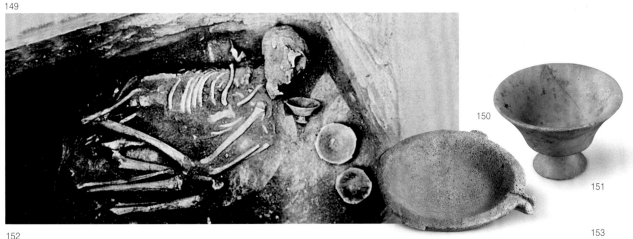

150

151

152

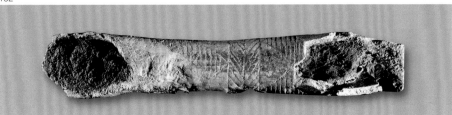

153

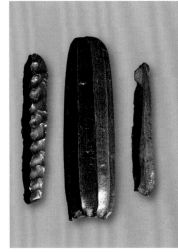

154

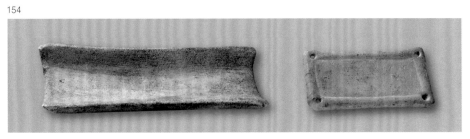

155. Shallow bowl with out-turned rim. Said to come from 'Kapros cist grave D' on Amorgos. Early Cycladic I–II, 3200–2300 BC. Silver. 1.6 (H) × 8.5 cm (rim Diam.). Weight: 71.49 gr. AE.158 (AN1893.46).

156–157. Small cup or bowl with a fine vine leaf impression on the underside. From Christos Tsountas's excavations at the cemetery of Chalandriani on Syros. Early Cycladic II, 2800–2300 BC. Clay. 7.1 (H) × 12.5 (rim Diam.) × 6 cm (base Diam.). AN1923.205. Donated by the National Museum, Athens.

158–159. Soft green stone stamp-cylinder seal with hole for suspension. Said to come from 'Kapros cist grave D' on Amorgos. 4.6 (H) × 1.9 cm (base Diam.). Near Eastern, perhaps North Syrian, early third millennium BC. AE.159 (AN1889.307). Purchased by Greville John Chester in Athens in 1889 and sold to the Museum the same year.

(Fig. 151) has been identified as cinnabar (mercuric sulphide), often found in association with silver deposits – and when the shallow marble bowl (Fig. 150) was purchased from a dealer in Athens in 1893 traces of red colour (now long gone) were noted in its interior. Traces of cinnabar have also been found inside other marble vessels from graves and on marble figurines, while hollow bone tubes (like that shown in Fig. 152) often contained azurite (a bright blue pigment). Occurrences of tattooing needles suggest that the bodies of perhaps both living and dead may have been decorated with colours such as these. The so-called 'palettes' form another group of objects that might have been used for the grinding and mixing of pigments, though their exact function remains puzzling (Fig. 154).[7]

The silver bowl (Fig. 155) may have been associated particularly with wine-drinking, since silver for vessels associated with elite wine-drinking ceremonies had already become the metal of choice in the East by 3000 BC. Its weight, which appears to conform to an eastern weight system, suggests that, by the Early Cycladic period, some drinking vessels for use in the East may have been made of Cycladic silver. Allegedly (though not entirely reliably) it is said to have been found in the same grave as a stamp-cylinder seal (Figs. 158–159) of Syrian type and almost certainly of ultimate Syrian origin.

At a more mundane level, the relatively unprepossessing clay drinking bowl excavated by Tsountas in the 1890s in a grave in the cemetery at Chalandriani on Syros (Figs. 156–157) also testifies more explicitly to the practice of social wine drinking in the Early Bronze Age Cyclades. Its base has been deliberately stamped before firing with the impression of a vine leaf[8] – so deliberately that it has distorted the shape of the bowl. Since the vine-leaf impression would only be visible when the bowl was raised to the lips for drinking, it may well have had an ideographic purpose – to emphasise to others that it was specifically wine which was being drunk.

MARBLE VESSELS AND FIGURINES

Among other typical contents of Early Cycladic graves, perhaps the best known are the marble vessels and figurines. Among the former, the *kandiles* (Figs. 160–161, from graves on Naxos and Paros respectively) are so called from their resemblance to the sanctuary lamps used in eastern Orthodox churches. They occur predominantly in graves in the early part of the period. That they were indeed regularly suspended by their perforated handles or 'lugs' is shown by the fact that these are often worn right through.

The sheep with the two hollowed out cups on its back (Fig. 162), which is one of a few similar sheep-like vessels from the early Cyclades, is particularly interesting, not least for the implications it has for the early production in the Cyclades of woollen textiles – an industry which gained particular importance in the Middle Bronze Age, when a variety of evidence for wool-weaving and dyeing is found at settlement sites such as Phylakopi.[9] The conceptual importance of the fleece is indicated by the great care that has been taken to represent it by means of a form of incised herringbone pattern, similar to that found on contemporary pottery (Fig. 163) from the cemetery at Pelos on Melos and reminiscent of traditional tweed patterns. Both these vessels probably also belong to the

160. Stemmed collared jar (*kandila*). From a tomb at Kanaki on Naxos. Early Cycladic I, 3200–2800 BC. Marble. 20.2 (H) × 7.7 (rim Diam.) × 5.2 cm (foot Diam.). Weight: 2465 gr. Capacity: 50 ml. AE.419. Purchased and sold to the Museum by Duncan Mackenzie in 1900.

161. Miniature stemmed collared jar (*kandila*). From a cist tomb near the village of Lefkes on Paros. Early Cycladic I, 3200–2800 BC. Marble. 6.5 (H) × 3 (rim Diam.) × 2.5 cm (foot Diam.). Weight: 194 gr. Capacity: 150 ml. AE.423. Purchased and sold to the Museum by Duncan Mackenzie in 1900.

160

161

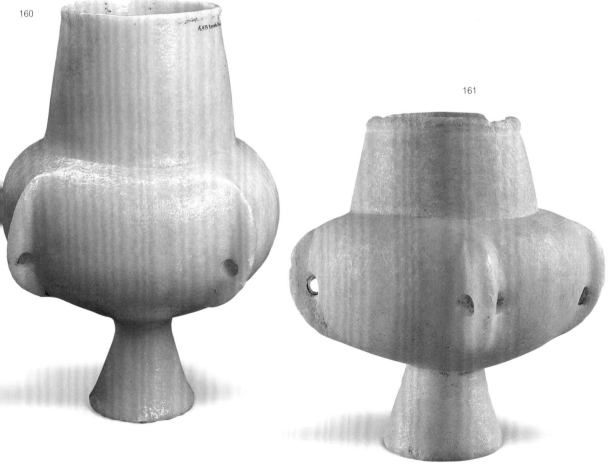

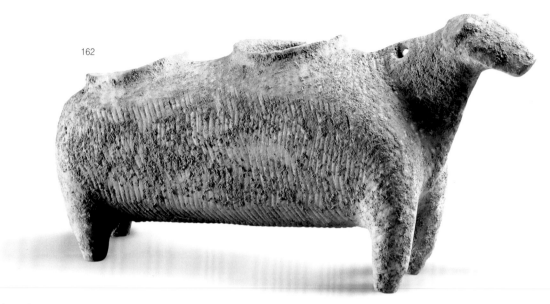

162

162. *Kernos* (multi-container vessel) in the shape of a sheep. Said to come from the Cyclades. Early Cycladic I, 3200–2800 BC? Marble. 11 (H) × 22 (L) × 4.5 cm (W). Weight: 1188 gr. AN1912.71.

163. Lidded pyxis decorated with incised herringbone pattern. From Pelos on Melos. Handmade. Early Cycladic I, 3200–2800 BC. Clay. 8.1 (H) × 9.8 (rim Diam.) × 9.5 cm (base Diam.). AE.435. Acquired 1902, probably through Duncan Mackenzie.

164. Lower part of a small handmade bowl or cup with woven mat impression on the base. Phylakopi on Melos. Early Cycladic III–Middle Cycladic, 2200–1900 BC. Clay. 3.5 (preserved height) × 5 cm (base Diam.). AE.569a. British School at Athens Excavations, 1896–1899.

165. Head of a male figure. Its naturalism attracted a certain amount of suspicion concerning its authenticity. From Amorgos. Early Cycladic II–III?, 2800–2100BC. Marble. 9 cm (H). AE.147. Bought by R.C. Bosanquet on Amorgos in 1897 and sold to the Museum.

166. Rare marble container in the shape of a female figure. Cyclades (provenance unknown). Early Cycladic I–II transition, 3000–2700 BC. 7.3 (H) × 7.9 (rim Diam.) × 5 cm (base Diam.). Capacity: 200 ml. AN1938.727.

early part of the Early Cycladic period, before 2800 BC, and suggest that sheep bred for their woolly fleeces and the introduction of woollen textiles were innovations of this period, of which certain elements among the island populations were particularly and proudly conscious.

Another textile-related activity – that of mat- and basket-weaving – can be glimpsed in the impression of some woven matting on the underside of a small bowl from the settlement site of Phylakopi on Melos (Fig. 164). Unlike the deliberately impressed vine leaf of the Chalandriani bowl, however, this probably merely reflects the use of a mat as a convenient base on which to form the hand-modelled pot. Although this one dates from the end of the Early Cycladic or early in the Middle Cycladic period, such mat or basketry impressions are not uncommon in earlier periods in the Cyclades. In an environment in which organic materials do not generally survive in

163

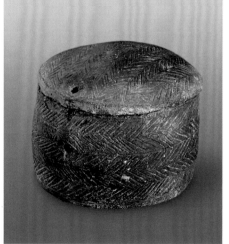

164

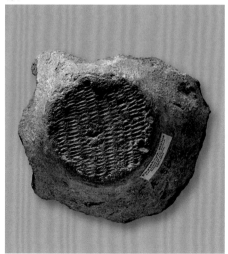

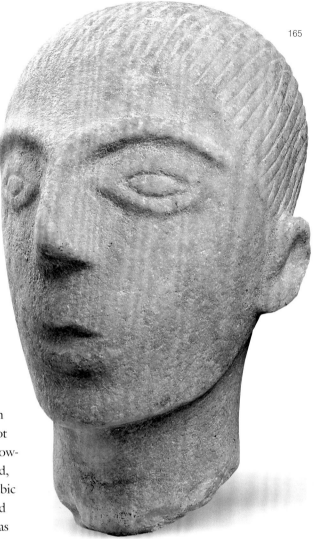

the ground, they provide virtually the only insights
we have into the arts of mat- and basket-weaving and
their development.

Another unusual marble vessel in the Ashmolean collection
(Fig. 166) has a distinctly anthropomorphic appearance, not
unlike the body of some marble female figurines, with its low-
relief arms extending upwards towards a pair of nipples and,
below these, what looks like a stylised representation of pubic
triangle and vulva. The figurines themselves are represented
by both schematic and more naturalistic examples, as well as
by an example of a unique and rather problematic head with
fully sculpted features (Fig. 165), which may, if genuinely
Cycladic in origin, belong to a large male figure.

Schematic figurines, like the 'violin' type (Fig. 167), with its
legless hourglass body and phallic projection at the top, are
generally the only types found in the earliest Early Cycladic
graves, along with marble *kandiles*, clay pots and obsidian
blades. The more naturalistic types, which include the well-
known folded arm varieties (Figs. 168–175), first seem to
appear in graves around 3000 BC, and continue throughout
the rest of the period. It often comes as a surprise to those
who have traditionally admired the 'pure abstract form' of
these marble figurines and their pristine whiteness, that most
– if not all – of them (probably including schematic types)
were originally painted with the same gaudy pigments as are
sometimes found in the interiors of marble vessels or in

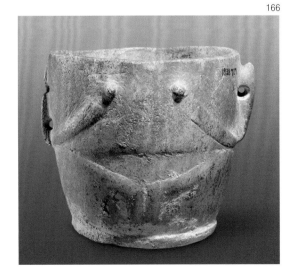

166

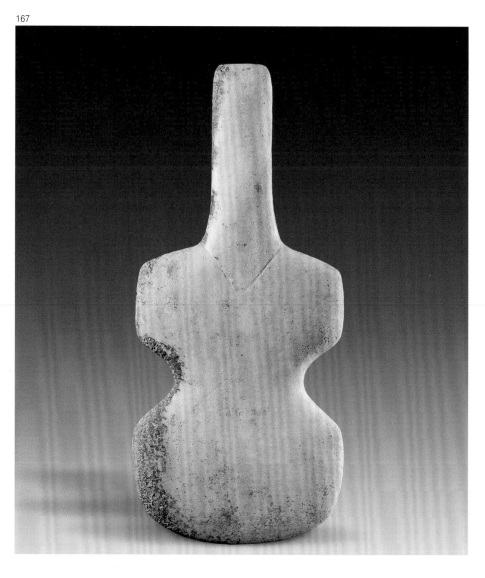

167. Schematic figurine of 'violin' type. Said to be from a cist grave on Amorgos. Early Cycladic I, 3200–2800 BC. Marble. 31.2 cm (H). Weight: 1,391 kg. AE.167 (AN1895.167).

168–170. Female figure of folded arm type combining features of the Spedos and Dokathismata varieties. This figurine, which cannot stand upright on its own, is the tenth largest known Cycladic figurine in the world. Said to be from a cist grave in Amorgos. Early Cycladic II, 2800–2300 BC. Marble. 75.9 cm (H). AE.176. Museum purchase.

bone tubes. This was well known in the late 19th century, when figurines were occasionally unearthed with traces of these pigments still clinging to them (Fig. 175). But these colours soon wore off, particularly after assiduous cleaning in museums and private collections, so that for much of the 20th century there was a fashionable perception of them as unadornedly white. This perception was influenced by the admiration of their apparent elemental simplicity by contemporary artists such as the sculptor Constantin Brancusi. However, chemical analyses have now detected the remains of cinnabar and other pigments on a number of figurines, and other techniques, such as the use of ultra-violet reflectography, have been able to show the traces of sometimes bizarre painted patterns which adorned their faces and bodies. Even without such techniques, it is often possible to distinguish the 'ghosts' of painted areas, from differences in colour of the surface patination, or to infer their existence from the lightly incised lines around eyes and sometimes mouths, which were probably intended as guidelines for the application of paint (Fig. 174).

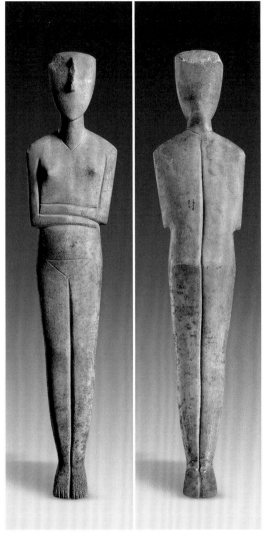

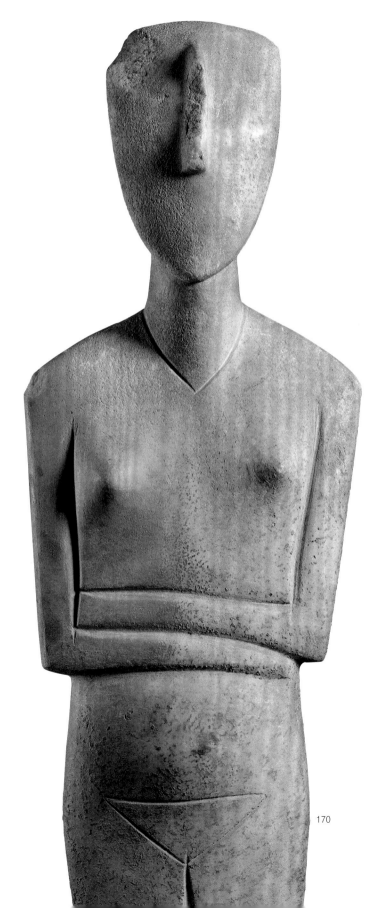

Areas which seem commonly to have been painted are the tops and backs of heads and faces, particularly to indicate headdresses (or hairstyles), eyes and mouths as seen, for example, on some of the Ashmolean pieces (Figs. 170–174). Once faces and headdresses or hairstyles are imagined back onto these figurines, they lose much of their abstract appearance and begin to look more conventionally human. We can perhaps begin once more to think of them less as the abstractions of elemental form, which Brancusi, Henry Moore and other 20th-century sculptors so admired, and more as direct reflections – albeit perhaps in idealised form – of early Cycladic women.

170

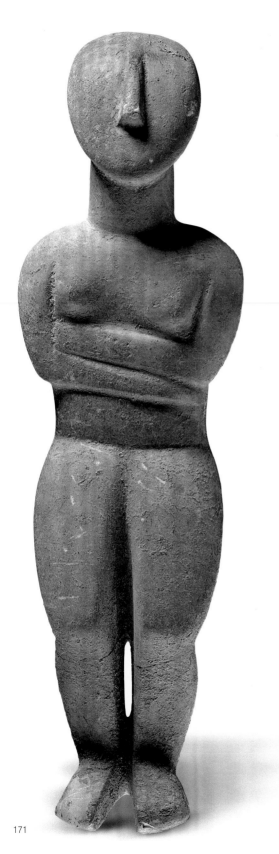

We do not know precisely what any of these figurines were designed to do or what they represented to those who made and owned them. There have been numerous suggestions, ranging from images of goddesses or their votaries, through companions of the souls of the dead, to 'canvases' on which to represent the successive life stages of individual women by means of repeated painting in different ways; but without a much more comprehensive understanding of their contexts it is unlikely that this question will be answered. However, the development over time of the naturalistic figurines suggests some interesting trends which may well have something to do with the construction of an image of women and gender roles during the course of the Early Cycladic period.

172 173

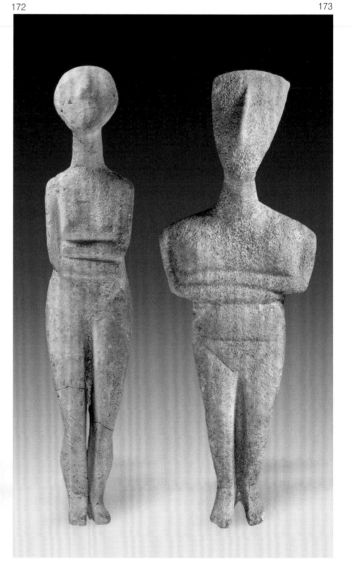

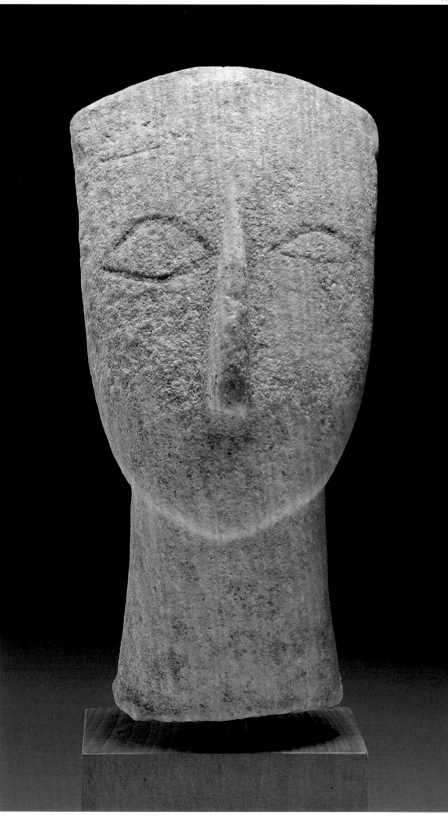

171. Female figurine of folded arm type of the Spedos variety. The figurine preserves traces of painted eyes, eyebrows, and hair or headdress. Said to be from a cist tomb on Amorgos. Early Cycladic II, 2800–2300 BC. Marble. 30 cm (H). AE.178. Museum purchase.

172. Female figurine of folded arm type. Said to be from Naxos and from the same grave as the lead boat models. Kapsala variety. Early Cycladic II, 2800–2300 BC. Marble. 18.2 cm (H). AN1929.28. Purchased by R.M. Dawkins in Athens in 1907, and presented by him to the Museum in 1929.

173. Marble female figurine of the folded arm type and of the Dokathismata variety. Remains of painted decoration are still visible, especially the eyes and traces of a headdress or hair. Said to be from Amorgos. 18.2 cm (H). AE.168 (AN1896.9).

174. Head of figurine of the Spedos variety. The large eye incisions are clearly visible. Said to be from Amorgos. Early Cycladic II, 2800–2300 BC. Marble. 14.6 cm (H). AE.152 (AN1893.73).

175. Drawing of a head with traces of painted decoration. Said to be from Amorgos. Early Cycladic II, 2800–2300 BC. Marble. 29 cm. National Archaeological Museum, Athens, no. 3909.

175

While earlier naturalistic figurines, such as the dumpy, fat-bottomed Neolithic ones (Fig. 176), or the Plastiras ones (Fig. 177) of the period just before 2800 BC, can generally stand upright, the canonical varieties of folded arm figurines (particularly the Spedos and Dokathismata varieties: e.g. Figs. 168–171, 173) cannot do so. Their increasingly downward-pointing feet make this impossible, and they can only lie in a supine position. Even the attractive, gently rounded Kapsala variety (Fig. 172), which is probably the earliest regular variety of folded arm figurines, can stand only with the greatest difficulty, and it is not at all clear that this was ever intended. At the same time, we see a shift of emphasis from the heavy buttocks and thighs (seen for instance in Fig. 177), which become slenderer and slimmer, towards shoulders and breasts. Particularly in the Dokathismata variety this shift tends to give the figures a somewhat top-heavy appearance (Fig. 173). What this suggests is a shift over time in the perception of women from one which emphasises their active (and achieved) fertility to an emphasis on passive nubility, with the promise of future fertility indicated by the fact that some of them seem to be shown in an early stage of pregnancy (Figs. 168–170). And perhaps by the left-above-right folded posture of their arms, ready to cradle a future baby. This would tie in well with a social context in which women were regarded as possessions, and wives as prizes to be won through exchange or perhaps even by shipborne raids on other island communities.

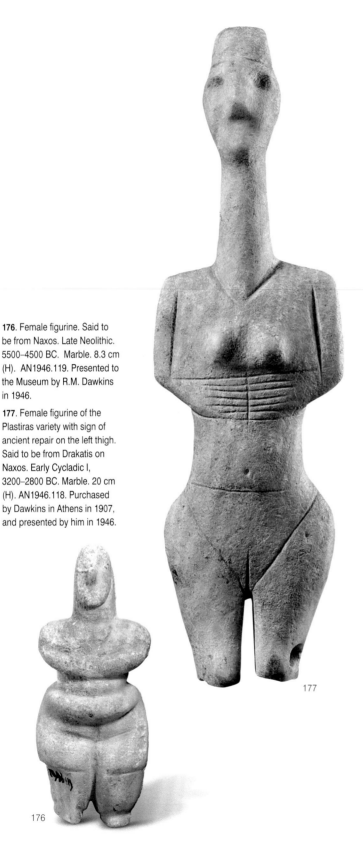

176. Female figurine. Said to be from Naxos. Late Neolithic. 5500–4500 BC. Marble. 8.3 cm (H). AN1946.119. Presented to the Museum by R.M. Dawkins in 1946.

177. Female figurine of the Plastiras variety with sign of ancient repair on the left thigh. Said to be from Drakatis on Naxos. Early Cycladic I, 3200–2800 BC. Marble. 20 cm (H). AN1946.118. Purchased by Dawkins in Athens in 1907, and presented by him in 1946.

177

176

PHYLAKOPI: THE MIDDLE AND LATE BRONZE AGES

Some of the Cycladic objects represented in this guide date from the Middle and early Late Bronze Age. Most of them come from the settlement at Phylakopi on Melos, which was first excavated by the British School at Athens between 1896 and 1899 (Fig. 178). Although it was clearly inhabited from early in the Early Cycladic period, this is a site which seems to have grown in size and gained particular prominence at the end of the Early Bronze Age. Its growth was possibly the result of nucleation of existing settlements on the island once the appearance of sailing ships began to alter the earlier configuration of maritime routes around the Aegean, and the large southern Aegean island of Crete became the main contact point for larger eastern ships making the direct sea voyage from centres like Byblos in the East Mediterranean. Around 2000 BC the first palace administrations and their related structures appear on Crete, and thereafter we see the start of the development of a degree of cultural and probably also economic convergence between Crete and the Cyclades which eventually diminishes the distinctiveness of a separate Cycladic culture.

178

178. Phylakopi on Melos. A substantial part of the site has been destroyed by coastal erosion.

179. 'Later Local' style conical vessel (*rhyton*). Phylakopi on Melos. Late Cycladic I, 1700–1600 BC. Clay. 27 (H) x 1.4 cm (base Diam.). AE.518. British School at Athens Excavations, 1896–1899.

179

180. Beaked nippled jug. Phylakopi on Melos. Cycladic White ware, Middle Cycladic, 2000–1700 BC. Clay. 28 (restored height) × 6.4 cm (base Diam.). AE.542. British School at Athens Excavations, 1896–1899.

181. Conical 'flowerpot' of Cycladic White ware. Phylakopi on Melos. Late Cycladic I, 1700–1600 BC. Clay. 12 (H) × 17 (rim Diam.) × 7 cm (base Diam.). AE.527. British School at Athens Excavations, 1896–1899.

182. Red and Black style pedestal bowl. Phylakopi on Melos. Late Cycladic I, 1700–1600 BC. Clay. 16 (H) × 20.1 (rim Diam.) × 8.4 cm (base Diam. of stand). AE.536. British School at Athens Excavations, 1896–1899.

This is reflected in the forms and decorations of some of the pots from Phylakopi. For example, the mysterious pedestalled bowl (Fig. 182), which dates to the end of the Middle Bronze Age or beginning of the Late Bronze Age (circa 1700 BC), is a type with a long history in Crete. Several such pedestalled bowls were found at the site, in contexts which suggest some ceremonial or religious use, perhaps connected with pouring libations (liquid offerings). A 'flowerpot' (Fig. 181) of roughly similar date may also have had some esoteric ritual function, though the hole pierced through the base close to one edge would equally make it a perfectly usable plant pot. Again, both its shape and decoration reveal Cretan influence. A ritual use is usually assumed for conical vessels such as the rhyton illustrated here (Fig. 179), which also has a hole in the base and is decorated with patterns with strong similarities to those on some early Late Bronze Age Cretan pots. Another characteristic, and rather playful, shape of the Cyclades is the beaked nippled jug (Fig. 180). The motifs on these jugs often allude to textile patterns, such as the four-petalled rosette inside the circle or the antithetic spiral with the arc-shaped pendant.

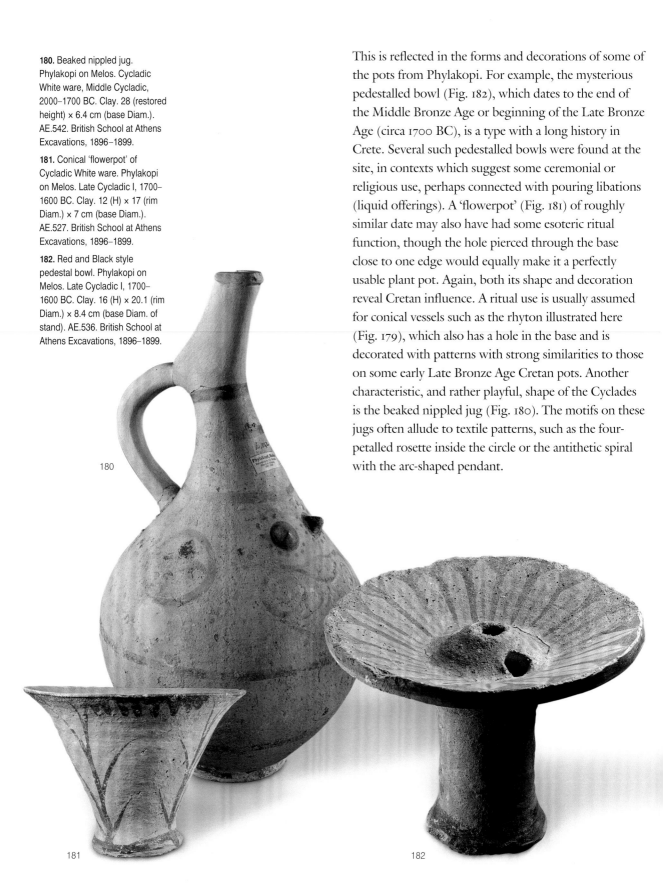

180

181

182

100

Finally, the vase decorated with a frieze of birds (Fig. 183), though of Cycladic (most probably Melian) manufacture, was actually unearthed by Arthur Evans in the palace at Knossos. It is one of several similar jugs found on Crete, and, though we do not know what they contained, the presumption must be that they were imported to Crete from the Cyclades on account of their contents.

OBJECTS AND CONTEXTS

The objects illustrated here represent only a small sample of the material culture of the Cyclades between four and more than five thousand years ago, at a time when the Cycladic way of life (and its treatment of the dead) was at its most distinctive in comparison with those of adjacent areas. Many of them originated in graves, some of which were almost certainly excavated illicitly precisely because of the attractive nature and materials of the grave goods they contained. Since then, items like marble figurines and vessels have attained great commercial value as individual 'art' objects, according to anachronistic post-Renaissance ideals of art and the artist;[10] and changing perceptions over the years, led largely by the fashionable views of the art market, have materially influenced the ways in which they have been observed and interpreted. Nevertheless, by examining them closely, and looking at them in the context of other grave goods and against the wider background of what is known of contemporary settlements, it is still possible to use them to reconstruct some sense of the kind of image Cycladic islanders wished to project of themselves – in death, if not in life. But if we wish really to understand the nature of Early Cycladic culture and society, then this will depend on preserving the totality of contextual information – what was associated with what (and whom), how graves fitted into their associated cemeteries, how cemeteries related to their associated settlements, and how human activity related to the landscape in which it took place. The industries and mythologies which the collectability of certain Early Cycladic objects has engendered, and which have often succeeded in obscuring and destroying their original circumstances of use and deposition, will have to give way to a recognition that their elucidation lies in the preservation and understanding of their contexts rather than in some notion of self-standing art which merely encourages the continued looting of Cycladic graves.

183. Melian bird vase, with beaked mouth. From the 'Temple Repositories' at Knossos. Middle Minoan III–Late Minoan IA (context); Middle Cycladic III-Late Cycladic I (style), 1800–1600 BC. Clay. 53.5 (restored height) × 12.5 cm (base Diam.). AE.807. Excavated by Arthur Evans in 1903.

183

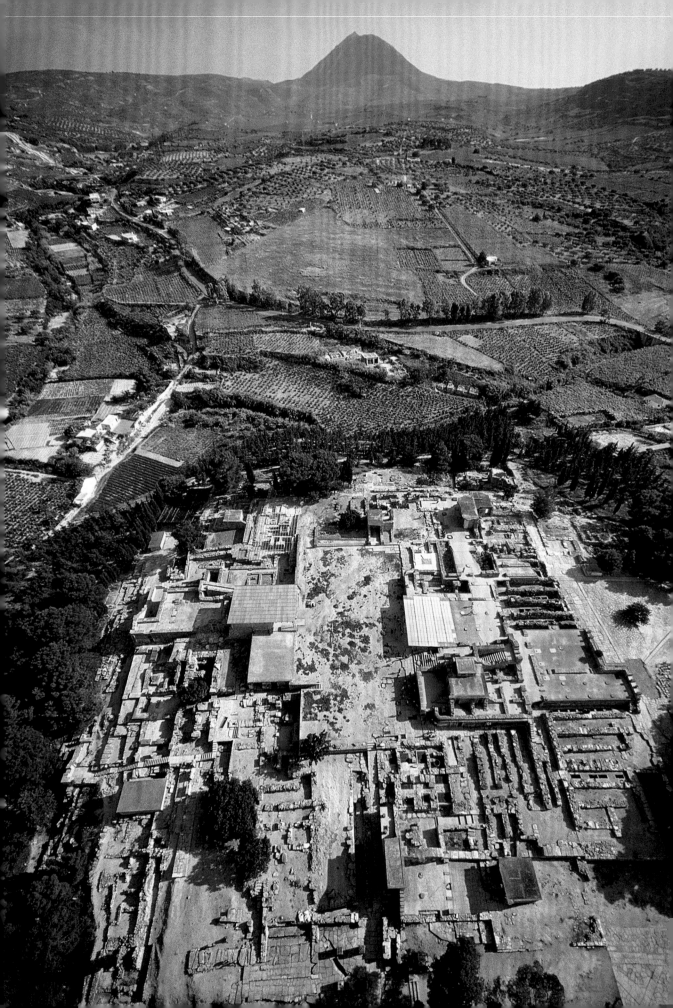

5. Minoan Crete: People in a World of Objects and Places

JOHN BENNET

Professor of Aegean Archaeology, University of Sheffield

SETTING THE SCENE

Crete – known in Greek as the 'Great Island', at just over 8000 sq. km. (Fig. 187), the fifth largest in the Mediterranean – is the last island of any size in the southern Aegean Sea as one travels towards North Africa, where the nearest landfall is about 300 km distant. Equally, it is the first major island encountered on any trip into the Aegean and routes between Crete and the southern mainland of Greece (Peloponnese) or southwest Anatolia involve 'hops' between islands of around 30 km. Due north of central Crete lies the island of Thera (also called Santorini), only just over 100 km distant, while from there a western island route takes one via Melos into the Gulf of Argos or, one step further, via Keos to the region of Attica and its metal ore sources in the Lavrion.

Throughout its 9000-year history of permanent human occupation[1] Crete acts both as a destination for those travelling south within the Aegean and as a 'filter' between the Aegean and the wider Mediterranean. Island contacts were particularly strong along the island's north coast in the mid-third millennium BC, when objects like the so-called Cycladic figurines or materials like obsidian (from Melos), or copper (from Kythnos) are attested. For much of the third millennium BC, such contacts were probably carried on in the oared longboats depicted on the enigmatic 'frying pans' of the Cyclades (Fig. 144). Towards the end of the millennium, however, a new type of sea craft appears in the Aegean and is depicted on some of the early Cretan seals (Fig. 185–186): the sailing ship (see also **Chapter 4**).[2]

'PALACES'

One can perhaps liken the appearance of the sailing ship in the Aegean at the end of the third millennium BC to that of the jet aeroplane towards the end of the second millennium of our era: both collapsed distance and facilitated the movement of people and materials on an unprecedented scale, over considerable distances, along well-defined routes. The world of Minoan Crete expanded from one centred on the

184. Aerial photograph of the Palace at Knossos looking towards Mt Iouktas to the south.

185–186. Loop signet with flat face showing Hieroglyphic signs around a ship with a mast and oars. Said to be from Neapolis in east Crete. Obtained by Arthur Evans by exchange from R.B. Seager. Silver alloy. 1.1 (Diam.) × 1.55 cm (H). AE.2327.

185

186

187. Bronze Age Crete.

188. Jar, hollow from top to bottom. Said to come from Central Crete. There is something of a mystery as to which side is the top and which the bottom. If the wider side is the bottom, then the vase resembles an Egyptian baggy alabastron. If the narrow side is the bottom, then it is closer to an Egyptian heart-shaped jar. Since the material (serpentinite) is not local to Crete, the vessel was probably made in Egypt and re-carved on the island. Third millennium BC (if considered a heart-shaped jar); 18th Dynasty (second half of the second millennium BC, if a baggy alabastron). 11 (H) × 9.7 (max. Diam.). AE.384.

Aegean and western Turkey to one that incorporated the coastal eastern Mediterranean from southern Turkey, through modern Syria, Lebanon and Israel, to Egypt (Figs. 188–189). Exotic materials, such as the hippopotamus ivory used for some Early Minoan seals, had existed in small quantities and in some locations, but contacts with this new world enhanced and expanded their acquisition, for the first time, to a regular flow of novel materials, manufactures, and ideas. It is no accident that it is exactly at this time that the first palatial building complexes were constructed on the island, ushering in a millennium of palatial culture that Sir Arthur Evans, who did so much to shape our view of it in the early 20th century, called 'Minoan'.[3] Evans regarded Minoan Crete as the first 'European civilisation', its writing systems the earliest in Europe, partly for political reasons, because Crete had been wrested away from the Ottoman Empire two years before Evans's excavations began in 1900 (see also **Chapter 3**). It is clear, however, that Crete's position at the interface between East and West produced that amalgamation of local with exotic that so typifies the Minoan material world and eventually, over the following millennium, that of the Aegean as a whole.

We should not mistake the importance of external contacts for the passive transformation of Minoan Crete by simplistic processes of invasion, colonisation, or diffusion. If this were the case, then we might expect palatial complexes to appear more or less randomly across the island. The earliest, however, appear at sites that were already of some size, history, or complexity, within a mosaic of smaller sites whose nature we only imperfectly understand, since, with a few notable exceptions, they have not attracted the attention of major excavations. We might think of palatial complexes as crystallizing out of a mixture of cultural practices within various regions. This observation highlights an important ambiguity in

189

188

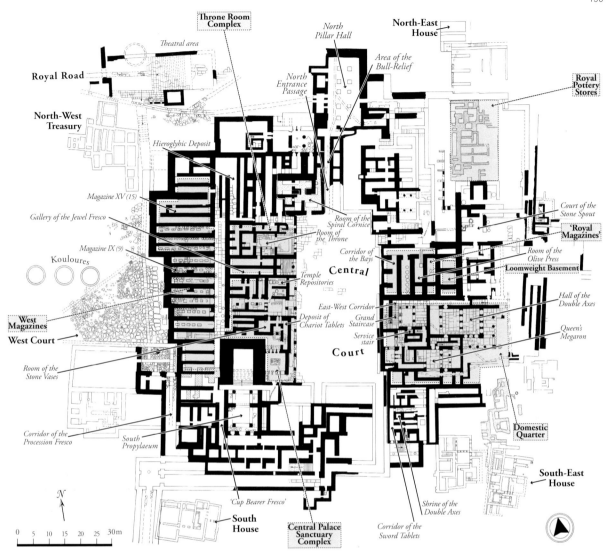

Throne Room Complex

North Pillar Hall

North-East House

Theatral area

North Entrance Passage

Area of the Bull-Relief

Royal Road

Royal Pottery Stores

North-West Treasury

Hieroglyhic Deposit

Magazine XV (15)

Room of the Spiral Cornice

Court of the Stone Spout

Gallery of the Jewel Fresco

Room of the Throne

'Royal Magazines'

Magazine IX (9)

Room of the Olive Press

Kouloures

Central

Corridor of the Bays

Loomweight Basement

Temple Repositories

Hall of the Double Axes

East-West Corridor

West Magazines

Deposit of Chariot Tablets

Grand Staircase

Queen's Megaron

West Court

Service stair

Court

Room of the Stone Vases

Corridor of the Procession Fresco

South Propylaeum

Domestic Quarter

N

South-East House

0 5 10 15 20 25 30m

'Cup Bearer Fresco'

South House

Central Palace Sanctuary Complex

Shrine of the Double Axes

Corridor of the Sword Tablets

the term 'palace'. In one sense, the term has a narrow, architectural definition within Minoan archaeology: a monumental building complex comprising specialised areas for storage, ritual, residence and (probably) manufacture, arranged around a central open court, with a second open court on its western edge (Fig. 190). In the narrow, architectural sense, these complexes appear relatively suddenly just after 2000 BC, in the Middle Minoan IB period,[4] at the sites of Knossos, Phaistos, and Mallia. However, the uniformity of layout is a mirage based on the fact that the best attested structures at these sites belong several centuries later, in the Neo-Palatial period. The more we learn about the earliest monumental constructions on these sites the more it appears that, other than the presence of central and western courts, they differed considerably in detail, reflecting their origins within local practice.[5] Equally, just like any large building complex, particularly in an earthquake zone like the

189. A bridge-spouted Kamares pot found in Egypt. Though heavily restored, when it was first discovered at Abydos (Tomb 416) by John Garstang in 1907, it sent waves of enthusiasm to the scholarly community as it offered, at the time, 'the most definite datum yet obtained for the relative chronology of this period in Crete'. Middle Minoan II, 1900–1800 BC. Clay. E.3295.

190. Plan of the Palace of Knossos. Remains indicated in solid black refer to the Neopalatial period.

southern Aegean, they are organisms, constantly being repaired, modified, and expanded. To say 'the palace at Knossos', therefore, begs the questions: which palace, and at what particular point in its history?[6]

The second sense of 'palace', however, is social, not architectural. In this sense, we use the word in a broadly similar way to its usage in relation to Mesopotamian or east Mediterranean societies, stressing the social roles played by those whose authority we imagine resided in the architectural complexes. 'Palaces', in this sense, are centres of power, of consumption, of production, of exchange, and of ritual. They are focal points within a broader community. In Minoan Crete, it is clear that settlements like Knossos, Phaistos, Mallia (and some others not architecturally 'palatial', like Mochlos in eastern Crete) were already, in the strictly Pre-Palatial phase, local centres for production, consumption or exchange, while there is growing evidence for complex architecture in this period. This highlights the relevance of external contacts: they did not, in and of themselves, trigger the emergence of palatial civilisation on Crete, but the potential already existed within certain communities for the active appropriation of exotic materials, manufactures and knowledge.[7]

Knossos illustrates these points nicely. By the time the palatial structures were built there, humans had inhabited the site for at least five millennia. The 'tell' (i.e. the mound) comprising the accumulated deposits of 4000 years of Neolithic habitation was levelled to make a platform for the palatial complex, no doubt revealing buildings and artefacts to those carrying out the work, bringing them into physical contact with the products of prior generations of inhabitants. Not only was Knossos a place of history, perhaps the oldest permanent settlement on the island, it was also a place of mystery. Located a few kilometres to the south is the mountain now known as Iouchtas, whose characteristic shape dominates the landscape of the Knossos valley (Fig. 184). Little surprise, then, that the southern skyline, viewed from the central court

191. View to the north from the central court at the palace of Phaistos toward Mt Ida (Psiloritis), showing Kamares cave below right-hand peak.

192. View of the Plateau of Lasithi.

191

of the Knossos palace is dominated by Iouchtas, or that there is evidence for ritual on the peak from late in the Pre-Palatial period. We see a similar arrangement at Phaistos, a site that also has a deep history of prior occupation, if only around two millennia. Here Mount Ida (or Psiloritis) dominates the central court, presenting itself as a pair of peaks (Fig. 191).[8] Beneath the right peak, as one looks at the mountain from Phaistos, is a prominent dark circle. This is the entrance to the Kamares Cave, which was in use in the Proto-Palatial period as a sanctuary. It is possible that the palace at Mallia is linked in a less obvious manner to the Lasithi massif dominating the horizon to its south, on whose northern border lay the peak-top sanctuary of Karphi. The cave sanctuary at Psychro, known also as the Dictaean Cave, overlooked the upland plateau of Lasithi (Fig. 192), but was itself hidden from view from the coast.

The 'true' palaces are therefore intimately linked to a history of occupation and to a local landscape marked by ritual activity. This point is important, because the term 'palace' has recently been questioned as a meaningful one, precipitated in part by the discovery of other building complexes arranged around central courts which are described as 'court-centred buildings' or 'court compounds'.[9] Prominent among these are the sites of Kommos, on the western coast of the Mesara plain, and Galatas, some 30 km southeast of Knossos, on the river valley that ultimately reaches the sea at Amnisos. At both a central court exists, but as a Neo-Palatial feature, not part of the original layout at either site and, in the case of Galatas, a relatively short-lived feature belonging to a generation or two within the early Neo-Palatial. It seems that at both of these sites – and a few others, including perhaps the early complex at Pylos on the mainland (see **Chapter 6**) – the palatial architectural form is being appropriated to make claims about authority. Even the fourth palace to be discovered, Kato Zakros, falls into this category, since its palatial architectural form is Neo-Palatial. We should not expect cultural meanings to remain static over the considerable life span of Minoan settlements, especially the palaces.[10]

192

PEOPLE AND OBJECTS IN ACTION

193. House façade inlay with two stories and dormer from the Knossos 'Town Mosaic'. From the filling north of the 'Loomweight Basement', East Wing, Knossos. Middle Minoan IIB or III, 1900–1700 BC. Faience restored in plaster. 3.35 (H) × 3 (W) × 0.4 cm (Th.). AN1936.591.

194. The reconstructed area of the Propylaeum at Knossos which Evans saw as the main monumental entrance to the palace.

Minoan social life was played out within architectural frames (notably the palaces) and in places in the landscape invested with meaning through repeated visits and actions carried out there. Palace spaces were carefully managed to create an effect in those who moved through their corridors, or participated in gatherings within their open courts. In Neo-Palatial Knossos, for example, visitors approached from the northwest, along the so-called Royal Road, and were offered two possible ways into the palatial complex itself. One led to the north of the palace, then, after a right-angle turn, through the North Entrance Passage, past a life-size representation of a bull in relief, straight into the open-air space of the central court at its northern edge (Figs. 195–196). The other led to a less imposing entrance through the west facade, which in turn led into the

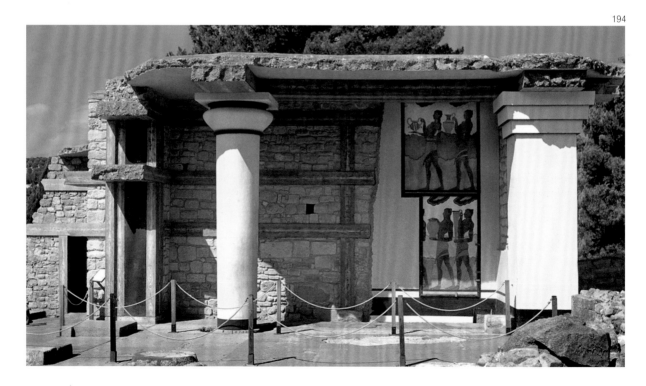

194

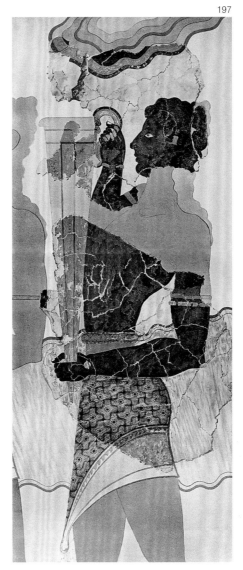

Corridor of the Procession Fresco, along which the visitor passed, 'accompanied' by near life-size representations of individuals carrying objects of elite material culture (Fig. 197). After making three right-angle turns, the visitor would emerge from the interior space of the corridor into the open-air space of the south edge of the central court (Figs. 194, 197). The effect of each of these journeys would have been different, evocative, certainly in the latter case, of later traditions surrounding the labyrinth. What is important to bear in mind is the emphasis on experience and performance; the architectural effect only works in the presence of actors moving through the spaces created.[11]

Performance and participation were key aspects in Minoan elite cultural practice. Architecture – and arguably the landscape itself – were the only monumental art forms, while human representation at life-size was confined to wall paintings, some of them accentuated by relief modelling, themselves intimately linked to architectural context. The richest representations often appeared on the surface of portable, often small, objects,

195. Piet de Jong. Reconstruction of the North Entrance Passage at Knossos. Ink drawing.

196. A reconstruction of the raging bull relief that may have adorned the bastions of the North Entrance Passage, although almost certainly not in this precise form.

197. E. Gilliéron *père*. Restored drawing of the 'Cup-Bearer' fresco. Early 20th century AD (date of the original: Late Minoan II, 1500–1400 BC. Watercolour. 1.28m (L with frame) × 60 cm (W with frame). Arthur Evans Fresco Drawing M/2.

198

199

198-199. Fragment from a conical vessel (*rhyton*). Relief scene with ashlar building decorated with horns of consecration on top, tree and men. Said to come from Gypsades, to the south of the palace at Knossos. Late Minoan I, 1700–1450 BC. Serpentine. 8.9 (L) × 5 (preserved W) × 1.5 cm (Th.). AE.1247.

200-201. Banded agate cushion seal showing a 'bull at the trough' and a man leaping onto the bull. Said to come from Priene, Turkey. Late Minoan I, 1700–1450 BC. Agate. 2.2 (L) × 1.7 (W) × 0.65 cm (Th.). AN1938.964. Ex-Tyszkiewicz coll.

202-203. Fragment from a conical vessel (*rhyton*) showing a relief scene with a man, a goat and part of a helmet, possibly along with a spear and the top of a figure-of-eight shield. NW of the Palace at Knossos. Late Minoan I, 1700–1450 BC. Serpentine. 3.9 (L) × 4.1 cm (W). AN1938.698.

such as the numerous gems (Figs. 200–201), whose detailed scenes were often difficult to make out against the natural patterns in their material, until they were 'performed' by being impressed on clay. Plaques of faience – a material whose production technology was probably a palatial monopoly – seem to have been assembled, perhaps on items of furniture, to create larger scenes, like the famous 'Town mosaic' (Fig. 193). Scenes of considerable detail were carved on the surface of stone vessels (Figs. 198–199, 202–204), the whole sometimes overlain with gold leaf, to judge by the traces that occasionally survive.

Objects like these could only be appreciated at close quarters, functioning 'horizontally' within a select group, rather than projecting a monumental message 'vertically' from elite to masses. However, these objects were embedded in practice, not mere decorations. The seals were used to mark a range of complex sealing forms linked to different stages in the administrative system of Neo-Palatial Crete. Stone vessels, depending on their shape, were used in the pouring of liquids or as receptacles for offerings, for example on peak-top sanctuaries (Fig. 205). The fact that none has survived intact suggests the possibility that the final act of some rituals might have been to smash the vessel used.

200

201

202

203

204. This scene is often interpreted as showing a mountainous sanctuary. It appears in relief on the body of a stone conical vessel (*rhyton*). Kato Zakros. Late Minoan IB, 1600–1450 BC, drawing by Thomas Phanourakis.

205. Crest-shaped bowl (ladle). Knossos. Middle Minoan III–Late Minoan I, 1800–1450 BC. Grey and white banded limestone. 3.6 (H) × 15 cm (L). AN1938.800.

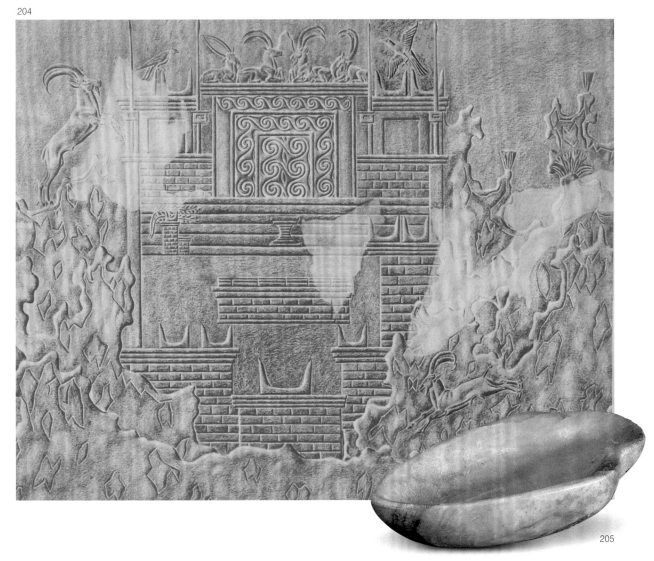

204

205

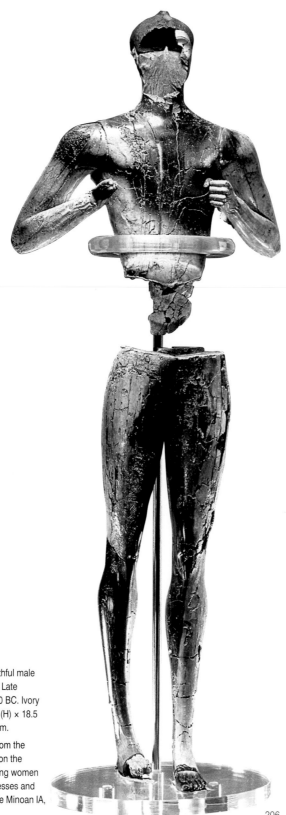

Materials were important too. We are unfortunately not in a position, as we are in the case of the Egyptian, Mesopotamian or later Greco-Roman cultures, to appreciate from contemporary informants the cultural meanings attributed to materials, but we can imagine that the choice of a particular colour or pattern in stones for vessels or sealstones was significant. The use of multiple materials in combination clearly had value, as is evident in a tour de force of Minoan conspicuous production, a figure, originally just over half a meter high, discovered smashed in the Late Minoan IB destruction level at Palaikastro (Fig. 206). Dubbed the Palaikastro *kouros*, the figure represents a youthful male, his musculature and veins carefully modelled, and realised in a combination of ivory, gold, serpentine, wood and Egyptian blue. We should also be aware of materials lost to the archaeological record, such as the elaborate textiles attested in the Linear B tablets from Knossos, but depicted in earlier wall paintings, such as those from Thera (Fig. 207) or on the arms of men of Keftiu, the Egyptian name for Crete, depicted in Egyptian tomb paintings like that of Senenmut and Rekhmire (Figs. 120, 239).[12] Objects, then, took on meaning through their surfaces as well as their implication in elite activities.

206. A figure of a youthful male (*kouros*). Palaikastro, Late Minoan IB, 1600–1450 BC. Ivory and serpentine. H 20 (H) × 18.5 cm (W). Siteia Museum.

207. A wall painting from the settlement at Akrotiri on the island of Thera showing women wearing elaborate dresses and collecting crocus. Late Minoan IA, 1700–1600 BC.

206

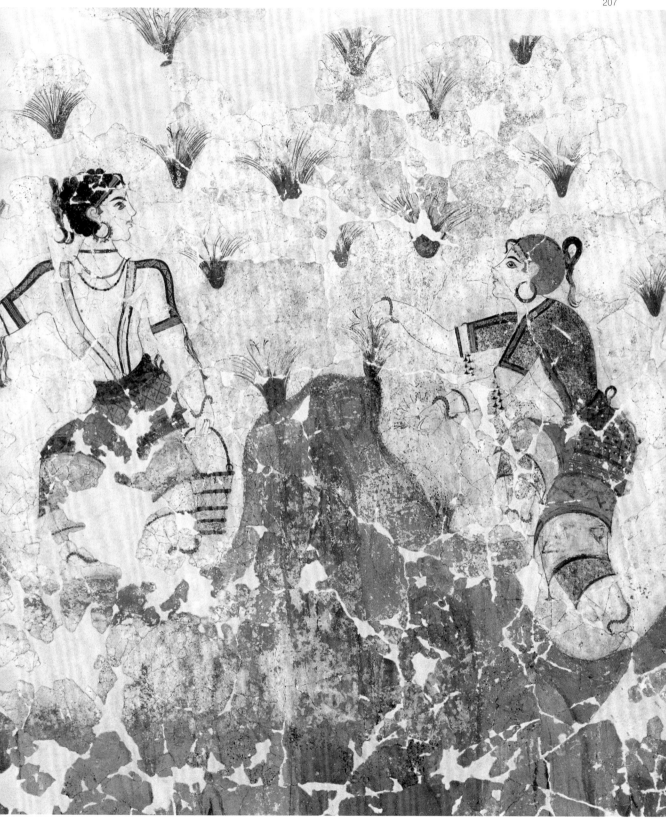

IMAGE AND TEXT

Scenes in miniature, on seals or stone vessels, often reappear at larger scale on wall paintings. These exist at two scales: life-size, or near life-size representations that invite participation by actors within the space or the room or corridor with the actions depicted, or miniature, where the entire action can be comprehended in an all-encompassing ('panoptic') view, but participation is impossible.[13] Into the former category would fall the Procession Fresco mentioned above inviting the presence of an individual to complete the composition, or the scenes of landscape that 'dissolve' the walls of the interior space. The latter would include representations like the so-called 'Grandstand Fresco', which appears to depict a gathering within the palace (see Fig. 141), the so-called 'Sacred Grove and Dance Fresco' (Fig. 210), showing women dancing in front of a large male and female audience on the open space of the palace's west court, or depictions of bull-leaping (Fig. 208).

Given that some Cretans, at least among the elite, were literate, a striking feature of Minoan representation is that image and text are almost never brought together in the same field, in stark contrast to contemporary Egypt, where text and image are virtually inseparable in the art of public display from an early date. Occasionally, object surfaces bear inscriptions where images normally appear, such as stone vessels (Figs. 256–257), or pieces of jewellery (Fig. 209). However, there are many examples of wall paintings that depict scenes of action that carry no text to make them specific, yet the wall paintings themselves share conventions with contemporary eastern Mediterranean art and Minoan-style wall paintings have even been found in early 18th dynasty Egypt at the site of Avaris, modern Tell el Dab'a.

The significance of this difference from cultures of the eastern Mediterranean can perhaps be appreciated in relation to the representation of authority. In contemporary Egypt (and the city-states and empires of Mesopotamia) representations of the ruler – at life-size or even monumental scale – are common. In Minoan Crete, by contrast, no indisputable representation of a ruler is attested, certainly not at a large scale, a fact that has prompted one scholar to coin the phrase 'the missing ruler' in relation to Aegean representational art.[14] It seems that, unlike in other eastern Mediterranean cultures, where text and image combine to create specific representations of rulers that do not require their physical presence (third person representations), in Minoan Crete, the emphasis was on presence and action in context (first person representations). Similarly, the context for various types of specialised performance, especially ritual, were not fixed, but created by moving objects around to the appropriate space when required; they were not there as permanent equipment.

The 'missing ruler' question is one that is currently being debated within the field, because the lack of a clear iconography of power means that the nature of authority in Minoan Crete is unclear. For Evans, working in late-Victorian England, the palaces were frequented by kings, with their queens, authority very much linked to the religious

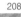
208

208. Bull-leaper. The two large fragments that make up the 'bull-leaper' seen here were restored together by A.J. Lambert early in the 20th century. While the torso belongs to the figure who has successfully completed the leap over the bull, the open legs belong to the figure who would have been placed in front of the bull just about to leap over the animal's body. From the 'Court of the Stone Spout', East Wing, Knossos. Late Minoan II, 1450–1400 BC. Fresco. 61 (L) × 30 cm (W). AE.1708.

114

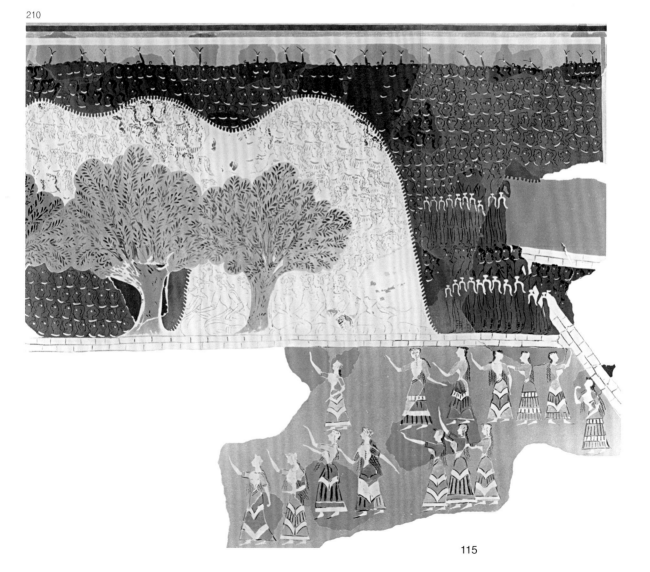

sphere – hence his coining of the term 'Priest-King'.[15] Recent discussions have sought to move away from the notion of a single authority, headed by a (male or female) individual, towards a notion of competing factions, a state of affairs sometimes termed heterarchical, as opposed to the hierarchical view implicit in the idea of a single ruler.[16] This viewpoint would see the palaces as ceremonial centres, not elite residences. Neither imagery nor texts help us here and we may simply have to admit that the exact qualities of Minoan authority still elude us. We should, however, at least be wary of assuming that absence of *representations* of authority meant absence of authority or that whatever authority existed retained the same form throughout the several hundred years of palatial culture. The question works at a higher level, too, since it is a widely held view that Knossos, the largest, the oldest and the first palace to be excavated and presented extensively in print, ruled Crete through at least part of the Neo-Palatial period. There are no conclusive arguments here and little definitively to counter the idea of the island as politically sub-divided.

209. Silver pin bearing a Linear A inscription from the Mavrospelio cemetery, Knossos, Late Minoan IA, 1700–1600 BC, 15 cm (L). Herakleion Museum. HM 530.

210. Reconstruction drawing of the miniature 'Sacred Grove and Dance' painting indicating original fragments. 115 (W) × 50 cm (H). 'Room of the Spiral Cornice'. Palace at Knossos. Late Minoan I–II, 1700–1400 BC. 58 (W) × 46 cm (H). Arthur Evans Fresco Drawing J/3.

210

CRETE IN THE MYCENAEAN WORLD

Whatever the situation in the Neo-Palatial period, around 1500–1450 BC, the end of the Late Minoan IB ceramic phase, the situation changes, as we can confirm through Linear B texts (see also **Chapter 7**). Many sites on Crete experience substantial burnt destructions. The palaces at Mallia, Phaistos and Kato Zakros are burnt and never rebuilt in their Minoan form, although they are reoccupied, while major towns like Palaikastro, Gournia, and Ayia Triada show similar burning. Knossos, however, despite some evidence of destruction in the vicinity of the palace, continues in use as a palatial centre, its layout modified to accommodate new styles of administration and storage, but not substantially altered. Evans regarded this phase at Knossos as contemporary with the pre-destruction phases of other major sites and suggested that Knossos displayed a special variant of Minoan culture, including a new writing system, Linear B. The following phase, he thought, was a Post-Palatial phase, with Crete in decline. We now realise that 'Linear B Knossos' post-dates the destruction of other sites and this is reflected in the terminology we now use: the 'Third or Final Palace period'. The documents (now deciphered, although their exact find spots and chronology still excite debate over a century after their discovery) relate to a changed world, in which, it seems, Knossos had economic control of key aspects of production over much of the west and centre of Crete, from Chania to the Lasithi region.[17] If there was a period of Minoan history when Knossos was the sole centre for (much of) the island, then this was almost certainly it.

Michael Ventris's decipherment in 1952 of the language behind Linear B as Greek has engendered a simplistic reconstruction of Minoan history in this period, in which Crete is overrun by marauding mainlanders. The simple presence of the Greek language tends to mask the role of Knossos itself in the transformation of Crete at this period. We know that polities on Crete had been in contact with mainland polities, sharing materials and knowledge, at least since the period of the Mycenae Shaft Graves, perhaps two hundred years prior, so Greek must have been a language familiar to those Cretans involved in such interaction. Equally, within the 15th century BC, styles of visible burial appear at Knossos that combine local ritual and funerary symbolism with mainland-derived traditions, like the tholos tomb (see also **Chapter 6**). Burials also appear in new areas, north of the palace, towards Knossos's harbour town at Poros-Katsambas.[18] New forms of drinking vessels appear too, implying a different style of consumption at the dinner table. These features seem to represent the creation, through material display, by the Knossian elite, of a distinctive, hybrid identity, neither purely Cretan, nor purely mainland. It is most visible around 1450–1400 BC, the Late Minoan II ceramic phase, immediately after the wave of destructions, when Knossian ceramic styles seem prevalent over much of the island. A more plausible reconstruction, then, suggests that Knossos, perhaps with the encouragement or sponsorship of one or more mainland polities, staged a take-over of much of western and central Crete, consolidating economic control over two to three generations.

However, this control seems not to have lasted very long. It may have been undermined by the difficulty of controlling Crete from a single central point near the north coast,[19] but,

perhaps three to four generations later, around 1375–1350 BC, the early Late Minoan IIIA2 ceramic phase, Knossos suffered a major destruction. Although people continued to live there (and, it seems, to use the Linear B script), the political map of Crete was again redrawn, power now shared among a number of smaller, regional 'successor' polities, most of them probably second-order centres under the Knossos administration. Prominent among these were Chania (Kydonia in Linear B) in the west, where Linear B documents dating to the mid-13th century BC have been found, Ayia Triada in south-central Crete, with its port at Kommos, and Mallia to the east of Knossos.

These centres formed part of a larger 'Mycenaean' world dominated by the mainland centres of Thebes, Tiryns, Mycenae (Fig. 211), and Pylos that controlled exchange networks extending from Sardinia and Sicily through the Aegean to southern Anatolia, Cyprus, the Syro-Palestinian coast (notably Ugarit in Syria) and Egypt. The movement of valuable commodities and products along these routes is vividly attested by the late-14th-century BC Uluburun wreck excavated off the southern coast of Turkey in the 1980s (Figs. 238, 240).[20] Crete is far from being a backwater in this period, as the activity at the port site of Kommos and nearby Ayia Triada clearly attests,[21] but the island's fortunes were now intimately bound up with those of the mainland polities (see also **Chapter 6**). The Bronze Age ends here, as it does on the mainland, around 1200 BC with the destruction and abandonment of many sites, the collapse, no doubt, linked to major geopolitical events in the eastern Mediterranean and the emergence of new economic and political forces together with the growth in use of a new material: iron.

211. View of the citadel at Mycenae.

211

6. Mycenaean Greece: from Crete to the Mainland of Europe and Back

JACK L. DAVIS

Carl W. Blegen Professor of Greek Archaeology, University of Cincinnati

The concept of a Mainland (with a capital 'M') has long been current in Greek prehistory, although it has rarely been defined. More often than not it is described by what it is not – not the Cycladic islands; nor the island of Crete, home of the 'Minoans'. In the minds of many, the Argolid in the Peloponnese, and in particular the citadel of Mycenae (Fig. 212), is the heartland of Mainland prehistory. But for other professional archaeologists it includes a much larger area that in part lies outside the borders of the modern Greek state: from Albania, the Former Yugoslav Republic of Macedonia, Bulgaria, and European Turkey, on the north, to the southernmost tips of Greek Messenia and Laconia, on the south.

Definitional issues of this sort are more than academic semantics. The proper geographical scope of any essay such as this one can only be determined in light of the particular concerns of its author and his audience. Here these must be the Mainland finds from the Ashmolean Museum, all of which are characteristic of the Mycenaean Civilisation, a culture that affected much of the southern Balkan Peninsula in the Late Bronze Age and was focused on the northeastern part of the Greek Peloponnese. There, a broad plain that extended northwards from the head of the Argolic Gulf was home to several centres of power. Chief among them was Mycenae at the head of the plain, near the southern end of the Tretos Pass that leads north to the Isthmus of Corinth (Fig. 213).[1]

By the start of the Late Helladic period interaction among centres in the Argive Plain and others in southern Greece had set off a cycle of competition and emulation that resulted in the emergence of the distinctive material culture that we know as Mycenaean – artistic styles and technologies much impacted by contact with contemporary fashions on the island of Crete and in the southern Aegean islands.[2]

By the 14th century BC Mycenaean centres on the Mainland had become dominant economically, if not also politically, in the Aegean, having eclipsed Minoan centres long since. Inhabitants of the Greek peninsula and the Aegean islands embraced Mycenaean material culture as they were incorporated into Mycenaean kingdoms or their spheres of influence.

212. Aerial photograph of the citadel of Mycenae looking towards the pass leading to the Berbati Valley.

HEINRICH SCHLIEMANN AND THE
ORIGINS OF MYCENAEAN CIVILISATION

At Mycenae itself the earliest manifestations of the competitive acquisition of power come in the form of elaborate burials in so-called Shaft Graves. And it is with these, too, that the story of Mycenaean archaeology begins at the end of the 19th century (see also **Chapter 3**). Following his own test excavations in 1874, the first systematic investigation of prehistoric remains at Mycenae was started by Heinrich (Henry) Schliemann (Fig. 214), a German-born American citizen, merchant and scholar, on 7 August 1876.[3] Only a few years earlier he had announced to the world his discovery of the very Troy that was described by Homer in the *Iliad*. Schliemann unleashed his workers and let loose a storm of controversy.

Mycenae is a small rocky crag, a plug that blocks the pass leading east between the twin peaks of Profitis Elias and Zara; to the traveller who approaches from the south, north, or west, it lies hidden behind the ridge of the Virgin Mary (the Panayia) until one draws near.[4] Steep slopes and a dizzying chasm protect its citadel on the north and south; ascent to its crest by the more gentle neck to the west could be easily impeded by a man-made wall, as it was when the Mycenaeans built a strong 'Cyclopean' fortification there[5] (Fig. 212).

213. Map of the Aegean showing a small selection of Late Bronze Age sites.

213

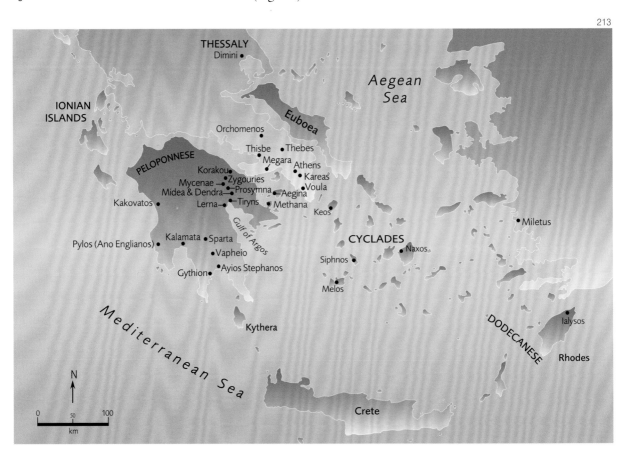

Schliemann was drawn to Mycenae because it was the legendary home of King Agamemnon, leader of the Greek armada that had sailed to Troy to recapture the hand of Helen, purloined wife of his brother, Menelaos of Sparta. With the text of Pausanias, a 2nd century AD Greek-speaking writer as his guide, Schliemann surveyed the site. Mycenae's location had long been known: monumental tombs of its rulers had been explored and described by western European travellers and the 'Lion Gate' of its acropolis had often been illustrated (Fig. 215). Already by late winter of 1874, Schliemann had dug 34 pits within the walls of the acropolis to search for the burial place of Agamemnon and other members of his dynasty: one struck pay-dirt – an undecorated tombstone-like slab.

The discovery in 1876 of the first two additional limestone slabs with carved decoration fuelled his interest further.[6] Their similar designs are characteristic leitmotifs of Mycenaean culture: on the first (Fig. 216) was a framed panel with zones of interlocking spirals above; a horse-drawn chariot preceded by an armed warrior, perhaps its elusive victim, below (Fig. 217). The second slab seems to clarify the meaning of the first: a chariot, its horse in flying gallop, chases down a fallen enemy; below, in a metaphorical echo, a lion pursues its prey.[7]

Schliemann eventually revealed other tombstones, both complete and fragmentary, that had marked the locations of deep shafts cut into the native rock on the western slope of the citadel of Mycenae. Several successive burials had been deposited in each of these shaft graves. The bodies, dressed in lavish funeral shrouds, were garnished with attachments of gold and their faces sometimes covered by masks of gold. The dead must have been lowered into the grave in wooden coffins, or suspended in

214

215

214. Portrait of Heinrich Schliemann about the time of the excavations at Mycenae. His signature can be seen at the bottom.

215. Drawing of the 'Lion Gate' at Mycenae by Josef Durm, 1910.

121

216

217

216-217. Grave markers from Mycenae's 'Grave Circle A'.

218-219. Drawings of Mainland pottery by Piet de Jong.

220. 'Palace style' jar with wave pattern and lilies; largely restored. Little Palace, Knossos. Late Minoan IIIA, 1400–1300 BC. Clay. 111 cm (H). AN1923.763. Excavated and presented by Arthur Evans.

slings. Once set into the tomb, offerings were laid alongside them. These attest to the enormous wealth of the rulers of Mycenae and, although details in Schliemann's reports may be inaccurate, they constitute the most spectacular deposit of precious prehistoric metal objects that has been found anywhere on European soil. Some of his contemporaries doubted that such marvels could be as early in date as the Bronze Age; others imagined that those buried in the graves were invaders, newly arrived in Greece. But it is absolutely certain that the tombs he found do date to early in the Mycenaean period (circa 1700–1500 BC).

Schliemann triumphantly announced in a telegram to King George of Greece, on the 28th of November 1876, that he had before him the graves of Agamemnon, Cassandra, Eurymedon and their comrades, discoveries that would attract thousands of foreigners to Greece from every land. On the latter point he was certainly correct, but not on the former. At the time of these graves there is hardly any evidence for interaction between Greece and Troy, and we are four centuries prior to the traditional date of the Trojan War (1180 BC).

The appearance of the site of Mycenae at the time when the first Shaft Graves were dug by its prehistoric inhabitants was unimaginably different from today. No beehive tombs had been built. The settlement was un-walled. Its rulers seem to have had a mansion, but little of it is preserved. The western slopes of the citadel had not yet been extensively settled. Instead, adjacent to the town was an extensive cemetery, where most of the dead were buried in small cramped boxes or cist-graves. Within that cemetery were more richly provided tombs, such as those explored by Schliemann, and a second cluster of similar graves excavated in the 1950s by Greek archaeologists Ioannis Papadimitriou and George Mylonas.[8] Both groups of special burials were probably surrounded by low stone enclosures and are known as 'Grave Circles', Schliemann's 'A', Mylonas's 'B'.

218

219

THE EXPANSION INTO THE AEGEAN AND MYCENAEAN CULTURE

From the time of the Shaft Graves, Mainland material culture came quickly to dominate the Aegean: new Mycenaean fashions replaced traditional styles or those that had been patterned directly on Minoan prototypes (see essay **Chapter 4**). At Cycladic centres such as Ayia Irini on Keos, Phylakopi on Melos, or Akrotiri on Thera, by the beginning of the Old Palace period on Crete, almost every aspect of life had been affected through contact with people from Minoan Crete.[9]

But with the destruction of the Minoan New Palaces about 1450 BC, changes were swift. Events on Keos are illustrative. There the entire settlement of Ayia Irini was badly damaged, and there is little subsequent evidence for direct contact, or even indirect influence, from Crete. By the end of the 15th century BC, the material culture of the community looked instead to the Mainland. Pottery, for example, almost entirely followed trends being set in the Peloponnese.

Ceramics are, in fact, the most recognisable and widespread attribute of Mycenaean civilisation. In the early Mycenaean period, there was considerable variation in the shapes and decorations of pottery produced on the Greek mainland. Much was fine and colourful; vases with contrasting Black and Red ('Bichrome') paint on a highly polished lustrous surface are worthy of special note (Fig. 218). This seems to have been an age of considerable experimentation.

One style ultimately squeezed out the others: we call it 'Mycenaean' (Fig. 219).[10] The patterns and shapes employed are highly derivative, stylised versions of freer or more elaborate decorations invented on Minoan Crete. Shapes also for the most part aped Cretan ceramics, which were at least in part produced in imitation of contemporary metallic forms. Mainland potters appear to have copied these, first in the Peloponnese at places where Mainlanders came into frequent contact with established Cretan communities; their patrons were thus bought into the great prestige of a venerable Minoan tradition.

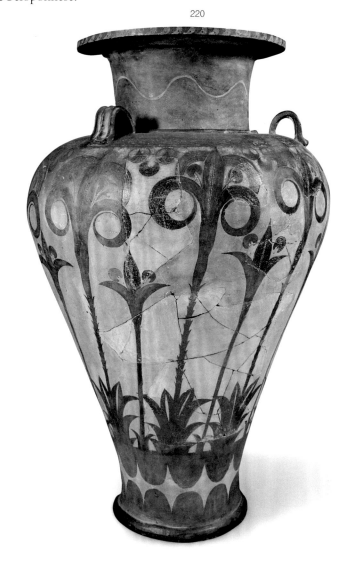

220

But the tale of interaction between the Mainland and Crete in the 15th century BC is not only a matter of a 'younger' civilisation imitating an 'older'. To the contrary, Mycenaean influence on the island of Crete is so pervasive that it has often been argued that the island was invaded by Greeks from the mainland who seized control of palaces like Knossos. One indication of Mainland influence on Crete was the creation of a 'Palace Style' in both Mycenaean and Minoan ceramic decoration (Figs. 220–221). But attributing all such change to an invasion may be much too simplistic (see also **Chapter 5**).

Benefits for the Mainland of more direct contact with Crete were substantial. A system of writing Greek in the syllabic Linear B script evolved, based on the older Cretan Linear A script (see essay **Chapter 7**). Since its decipherment in 1952, it has been clear from documents discovered at Mycenae, Tiryns, Thebes, Ayios Vasileios near Sparta, the Palace of Nestor at Pylos, and elsewhere, that Greek was the language of administration in Mycenaean centres of 1400–1200 BC.[11] At the same time contact with Crete may have also been instrumental in encouraging the use of monumental architecture as a symbol of power, both in the worlds of the living and the dead.

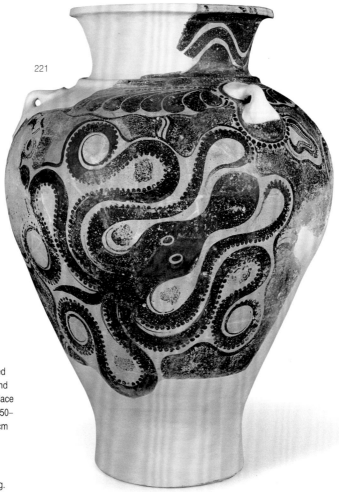

221

221. 'Palace style' jar decorated with a six-tentacled octopus and murex shells. 'NW border', Palace at Knossos. Late Minoan II, 1450–1400 BC. Clay. 74.5 (H) × 54 cm (Diam.). AN1911.608.

222-223. Drawings of a Mycenaean tholos and a chamber tomb by Piet de Jong.

THE MYCENAEAN DEAD

Countless numbers of Mycenaean tombs have been looted by grave robbers who seek complete pots and precious jewellery to sell in the international art market. Information from those that have been properly investigated by archaeologists makes it possible, however, to describe in outline the burial practices of the Mycenaeans (Figs. 222–223).[12] The most elaborate grave was the beehive tomb, or *tholos* – an impressive monument noticed by early travellers to Greece. The type first emerged in the 17th century BC in Messenia, in the southwestern Peloponnese, perhaps in imitation of older earthen burial mounds.

At Mycenae beehive tombs had by the 15th century BC totally replaced Shaft Graves: ultimately nine were built. All are similar in basic form and method of construction. A drum-like shaft was first cut into the slope of a hill. In it a conical vaulted chamber, circular in section, was constructed. This corbelled vault lacked a true keystone. Each higher course of the wall projected slightly toward the interior, so that the chamber was entirely roofed. When the shaft was then filled with earth, the outer ends of the stones in the wall were held in place by its weight. In the most magnificent of the beehive tombs (the 'Treasury of Atreus' at Mycenae), a broad conglomerate-lined corridor or *dromos* led to the chamber; the exterior façades of its doorway or *stomion* were decorated with attached columns and carved plaques of red and greenish grey stone.[13]

A simpler form of burial was the rock-cut chamber tomb. In that case an irregular circular or rectangular compartment was carved into the bedrock. On rare occasions, the corridors leading to the chambers might be lined with stone and the outer façade of the doorway even decorated with painted plaster. In a few instances, the chamber itself was carved to mimic a *tholos*. It is likely that many others of the dead were buried in pits or cists with few or no grave goods, or were given no formal burial at all. How a body was disposed was no doubt related to the social position and rank of the dead.

Mycenaean burial rituals were, however, remarkably similar, regardless of the form of grave. The locations of tombs were known to the living. As new deaths occurred, graves were reopened, fumigated, and the disarticulated bones from previous burials pushed to one side

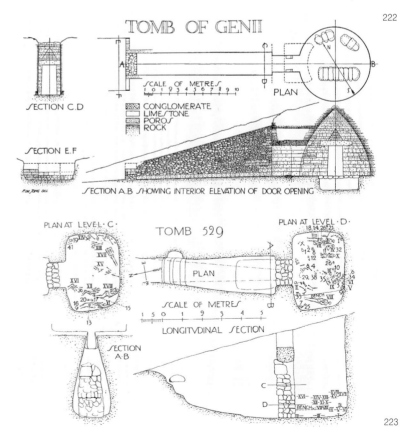

222

223

to make room for extended inhumations and new grave goods. Characteristic offerings were clay pots, glass beads (notably the relief beads so characteristic of the Mycenaean world), seals often engraved with Cretan-inspired patterns, and gold jewellery (Figs. 224–229). Graves thus served as ossuaries and family vaults over long periods of time, and must have emphasised the continuity of familial lines and rights to property and power.

THE MYCENAEAN PALATIAL CENTRES

In the world of the living major changes also occurred after the early Mycenaean period. Many citadels were surrounded by strong stone fortification walls (Fig. 212). At Mycenae the perimeter wall of the 13th century BC was nearly a kilometre in circumference, with blocks weighing two tons or more. At the top of the citadel was the palace of the king, at its core a three-room *megaron* (Homer's word for 'palace'). In this inner sanctum the royal throne faced a large centrally placed hearth that was surrounded by four columns.

The first Cyclopean fortifications at Mycenae date to the second half of the 14th century BC, but substantial modifications were made to them in the following century. The 'Lion Gate' was then added as the main entrance to the citadel and the west slope of the hill was enclosed. The area where Schliemann found his Shaft Graves was at that time monumentalised, perhaps as a shrine to the ancestors of the elite who then held power or to heroes of the community.[14] Ground level was raised; a high bench-like circular wall of slabs was built; the surface inside was paved; and older tombstones were re-erected. Schliemann thought this had been a council circle of the Elders and the slabs, seats. No mind that the tops of the benches are twice the height of modern chairs. Heroes were bigger than mere mortals of his day!

Not far south of this monument a complex of shrines was constructed in the Cult Centre of Mycenae.[15] A horseshoe-shaped altar, with an installation for pouring libations, was built in one room. Inside another, a large terracotta figure stood on a bench. In yet another, a goddess or mortal worshipper is depicted alongside a lion or griffin (a fabulous creature with the wings and head of an eagle but a lion's body), a sheaf of grain in each hand. The Mycenaeans may have

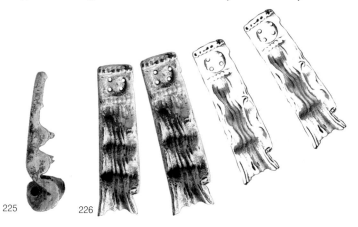

224 225 226

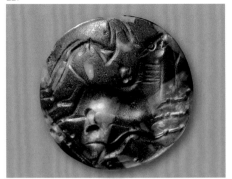
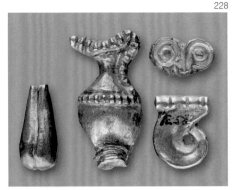

227. Seal showing a running bull with a man leaping over the animal's back and a dog below. Said to have been found at Gythion (south Peloponnese), mainland Greece. Late Minoan II–IIIA1, 1450–1375 BC. Lapis lacedaemonius (Spartan basalt). 2.1 (Diam.) × 0.85 cm (Th.). AN1938.1074.

228. Gold beads from a tomb in the 'Lower Town' at Mycenae. Late Helladic II–IIIA, 1600–1375 BC. 1-2 cm (L). AE.587-592. Bought by Arthur Evans in 1894.

229. Signet ring with two lions tethered to a pillar. Said to come from Mycenae. Late Helladic II–IIIA1, 1600–1375 BC. Gold (Au 66%, Ag 30%, Cu 4%). 2.35 (bezel L) × 1.6 (bezel W) × 1.55-1.62 cm (inner hoop Diam.). Weight: 8.7gr. AN1938.1126.

believed that griffins really existed; we have depictions of them nursing their young and it has even been suggested that ostrich eggs, when imported from the East to the Aegean, may have been thought theirs.

Frescoes (or rather wall paintings since it is unclear that paint was applied to wet, rather than dry, plaster) are characteristic of Mycenaean palaces. These are yet another legacy of Minoan Crete. The best preserved collection is from Pylos. A palace was first built there in the 14th century BC, perhaps with a central court as found in the palaces on Crete. Some of its walls were built of rectangular limestone cut blocks; one was marked with a Minoan symbol – a double axe.[16] The walls of its 13th century BC successor (Figs. 230–231) were covered with paintings, of which many thousands of fragments are preserved. By mending these it is possible to recover the original decorative schemes of entire rooms. The throne of the king was, for example, flanked by fabulous griffins (Fig. 232).[17] Nearby, men feasting at tables were entertained by a bard, playing a lyre and perhaps singing 'winged words' from some epic tale. But as on Crete there are no obvious depictions of the ruler himself (see also **Chapter 5**).

The hundreds of Linear B tablets discovered in the archive of the palace mention Pylos by name (as *pu-ro*) and allow the geography of its kingdom to be reconstructed.[18] All, or virtually all, documents date from the final year of the palace and were accidentally baked; none were intended to survive. At the time of its destruction circa 1200 BC, the kingdom of Pylos was divided into two administrative zones, a 'hither' and a 'further' province. The palace itself, along with nine lesser centres, lay west of a range of high mountains known as Mount Aigaleon. The other province was located to the east of this range and included the Pamisos River valley north of the modern city of Kalamata, and seven or eight lesser centres. A king or *wanax* controlled this extensive territory with assistance from district governors and vice-governors (see also **Chapter 7**). Some parts of the kingdom's economy were administered directly by the palatial administration, while others were independent of it.

229

230. The Palace of Nestor at Pylos. Excavation photo showing the main megaron.

231. Plan of the Palace of Nestor. Drawing by I. Travlos.

We know from analysis of hand-writing that more than 30 administrators wrote documents at Pylos; in addition to the collection of taxes, these comprise inventories of royal property, including military and festival equipment, and records of the production of luxury goods, such as perfumed oil that was packaged in the distinctive containers called stirrup jars (e.g. Fig. 224).

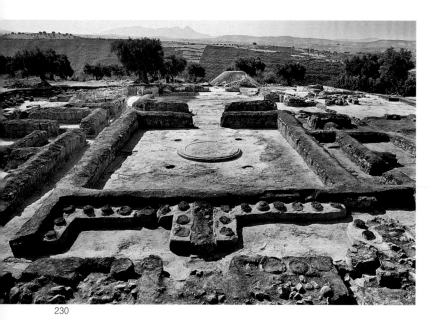

230

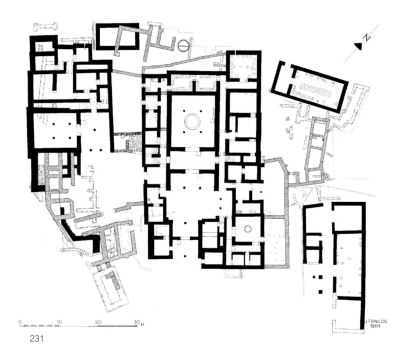

231

There is also documentation of offerings disbursed to shrines of gods. These texts concerned with religion hold surprises (see also **Chapter 7**). A god such as Dionysos, long thought to have been a late arrival in the Greek pantheon, was already worshipped in Bronze Age Pylos and Chania, in western Crete. Sheep, goats, pigs, and cattle were sacrificed and consumed, doubtless together with prodigious quantities of wine from ceramics stored in palaces. Recently, at Pylos, archaeologists have recognised the actual remains of cattle bones burnt on altars.[19] At least a few Mycenaean shrines were, however, not attached to palaces and small terracotta figurines representing goddesses and animals are commonly found in most excavations and even in the meanest houses (Figs. 233–234).

The 13th century BC was a time when the Mainlanders were at the height of their powers. Settlements were widespread and dense, and presumably the population of southern Greece was high; the census of the Pylos kingdom, for example, has been estimated at 50,000. Dozens of small settlements have been located by archaeologists – and it is also obvious that the palaces sat in the midst of large communities: the greater town at Pylos covered an area of nearly 16 hectares.[20]

Mycenaean palaces relied on substantial dependent labour forces, perhaps in part captives in war, in support of their operations. The labour force contributed to the production of specialised goods, such as

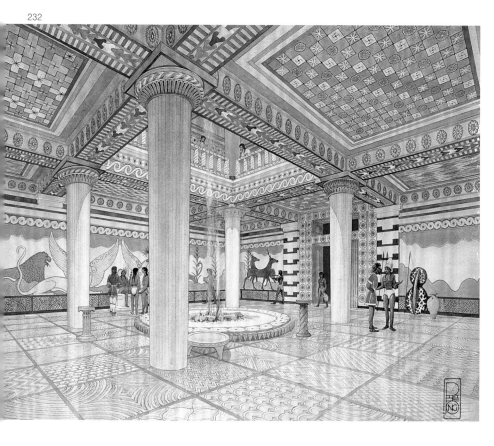

232. Romantic watercolour reconstruction by Piet de Jong of the 'Throne Room' in the 'Palace of Nestor' at Pylos. Digitally reworked by Craig Mauzy.

233. Animal figurine of an Ox. Voula, Attica. Late Helladic IIIA2–B, 1375–1200 BC. Clay. 9.6 (H) × 9.1 cm (L). AN1935.21. Given to Arthur Evans by Heinrich Schliemann.

234. Female 'Phi' figurine. Said to come from Megara, Attica. Late Helladic IIIA2–B, 1375–1200 BC. Clay. 11.4 cm (H). AE.315 (AN1893.105). Acquired and presented to the Museum by Ferdinand Dümmler.

textiles, that were encouraged by the palatial administration. There were also specialised craftspeople; the 'royal potter' attested at Pylos may have been given land by the palace. Production of olive-oil on a larger scale may also have been promoted by the palaces in the 13th century BC, but the rural economy was based on small-scale farming of the 'Mediterranean triad' – grain, vines, and olives.

The impact of Mycenaean civilisation in the wider Mediterranean and Near East was considerable. Pottery has been found as far west as Spain and is particularly common in southern Italy and Sicily. Exchange has been documented between the Mycenaean Mainland and settlements on the western coast of modern-day Turkey, on the island of Cyprus (Figs. 236–237), and in coastal Syria, Lebanon, and Israel. Imports even reached Egypt, where they have been found at Amarna, in the court of Akhenaten. Ships (Fig. 240) loaded with copper and tin ingots plied the seaways between Greece and Near East (Fig. 239), and must also have been responsible for bringing Egyptian bric-a-brac like scarabs to the Aegean from the other direction (Figs. 238).[21] But other goods found at Mycenae, such as faience plaques bearing the name of Amenhotep III, may have been royal gifts exchanged between kings. From cuneiform texts found at Boghazköy in central Turkey it is also likely that rulers of the Hittite Empire were aware of the Mycenaeans and the threat that they posed.

233

234

235. Bronze weapons and an alabaster pommel from Mainland Greece:
a) Pommel. Mycenae. 1600–1200 BC. 5.2 cm (Diam.). Given by A.J.B. Wace, AN1920.349;
b–c) Two long swords (Naue type II). 'Graditza', Thessaly, 1250–1100 BC. 84.5 cm (L), 712.3 gr. (AN1927.1383); 86.7 cm (L), 845.1 gr. (AN1927.1384). Ex-John Evans coll.;
d–e) Two spearheads, said to be from Thisbe in Boeotia. 1400–1200 BC. 16.2 cm (L), AN1918.30; 28.2 cm (L), AN1965.286 (ex-Spencer Churchill coll.). Museum purchase;
f) Sword, said to be from Olympia. 1400–1200 BC. 69.3 cm (L), 648.5 gr. AN1927.1376. Ex-John Evans coll.;
g) Sword, probably from Corinth, 1375–1190 BC. Museum purchase (probably ex-South Kensington Museum coll.), AN1967.1273.

236. One-handled cup. From Tomb 5 at Enkomi: *Ayios Iakovos*, Cyprus. Late Helladic IIIB, 1300–1200 BC. Clay. 5.9 (H) × 10.6 cm (rim Diam.). AN1958.62. From C.F.A. Schaeffer's excavations at Enkomi. Given by C.F.A. Schaeffer.

237. Conical vessel (*rhyton*). From the floor of room 15 at Myrtou-Pighades, Cyprus. Late Helladic IIIB, 1300–1200 BC. Clay. 37.1 cm (H). AN1952.392. Ashmolean Museum and University of Oxford British Excavations at Myrtou Pighades.

238. Map of the conjectural journey of the Uluburun boat (around 1300 BC), the most famous Late Bronze shipwreck in the East Mediterranean, showing the provenance of its rich cargo.

The Mycenaean palaces were destroyed about 1200 BC. Pylos was not rebuilt. Clearly this was a time of great disruption in the eastern Mediterranean – many settlements were abandoned or destroyed in the Mycenaean world. Northern and western areas of the Peloponnese, such as Achaea, on the other hand, may have experienced an increase in population.[22] New types of weapons, such as the Naue II sword, are found in tombs (Fig. 235b-c). Mycenae and Tiryns enjoyed a revival in the 12th century BC, but life had by then changed dramatically. There were no palaces, no large-scale wall paintings, and, most significantly, a literate bureaucracy did not survive. Civilisation in Greece henceforth evolved along very different lines from the Near East: the Classical age in southern Greece was an age of city-states, not kingdoms; its writing system, the alphabet familiar to us today.

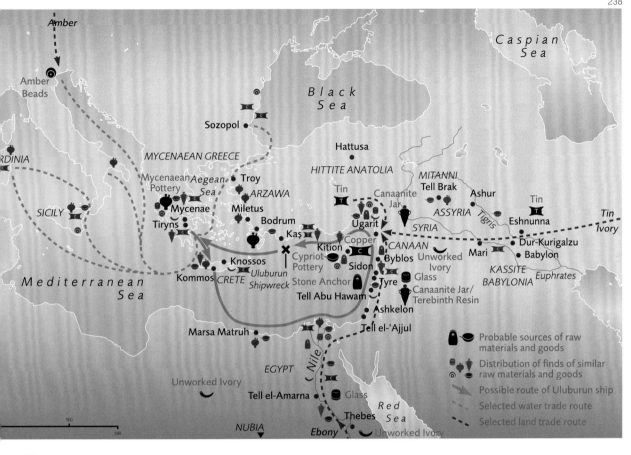

Amber

Amber
Beads

Caspian Sea

Black Sea

SARDINIA

Sozopol

MYCENAEAN GREECE

Hattusa

HITTITE ANATOLIA

MITANNI
Tell Brak Ashur

Mycenaean
Pottery *Aegean Sea* Troy

ARZAWA

Tin Canaanite
Jar *ASSYRIA* Tin *Tin Ivory*

SICILY

Mycenae Miletus

Tiryns Bodrum Kaş Ugarit *SYRIA* Eshnunna

Copper *CANAAN* Dur-Kurigalzu

Knossos Kition Byblos Unworked Mari Babylon
Cypriot Ivory
Kommos *CRETE* *Uluburun* Pottery Sidon Glass *KASSITE*
Shipwreck Stone Anchor *BABYLONIA* *Euphrates*

Tyre Canaanite Jar/
Tell Abu Hawam Terebinth Resin

Ashkelon

Mediterranean Sea Tell el-'Ajjul

Marsa Matruh

Probable sources of raw
materials and goods

Distribution of finds of similar
raw materials and goods

Possible route of Uluburun ship

EGYPT *Nile* Selected water trade route

Unworked Ivory Selected land trade route

Tell el-Amarna Glass

Red Sea

Thebes

NUBIA

Ebony Unworked Ivory

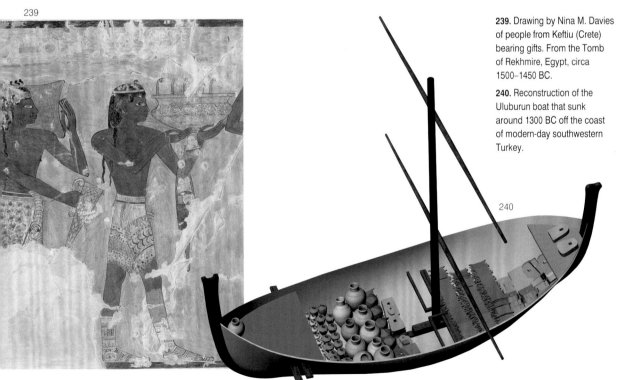

239. Drawing by Nina M. Davies of people from Keftiu (Crete) bearing gifts. From the Tomb of Rekhmire, Egypt, circa 1500–1450 BC.

240. Reconstruction of the Uluburun boat that sunk around 1300 BC off the coast of modern-day southwestern Turkey.

240

7. The Aegean Bronze Age Scripts

LISA BENDALL
Sinclair and Rachel Hood Lecturer in Aegean Prehistory
Tutorial Fellow in Archaeology (Keble College), University of Oxford

The first writing in Europe originated in the island of Crete around 2000 BC. Civilisations in Iraq and Egypt had by that time been literate for over 1000 years, but writing was unknown outside the Near East and the Indus Valley. The Cretans probably borrowed the idea from the East, but invented a system original in form and execution. Writing coincided with the rise of the first Cretan palaces, probably responding to a need for sophisticated recording systems to support increasingly complex bureaucracies.

Over time three related scripts were developed. Cretan Hieroglyphic was used from about 2000/1950 to 1650 BC. It is sometimes referred to as 'pictographic' or 'picture-writing' because many of the images are intelligible – a bee, an eye, a goat's head, a tree. However, the symbols did not stand for the items depicted, but rather for phonetic sounds.

Linear A (circa 1850–1450 BC) was related to Cretan Hieroglyphic, but there are important differences. Linear A was not merely a 'replacement' of the earlier script since the two overlapped for some 200 years and were even used together in the same archives.[1] Reasons for writing in one script or the other might have been linguistic, administrative, political or even religious.[2]

During the 15th century BC a third script, Linear B,[3] was created, adapted from Linear A for the purpose of writing a different language: Greek. Linear B was used in the palaces of the Greek mainland, and replaced Linear A in Crete, at least for administrative purposes (Fig. 241).[4] The reasons for the change are debated; the most commonly held view is that Crete fell to military action, although other scenarios are possible (see also **Chapter 5**). With the final destruction of the Mycenaean palaces around 1200 BC, Linear B was lost and the Aegean was illiterate until, some 400 years later, Greek-speakers adopted a new, unrelated writing system, the alphabet, from the Phoenicians.

Two other scripts related to the three above are known:[5] Cypro-Minoan, used in Cyprus during the final centuries of the second millennium BC (undeciphered), and Cypriot Syllabic, used to write Greek from the 8th down to the 3rd century BC. The latter script co-existed alongside the alphabet for some hundreds of years and was used particularly when it was desired to express a specifically 'Cypriot' identity.

241. A Linear B tablet from Knossos recording women workers and their children, 1375-1350 BC (see **Commentary** at the end of this chapter).

HOW THE SCRIPTS WERE USED

Cretan Hieroglyphic

Cretan Hieroglyphic appears on archival documents, seals (and their impressions on lumps of clay), and on miscellaneous objects such as clay jugs and cups and a stone offering table. The archival documents appear in a variety of forms, such as tablets, crescents, medallions (Figs. 242–243), and four-sided bars (Figs. 244–247). It is uncertain how most of these were used. The string holes on some of the objects suggest that they were attached to something, perhaps the commodities they recorded, so functioning as labels. Another possibility is that they were hung from pegs in archives or storerooms, as seems to have been done with some of the Linear B sealings. Seals also had an administrative function, but operated differently. They were impressed on clay either to authenticate transactions or to ensure integrity of contents. The Ashmolean has examples of seals engraved with Cretan Hieroglyphic (Figs. 248–254), and impressions made from such stones (Fig. 255; see also **Chapter 8**).

Archival documents were concentrated in the palaces of Knossos, Mallia, Phaistos and Petras, but seals and sealings were found all over east and central Crete. There are a few finds outside Crete, including a sealstone from Kythera and three sealings from Samothrace.[6]

242 243

242–243. 'Medallion' inscribed with Cretan Hieroglyphic. 'Medallions' were a special type of administrative document shaped like discs with ogival tops pierced with string holes. Ordinarily they would bear commodity ideograms, but the example here instead spells out the names of the items recorded. One side records '100 units' of some commodity, the other records '634 units' of something and '243 units' of something else. The function of these documents is obscure. It might be that they were attached to packages as transport labels, or were carried by the person responsible for delivery. *CHIC* 042. From the Palace at Knossos. Middle Minoan II, 1900–1800 BC. Clay. 3.7 (L) × 3.5 (W) × 0.7 cm (Th.). AN1910.208.

244 245

246 247

248 249

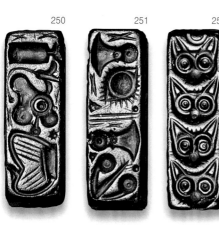

250 251 252

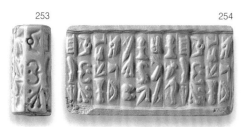

253 254

244–247. Four-sided bar inscribed with Cretan Hieroglyphic. This is an administrative document with eight lines of text. It is probably a record of various commodities being counted, but no ideograms appear so presumably the names of the goods were spelled out phonetically. The numbers include '40' and '400' (line .a), '130' (line .b), and '2300' and '300' (line .c). Whatever things were being recorded, there seems to have been a lot of them. The document was pierced at one end with a string-hole, and it may have been attached to the commodities themselves, or was perhaps hung from something in the room where it was found. *CHIC* 059. From the Palace at Knossos. Middle Minoan II, 1900–1800 BC. Clay. 5.6 (L) × 2.2 (W) × 2.2 cm (Th.). AN1910.210.

248–249. Olive-green steatite bi-facial seal decorated with the so-called 'Archanes formula'. The seal is engraved on both sides with a total of seven signs, including a double axe. Most symbols of the 'Archanes formula' can easily be compared with signs of the Cretan Hieroglyphic and Linear A scripts

and for this reason they appear to be part of either the former and/or the latter rather than an independent script. Said to be from Hellenika near Knossos. Early Minoan III–Middle Minoan IA, 2200–1950 BC. 1.3 (Diam.) × 0.4 cm (Th.). AN1938.929.

250–252. Four-sided prism decorated with four facing cats' heads and Cretan Hieroglyphic signs, including a harp. Said to come from the district of Herakleion. Middle Minoan II, 1900–1800 BC. Green Jasper. 1.7 (L) × 0.55 cm (W). AN1938.793.

253–254. Eight-sided seal. Engraved on all sides with 25 Cretan Hieroglyphic signs in total – the largest concentration of Cretan hieroglyphs of any known seal. Said to come from Neapolis, East Crete. Middle Minoan II–III, 1900–1700 BC. White agate. 1.95 (L) × 0.85 cm (W). AN1938.1166.

255. This 'object sealing' was impressed nine times by three different seals, two rectangular ones engraved with Cretan Hieroglyphic signs, and a round one with a scene of a lion attacking two cows. The rectangular impressions come from four-sided prisms; and the round one from a lentoid of hard stone. It is not clear what object the sealing was applied to. The irregular curvature on the back may suggest that it was pressed into the opening of a container of some sort. The container probably was not a vessel since the back also bears the impression of a flat object probably of wood while the front bears traces of a fine textile. Whatever was being sealed, the fact that three different seals were used may suggest it was particularly precious. The purpose of the multiple seals is not entirely certain but they could for instance have been used to give counter-authentication. From Knossos (exact provenance unknown). Middle Minoan III, 1800–1700 BC. Clay. 6.3 (max. W) × 5.2 cm (H). AN1938.1153b.

255

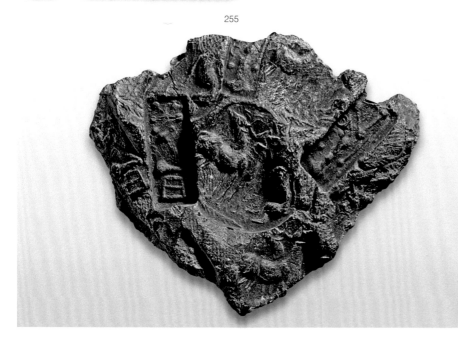

256–257. 'Offering table' with Linear A inscription. Psychro Cave, Lasithi, Crete. Middle Minoan III–Late Minoan I, 1800–1450 BC. Steatite. AE.1: 8.5 (H) × 19.6 (W) × 14 cm (Diam.); 1923.661: 8 (H) × 10.5 (W) × 10.5 (Diam.); IPS 358: 6.4 (H) × 17 (W) × 11.3 cm (Diam.). AE.1 + AN1923.661 + cast of Louvre IPS 358.

This famous offering table was found at the Psychro Cave, an important Minoan cult site high in the Lasithi Plain. The cave was used for ritual and offerings from Middle Minoan IA (2100 BC) until the 7th century BC. The cave is one of the possible contenders for Hesiod's birthplace of Zeus, a location for which in

Linear A

Linear A administration continued some of the Cretan Hieroglyphic document types, plus added some new ones, such as the flat-based nodules (Fig. 258–260). These preserve impressions of folded papyrus or parchment tied with string, important evidence that Linear A was written on materials that do not survive in the archaeological record. The script was also used for non-administrative purposes, for instance to write votive inscriptions (Fig. 256–257). Linear A travelled widely, and is attested throughout Crete and the Aegean (Fig. 261), a phenomenon probably connected with increasing trade abroad during the Neo-Palatial period.

The range of types of inscriptions, variety of materials, and wide distribution all argue for a high degree of literacy, at least among the elite. Ironically, sophisticated usage of the script may have contributed to its poor survival in the archaeological record if the majority of writing was on perishable materials – a thought worth considering for modern societies, since digital information is highly perishable.

256

257

East/Central Crete was given by several ancient geographers (although it is not clear whether even they were certain about which cave should be associated with the myth). Abundant votive deposits were found in all parts of the cave. An altar was built in the upper chamber in the Minoan period. In the lower cave was a sacred pool surrounded by some of the most spectacular stalactite and stalagmite pillars in Crete. Ancient worshippers had pressed into and between these formations all manner of votive offerings including bronze figurines, engraved gems, knives, tweezers, jewellery and double-axes. The offering table came to light in three pieces over several decades. The lower right corner was found near the altar in the upper cave by a local boy who was digging for treasures in

anticipation of Evans's visit in April 1896. He presented some clay bulls and plain cups and, in Evans's words: '[a]s a matter of comparatively minor importance... informed me that he and a friend... had found at the bottom of the hole a "broken stone, with writing". It may readily be imagined that I lost no time in securing the stone and also in ascertaining on the spot the exact circumstances of its position.' Excavating in the same area, Evans found a ritual deposit containing votive figurines, vessels, a wild goat horn and bones from sacrificed pigs, oxen and sheep. He did not find more of the table but further exploration by the French archaeologist Jean Demargne in 1898 recovered a joining piece which is now in the Louvre (a cast of this is joined to the Ashmolean fragment). A final, non-joining, piece was bought by

Evans in 1923. The table has three hollows which would have been used for making offerings – either of solids such as grain, figs or salt, or liquids (perhaps poured from a rhyton) such as oil (perhaps perfumed) or honey.

The Linear A inscription is undeciphered, but if the Linear B phonetic values were applied the left hand side would read TA-NA-I-301-TI (sign '301' has no Linear B equivalent), and the right hand side (following two signs from a broken word) would read JA-SA-SA-RA-ME. This combination of signs is frequently encountered in offering contexts and seems to represent an 'offering formula' of some sort. It is uncertain what the individual elements meant, but could be for example the names of deities, or prayers for blessings or even simply rubrics such as 'thus was offered'.

258

259

260

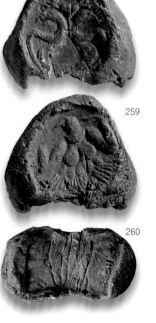

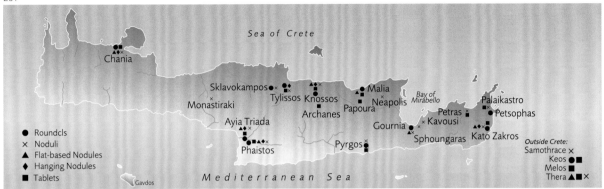

Legend:
- ● Roundcls
- × Noduli
- ▲ Flat-based Nodules
- ♦ Hanging Nodules
- ■ Tablets

Map labels: Sea of Crete, Chania, Sklavokampos, Tylissos, Knossos, Malia, Monastiraki, Archanes, Papoura, Neapolis, Bay of Mirabello, Palaikastro, Petras, Petsophas, Ayia Triada, Kavousi, Gournia, Sphoungaras, Kato Zakros, Phaistos, Pyrgos, Gavdos, Mediterranean Sea

Outside Crete:
- Samothrace ×
- Keos ●■
- Melos ■
- Thera ▲■×

Linear B

As far as we know, Linear B was used only for administrative purposes, and literacy was almost exclusively confined to the Mycenaean palaces (Fig. 262).[7] The administrative system was less complex than that of Linear A, comprising only tablets, sealings, and labels. Linear B was also painted on stirrup jars (Fig. 263) which clay analysis has shown come from Crete.[8] They are found at sites both in Crete and the mainland and were probably used to export olive oil and possibly wine.

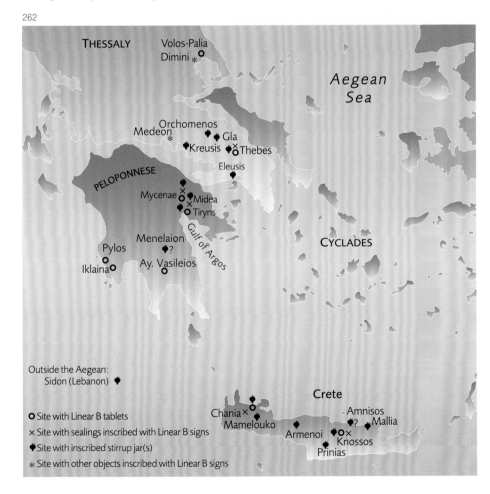

Map labels: THESSALY, Volos-Palia Dimini, Aegean Sea, Orchomenos, Medeon, Gla, Kreusis, Thebes, Eleusis, PELOPONNESE, Mycenae, Midea, Tiryns, Menelaion, CYCLADES, Pylos, Iklaina, Ay. Vasileios, Gulf of Argos, Crete, Chania, Mamelouko, Amnisos, Mallia, Armenoi, Knossos, Prinias

Outside the Aegean:
Sidon (Lebanon) ♦

- O Site with Linear B tablets
- × Site with sealings inscribed with Linear B signs
- ♦ Site with inscribed stirrup jar(s)
- ✳ Site with other objects inscribed with Linear B signs

258–260. 'Document sealing' impressed by two 'Zakro Master' seals. This is known as a 'document sealing' because the object it sealed was a piece of papyrus or parchment, which, having been written on, was folded up, tied with string, and sealed. These sealings are of great importance for our understanding of Minoan writing and literacy because they demonstrate that perishable materials were commonly used, even if unfortunately they do not survive well in the Mediterranean climate. Some 500 sealings were found in the room where this one was found – a great deal of writing has been lost. The seal impressions are of a type associated with the so-called 'Zakro Master', whose work was characterised by a flowing style featuring fantastical beasts and monsters. Room VII, House A, Zakros, Crete. Late Minoan IB, 1600–1450 BC. Clay. Seal impressions: 1.70cm (Diam.). AE.1199t. Given by the British School at Athens.

261. Distribution of main types of Linear A administrative documents.

262. Distribution of Linear B documents.

EVANS AND THE ASHMOLEAN COLLECTION

The search for early European scripts played a central role in Evans's discovery of the 'Minoans'. While he was Keeper of the Ashmolean, in 1889, the museum was given a sealstone engraved on all its four sides with what Evans recognised as a hitherto unknown writing system (Figs. 264–271). He found similar pieces in Athens and eventually traced them to Crete where they were called *galopetres* (milk-stones) and worn by the local women as fertility charms. Finding more examples of the script was a prime objective at Knossos and just eight days into the excavation, on 30 March 1900, Evans was rewarded with his first inscribed tablet.[9] By mid-April more than 700 had been recovered.

The Cretan and Greek authorities allowed Evans to remove some examples of Cretan writing, which he gifted to the Ashmolean. The museum now holds the most important collection of Aegean Bronze Age writing outside of Greece and the largest collection of Knossos Linear B tablets outside of Crete.

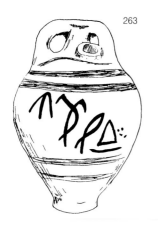

263

263. An inscribed stirrup jar from Orchomenos in Boeotia, mainland Greece (*ti-sa-ri*-[.], probably a personal name). The jar was made somewhere in west Crete.

264–271. The 'Chester Seal'. This four-sided prism seal engraved on all its sides with different signs, such as a wolf's head, a trowel, and vessels, is said to have provided to Evans the first inspiration to search for the existence of pre-alphabetic writing in the early Aegean. Probably from East Crete. Middle Minoan II, 1900–1800 BC. Agate. 2.2 (L) × 0.8 cm (W). AN1889.998. Presented by Greville John Chester.

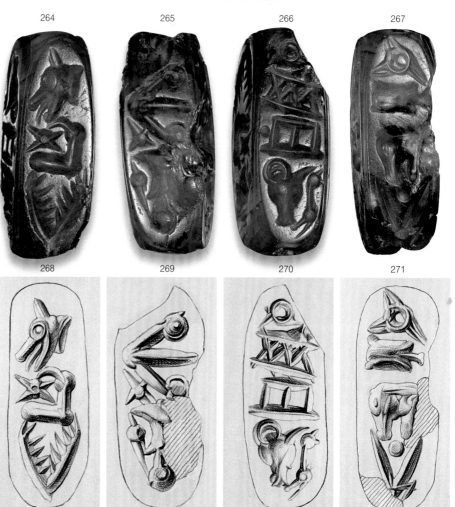

264 265 266 267

268 269 270 271

THE DECIPHERMENT OF LINEAR B:
MICHAEL VENTRIS AND JOHN CHADWICK

Linear B was deciphered in 1952 by Michael Ventris, a young British architect and amateur code-breaker (Fig. 274). The discovery that the language underlying the script was Greek rocked the scholarly world and extended the knowledge of the Greek language back by nearly 500 years (previously the earliest known Greek had been the Homeric Epics). Greek now has the longest attested written history of any language in the world except Egyptian.

272

273

274

275

272–273. 'I'm now almost completely convinced that the Pylos tablets are in GREEK. It's a pity there's not a new language to study, but it looks as if we must go to Linear A for that.'

274. Michael Ventris (1922–1956). Courtesy of the Faculty of Classics, University of Cambridge.

275. Letter by Ventris to Myres of 28 February 1952, just a few months before the announcement of the decipherment.

During the last couple of days I have been carrying on with the phantasy I discussed in my last Note; and though it is runs completely counter to everything I've said in the past, I'm now almost completely convinced that the Pylos Tablets are in GREEK. It's a pity there's not a new language to study, but it looks as if we must go to Linear A for that.

Ventris announced his discovery on BBC radio on 1 July 1952 in the course of a broadcast about *Scripta Minoa* II, the Linear B tablets of Knossos, published that year by Sir John Myres, a friend of Evans (Figs. 272–273, 275). The broadcast was heard by John Chadwick, a young researcher for the Oxford Latin Dictionary, who had just been appointed to a lectureship in Cambridge. He asked Myres to put him in touch with Ventris and borrowed copies of Ventris's worknotes. Within days Chadwick was convinced the decipherment was correct, and wrote to Myres (9 July 1952) that 'a new chapter in Greek history, language and epigraphy is about to be written'.[10]

Chadwick's support was the first Ventris had received and he invited him to co-author the publication of the decipherment (in the *Journal of Hellenic Studies* 1953). Thus began a close working relationship cut tragically short by Ventris's early death in an automobile accident in 1956 on the eve of the publication of their monumental joint work, *Documents in Mycenaean Greek*. By then 'Mycenology' – the study of Linear B and Mycenaean Greek – had been established as an international field.[11] Cooperation between scholars in different countries was eventually formalised in the Comité International Permanent des Études Mycéniennes (CIPEM), a cultural body under UNESCO, which continues today to support Mycenaean studies throughout the world.

HOW VENTRIS DECIPHERED LINEAR B

The decipherment of Linear B is one of the most remarkable accomplishments in the history of decipherment because it was achieved without the aid of a bilingual document – a document giving the same text in two languages. Ventris had to rely mainly on internal analysis.[12]

Linear B was known to be a syllabic script (meaning a sign represented not a single sound as with the alphabet, but a whole syllable, e.g. ku, do, ni), on analogy with Cypriot Syllabic. Ironically, Evans early on had correctly read a Linear B word by applying Cypriot Syllabic sign values, but he dismissed the reading as a fluke.[13] The word was *po-ro* which Evans read as /polos/ 'foal' – the tablet concerned had drawings of horse heads on it.

Some essential steps towards the decipherment had been taken by two American scholars, Emmett L. Bennett Jr. and Alice Kober. Bennett, among other things, established the table of signs; and Kober deduced that the language was 'inflecting', that is, grammar was marked with different word endings. Ventris used Kober's work to build a 'syllabic grid'. Signs he thought shared a vowel were put in the same column and signs likely to share a consonant were in the same row. The power of such a grid is that if the value of one sign can be determined, partial values are gained for other signs in the same row and column. One day, in what he called 'a frivolous digression', Ventris experimented with applying sign-values derived from ancient Cretan place

47 Highpoint,
North Hill,
Highgate,
N.6.

19 May 1953

Dear Sir John,

 I had a letter from Blegen this afternoon. He has been beginning to get ready his tablets of last year from Pylos for photography, and has tried out our experimental values on one or two. He wrote with some excitement to give me the text of his No 641, which seems to him to contain the clinching evidence from numbers that we have long prayed for. He says "all this seems too good to be true: is coincidence excluded ?". Here's a copy of his drawing of it:-

The first line isn't easy to make out, apart from an unmistakable ti-ri-po Τρίπος / plural: ti-ri-po-de Τρίποδες , but lines 2 and 3 are very exciting:-

di-pa me-zo-e! qe-to-ro-we : "with 4 ears" cf our Pylos
δέπας μέζων κʷετρώϜης· "quadrupeds",

di-pa-e me-zo-e ti-ri-o-we-e : "with 3 ears"
δέπαες μέζοες τριώϜεες·

di-pa me-wi-jo qe-to-ro-we
δέπας μέϜjων κʷετρώϜης

di-pa me-wi-jo ti-ri-jo-we
δέπας μέϜjων τριώϜης

di-pa me-wi-jo a-no-we : "with no ears"
δέπας μέϜjων ανώϜης·

The masculine δέπαες (for classical plural δέπα[α]) is odd. Note the alternative spellings of the "3-handle" adjective. The last entry immediately reminds one of the phrase on Knossos tablet 875a.1-5 , which also has its ideogram as a "handle-less" jug in the last line. This presumably resolves itself into:

 di-pa a-no-wo-to δέπας ανόϜατος "with no ears"

The variation in the adjectival compound is the same as that shown in the Greek for "2-handled":

 αμφ-ώης from -ωυ-
 αμφ-ωτος from -οϜατ-

All we want now is for Blegen to discover "5-handled", "2-handled" and "1-handled" ! *πεγκʷώϜης , *δϜιώϜης, *οϊϜώϜης [in line 1 ??]
 Yours,

 Michael Ventris

276. Letter from Ventris to Myres, 19 May 1953, discussing Blegen's Pylos tablet (P641). The vessels recorded as having various numbers of handles are described as *di-pa* (in singular), a word recalling the Homeric 'depas' ('jar'). Ventris called P641 'a sort of Rosetta stone', as it provided independent verification to his phonetic values.

names such as Knossos and Amnisos (Fig. 275). To his astonishment, the solution started yielding a great many words that were recognisably Greek (Fig. 276).

The discovery that Greek was spoken in Greece during the Bronze Age was of major importance since many scholars had previously argued that the Greeks 'arrived' in Greece only after 1200 BC and had nothing to do with the pre-classical civilisations of the Aegean. The decipherment provided definitive proof to the contrary.

THE WORLD OF LINEAR B

Apart from their importance for the study of Greek language, the Linear B documents tell us much about the Mycenaean world. The Ashmolean tablets deal with a variety of subjects including agriculture, animal husbandry, taxation, textile manufacture and warfare. Mycenaean social structure was hierarchical, headed by a figure called a *wanax* 'king'. Under him was a *lawagetās* 'Leader of the People' and a retinue of elite retainers called *hequetai* 'Followers'. The economy was 'redistributive', that is it operated at the command of the palaces rather than being driven by market forces.[14] The system, however, was extractive and most redistribution was directed upwards for the benefit of the dominant elite. The Knossos tablets show that most of central and western Crete was controlled from Knossos, which imposed taxes on towns throughout the region.

Two aspects of Mycenaean economy and society – the textile industry and religion – are here examined in further detail (see also the **Commentary** at the end of this chapter).

The Textile Industry

Knossos ran a massive textile industry in which every aspect of manufacture and production was centrally controlled, from management of wool-producing flocks (Fig. 279), to provision of raw materials and rations to skilled specialists in the textile workshops. As elucidated by John Killen, the industry operated much like medieval English textile-manufacturing estates producing woollens for export.[15] Non-breeding flocks composed of ewes and castrated males ('wethers') were allocated to shepherds responsible for their care and for delivering them at shearing time. Losses during the year would be made up from separate breeding flocks.

277–280. Linear B tablets from Knossos (for details see the **Commentary** at the end of this chapter).

281–282. Drawings of ideograms from a Linear B tablet (fig. 278).

After shearing, the wool would go to workshops for spinning and weaving (Fig. 280). Amounts issued were carefully weighed to protect against embezzlement. Finished textiles might be stored or could be sent on to 'finishing' workshops for embellishment. The workforce involved was substantial. Another Ashmolean tablet (Fig. 277) records monthly rations for women at Knossos, Amnisos, and Phaistos. The amount of grain issued would have sufficed for 500 women at each location.

Aegean wall paintings show people wearing elaborate and beautiful clothing, indicating highly skilled manufacturing techniques. The luxury textiles produced in palace workshops were valued abroad and exported to places such as Egypt and Syria. Killen demonstrated that a significant proportion of Knossian wealth derived from such trade. The tablets record some 100,000 sheep producing between 30 and 50 tons of wool annually for luxury textile manufacture – this was large-scale industry.

Religion and feasting
Many tablets deal with provisions for ritual and religious festivals. Some record offerings of honey and perfumed oil to gods familiar from the classical pantheon, such as Zeus, Hera, Athena, Artemis, Poseidon and Dionysos. Others record banqueting menus which could include animals for sacrifice (bulls/cows, pigs, sheep and goats), or foodstuffs such as cheese, olives, barley, figs and wine.[16] Supplies were lavish – one Knossos tablet (Uc 161) records some 1700 litres of wine, nearly 3000 litres of olives, and animals sufficient to provide over 4000 kilograms of meat.

Ritual and banqueting paraphernalia are also recorded. A tablet from Knossos (Fig. 278, 281–282) deals with libation vessels (bulls' head *rhyta*) and gold drinking cups, while a group of tablets from Pylos records an entire set of furnishings for a ritual sacrifice and feast: ebony tables and chairs inlaid with gold, silver and ivory, bronze tripod cauldrons, golden chains for binding sacrificial victims, and swords plus a hammer mallet for striking them.

281 282

EPILOGUE

Linear B represents a rich and invaluable source of knowledge about the Aegean Bronze Age, but it is the only one of the Bronze Age scripts to have been deciphered. While there is much to be learned from Cretan Hieroglyphic and Linear A even without being able to read them, decipherment of these scripts would increase our knowledge immeasurably. Unfortunately, this is unlikely to happen for the time being, as too few examples exist for the kind of decipherment by internal analysis Ventris achieved. However, excavations continue, and there is every hope that sites such as Chania in Crete or Akrotiri on Thera may yield more documents. Perhaps some modern archaeologist will one day be fortunate enough to discover archives on the scale of those found long ago at Knossos by Sir Arthur Evans.

COMMENTARY OF SOME LINEAR B TABLETS

Note: for the transcription of the Linear B tablets it was decided early on among scholars to follow conventions based on those used for transcribing, annotating, and publishing ancient texts more generally. Ideograms representing objects or people are transcribed using the abbreviation of the word they stand for in Latin (for example, the sign for chariot – *biga* in Latin – is transcribed BIG). The open brackets ('[' and '[') stand for text missing to the left and right of the bracket respectively.

AGRICULTURE

283. Linear B tablet recording 'working' oxen for ploughing fields. 'Room of the Chariot Tablets', Palace at Knossos (Ce 59). Late Minoan IIIA1, 1400–1375 BC. Burnt clay. 14 (L) × 4.3 (W) × 0.95 cm (thickness). AN1910.212.

283

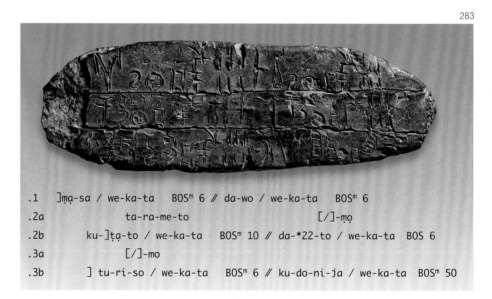

```
.1    ]ṃa-sa / we-ka-ta    BOSᵐ 6 ∥ da-wo / we-ka-ta    BOSᵐ 6
.2a              ta-ra-me-to                    [/]-ṃọ
.2b    ku-]ṭạ-to / we-ka-ta    BOSᵐ 10 ∥ da-*22-to / we-ka-ta   BOS 6
.3a              [/]-mo
.3b    ] tu-ri-so / we-ka-ta    BOSᵐ 6 ∥ ku-do-ni-ja / we-ka-ta   BOSᵐ 50
```

This tablet (Fig. 283) records oxen (indicated by the ideogram BOSᵐ) allocated by the palace for ploughing fields. The key word is *we-ka-ta*, interpreted as *wergatai*, 'working', referring to the oxen. There are six entries, each with the formula: 'place name, working, OXEN, number'; three entries further note the name of the local man in charge of the animals. The places listed are well-known towns spread around central and western Crete. *da-wo* was near Phaistos, in the rich Mesara Plain in the south of the island. *ku-ta-to* and *da-*22-to* were somewhere west of Knossos, perhaps in the vicinity of modern Rethymno. *tu-ri-so* (modern Tylissos) is near Knossos, and *ku-do-ni-ja* (classical Kydonia, modern Chania), is in the far west. The 50 animals allocated for Kydonia may have been working in the Apokoronas Plain east of the city, an area known for its agricultural produce to this day. That the harvests were rich is demonstrated by a tablet recording almost 1,000,000 litres of wheat at *da-wo*.

284

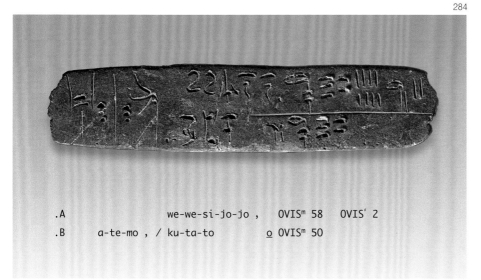

			we-we-si-jo-jo ,	OVIS^m 58	OVIS' 2
.A			we-we-si-jo-jo ,	OVIS^m 58	OVIS' 2
.B	a-te-mo ,	/ ku-ta-to		o OVIS^m 50	

284. Linear B tablet recording sheep producing wool for the textile industry. Probably from the 'East-West Corridor', East Wing, Palace at Knossos (De 1648). Late Minoan IIIA2 early, 1375–1350 BC. Burnt clay. 11.5 (L) × 2.4 (W) × 1.2 cm (thickness). AN1938.850.

This example (Fig. 284) records sheep producing wool for the textile industry. They are herded by a man *a-te-mo* (perhaps *Artemos* or *Anthemōn*) in the area around *ku-ta-to* (probably *Kutaiton*). His flock consists of 58 male sheep plus two ewes, and the tablet notes that a further 50 sheep are 'missing' (indicated by *o*, an abbreviation of the Mycenaean word *o-pe-ro*, *ophelos*, used in the records to indicate a shortfall). In the top line appears another man's name, *we-we-si-jo*, in the possessive (the Homeric genitive –*oio*), indicating that the sheep are in some way 'his'. He was probably an important personage among the palace elite to whom the administration wished to make a beneficiary gift of the wool supplied by this flock.

285

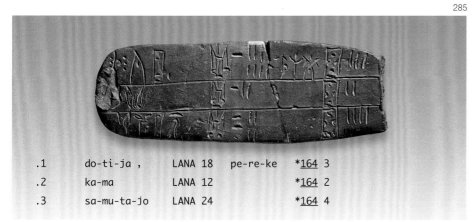

.1	do-ti-ja ,	LANA 18	pe-re-ke	*164 3
.2	ka-ma	LANA 12		*164 2
.3	sa-mu-ta-jo	LANA 24		*164 4

285. William Young. Replica of a Linear B tablet recording issues of wool to women workers for weaving cloth. This is a replica of the original tablet, which is today stored in the Herakleion Museum. It is signed by NEOS (W. Young) at the back. The original tablet comes from 'Magazine IX', West Wing, Palace at Knossos (L 520). Replica: early 20th century AD; original: Late Minoan IIIA2 early, 1375–1350 BC. Plaster cast. 13.1 (L) × 4.3 (W) × 1.3 cm (thickness). AN1910.222.

This is a plaster cast (Fig. 285) of a Linear B tablet (the original is in the Herakleion Museum in Crete). Evans had many of these casts made and gave them to museums and universities all over Europe to facilitate the study of Linear B. Apart from their value for teaching, they are by now sometimes better preserved than the originals which, being made of highly friable clay, are subject to deterioration no matter how

carefully stored. In some cases the casts preserve features no longer seen on the originals and have thus themselves become a 'primary record'. This particular example records allocations of wool (LANA) to groups of women workers for making a type of cloth indicated by the ideogram *164. We do not know precisely what this was, but it must have been very heavy or very large since each piece required some 18 kilograms of wool to make.

286. Linear B tablet recording monthly rations for women workers. 'Room of the Spiral Cornice', North Entrance Passage area, Palace at Knossos (E 777). Late Minoan IIIA2 early, 1375–1350 BC. Burnt clay. 8 (L) × 4.4 (W) × 0.6 cm (thickness). AN1910.214.

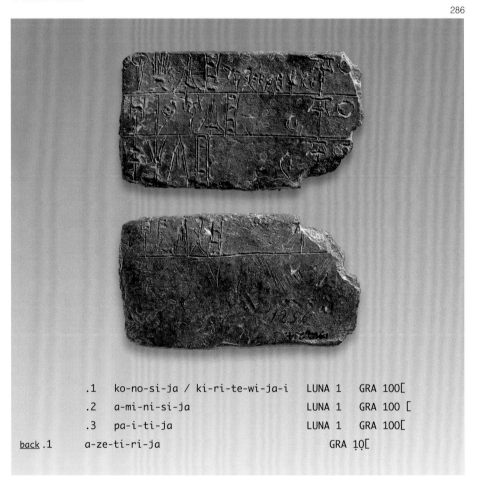

		LUNA	GRA	
.1	ko-no-si-ja / ki-ri-te-wi-ja-i	LUNA 1	GRA 100[
.2	a-mi-ni-si-ja	LUNA 1	GRA 100 [
.3	pa-i-ti-ja	LUNA 1	GRA 100[
back .1	a-ze-ti-ri-ja		GRA 10[

In this Linear B tablet (Fig. 286) we have a record of monthly rations of grain (indicated by ideogram depicting grain, transcribed GRA, and the ideogram depicting a moon, transcribed LUNA). We learn from the tablet that these rations are for women workers of Knossos (*Knossiai*), Amnisos (*Amnisiai*), and Phaistos (*Phaistiai*). The amounts issued would be sufficient for 500 women at each town. On the back of the tablet is a further ration for women described as *asketriai* 'decorators'. These were workers, probably involved in adding ornaments to the fabrics, such as embroidery, fringe or even beads and metal plates.

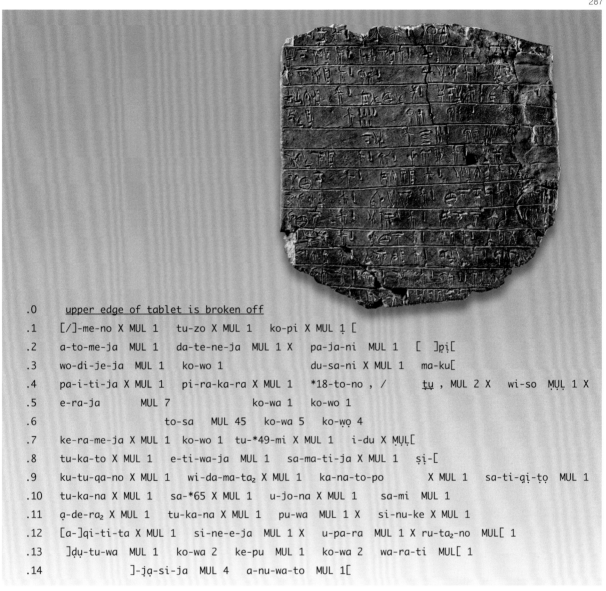

```
.0    upper edge of tablet is broken off
.1    [/]-me-no X MUL 1    tu-zo X MUL 1    ko-pi X MUL 1 [
.2    a-to-me-ja  MUL 1    da-te-ne-ja  MUL 1 X    pa-ja-ni  MUL 1    [  ]pi[
.3    wo-di-je-ja  MUL 1    ko-wo 1                 du-sa-ni X MUL 1    ma-ku[
.4    pa-i-ti-ja X MUL 1    pi-ra-ka-ra X MUL 1    *18-to-no , /    tu , MUL 2 X    wi-so  MUL 1 X
.5    e-ra-ja        MUL 7              ko-wa 1    ko-wo 1
.6              to-sa    MUL 45    ko-wa 5    ko-wo 4
.7    ke-ra-me-ja X MUL 1    ko-wo 1    tu-*49-mi X MUL 1    i-du X MUL[
.8    tu-ka-to X MUL 1    e-ti-wa-ja  MUL 1    sa-ma-ti-ja X MUL 1    si-[
.9    ku-tu-qa-no X MUL 1    wi-da-ma-ta₂ X MUL 1    ka-na-to-po      X MUL 1    sa-ti-qi-to  MUL 1
.10   tu-ka-na X MUL 1    sa-*65 X MUL 1    u-jo-na X MUL 1    sa-mi  MUL 1
.11   a-de-ra₂ X MUL 1    tu-ka-na X MUL 1    pu-wa  MUL 1 X    si-nu-ke X MUL 1
.12   [a-]qi-ti-ta X MUL 1    si-ne-e-ja  MUL 1 X    u-pa-ra  MUL 1 X ru-ta₂-no  MUL[ 1
.13    ]du-tu-wa  MUL 1    ko-wa 2    ke-pu  MUL 1    ko-wa 2    wa-ra-ti  MUL[ 1
.14           ]-ja-si-ja  MUL 4    a-nu-wa-to  MUL 1[
```

This Linear B tablet (Fig. 287) lists women workers. They are listed either by personal name (for instance, *Wordieia* 'Rosie' in line .3) or by ethnicon based on town name (for instance, *e-ra-ja*, women of *e-ra*, a major town in central Crete in line .5). Each name is followed by the ideogram depicting a woman, transcribed MUL in the text above. Occasionally they are accompanied by their children – for instance the women of *e-ra* are accompanied by a boy (*korwos*) and a girl (*korwā*). A sub-total for the first paragraph is given in line .7: *to-sa (tossai)* 'so many' WOMEN 45, 'girls' 5, 'boys' 4. Currently the paragraph only lists 22 women, but the top of the tablet is broken off so some of the original list must have been lost. Many of the names do not seem to have Greek etymologies so may have been 'Minoan', but it is difficult to be certain in most cases because we could, for instance, be dealing with lost forms.

287. Linear B tablet recording women workers and their children. 'Magazine XV', Palace at Knossos (Ap 639). Late Minoan IIIA2 early, 1375–1350 BC. Burnt clay. 10.5cm (L) × 10.7 (W) × 0.5-1.8 cm (thickness). AN1910.218.

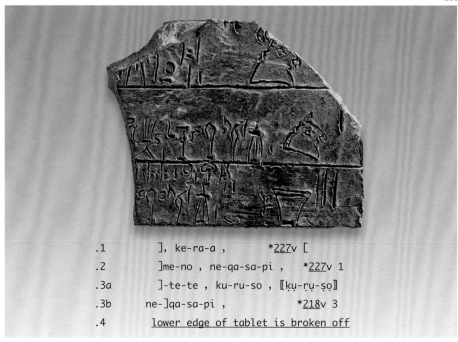

288. Linear B tablet recording ritual and drinking vessels in the shape of a bull and a 'Vapheio-type' cup. 'Area of the Bull Relief', North Entrance Passage area, Palace at Knossos (K(1) 872). Late Minoan IIIA2 early, 1375–1350 BC. Burnt clay. 6 (L) × 4.6 (W) × 1-1.5 cm (thickness). AE.2031.

```
.1      ], ke-ra-a ,            *227v [
.2      ]me-no , ne-qa-sa-pi ,   *227v 1
.3a     ]-te-te , ku-ru-so , ⟦ku̱-ru̱-ṣo⟧
.3b     ne-]qa-sa-pi ,           *218v 3
.4      lower edge of tablet is broken off
```

289. 'Vapheio-type' one-handled cup with tortoise shell or ripple pattern. 'Court of the Stone Spout', East Wing, Palace at Knossos. Late Minoan IA, 1700–1600 BC. Clay. 7.3 (H) × 9.2 cm (Diam.). AN1938.456.

290. 'Vapheio-type' cup with spirals. Perhaps from Kato Zakros. Late Minoan IA, 1700–1600 BC. Clay. 7 (H) × 8.5–9.1 (rim Diam.) × 4.6-5 cm (base Diam.). AE.862. Given by D.G. Hogarth.

In this example (Fig. 288) we find a record of bull's head *rhyta* (lines .1 and .2) and drinking cups (line .3b), probably for use at a banquet or religious festival. A *rhyton* was a special ritual vessel with a small hole at the bottom for pouring libations of wine, perfumed oil or honey. It would probably have been held over an offering table such as the one from Psychro (Fig. 256). *Rhyta* came in many shapes and sizes; real examples of the type in the tablet have been found at Mycenae and the 'Little Palace' at Knossos. The tablet uses the word *ke-ra-a* (horned), doubtless referring to their distinctive shape. Real examples of the cups have also been found; the most famous are the gold cups from the Vapheio tholos tomb near Sparta. Like the cups from Vapheio, those recorded in the tablet are described as *khrusos* 'gold'. Simpler versions of the same shape in clay are also commonly attested in tombs and settlements (Figs. 289–290, 292).

289

290

me-nu-wa TUN[] BIG [

291. Linear B tablet recording armour and a chariot. 'Room of the Chariot Tablets', Palace at Knossos (Sc 238). Late Minoan IIIA1, 1400–1375 BC. Burnt clay. 10.1 (L) × 2.1 (W) × 0.35–0.5 cm (thickness). AN1938.704.

This Linear B tablet (Fig. 291) records armour (transcribed TUN) and a chariot (transcribed BIG) for a man called by his official title *me-nu-wa* (meaning uncertain). A real suit of armour of the type drawn on the tablet was found in a chamber tomb at Dendra near Midea in the Argolid. We also have representations of chariots on wall-paintings and decorated pots (Fig. 293). These seem to have been used by the Mycenaean elite for ceremonial display and in connection with hunting as well as in warfare.

292. Gilliéron, E., *père* and *fils*. Replica of the Mycenae bull's head *rhyton*. Early 20th century. Electrotype. 30 cm (H with horns). AN1939.489. Bought by Arthur Evans.

293. Krater fragment from Mycenae showing a chariot. 1300–1200 BC. National Archaeological Museum, Athens.

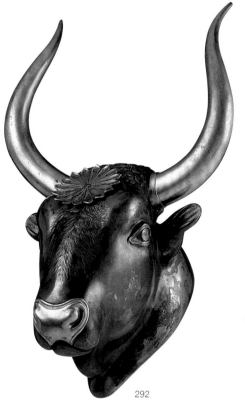

292

293

294. Linear B tablet recording swords. 'Corridor of the Sword Tablets', East Wing, Palace at Knossos (Ra(1) 1540). Late Minoan IIIA2 early, 1375–1350 BC. Burnt clay. 9.9 (L) × 2.6 (W) × 0.9 cm (thickness). AN1938.706.

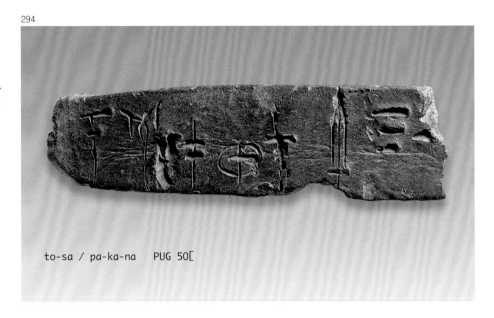

294

to-sa / pa-ka-na PUG 50[

This particular tablet (Fig. 294) records *tossa phasgana* 'so many swords' – 50 are recorded on this tablet, and some 200 or so appear on other documents. The palace was evidently well equipped for battle.

295. Linear B tablet recording chariot wheels. 'Area of the Bull Relief', North Entrance Passage area, Palace at Knossos (So 894). Late Minoan IIIA2 early, 1375–1350 BC. Burnt clay. 13.5 (L) × 7.8 (W) × 0.8-1 cm (thickness). AN1910.211.

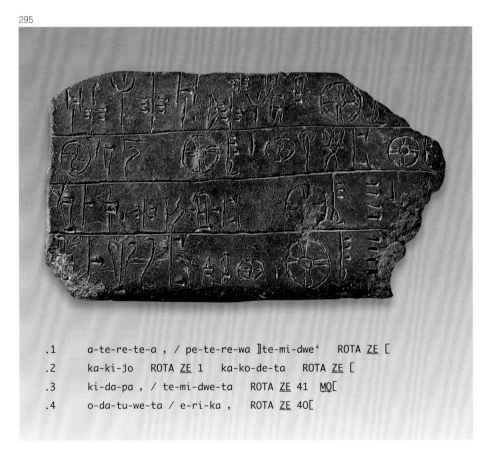

295

.1 a-te-re-te-a , / pe-te-re-wa]te-mi-dwe⁴ ROTA ZE [

.2 ka-ki-jo ROTA ZE 1 ka-ko-de-ta ROTA ZE [

.3 ki-da-pa , / te-mi-dwe-ta ROTA ZE 41 MO[

.4 o-da-tu-we-ta / e-ri-ka , ROTA ZE 40[

This tablet (Fig. 295) records chariot wheels (transcribed ROTA), listing them by form and type of material. There are wheels 'of elm' (*ptelewās*), 'of willow' (*helikās*), and 'bound with bronze' (*khalkodeta*). Some are described as 'toothed' (*odatwenta*), or 'provided with an edge/flange' (*termidwenta*). The wheels are recorded in pairs: *ZE* is an abbreviation for *zeugos* 'pair'. Some of the figures are lost, but the tablet records a minimum of 84 pairs of wheels – enough for the same number of chariots.

TAXATION

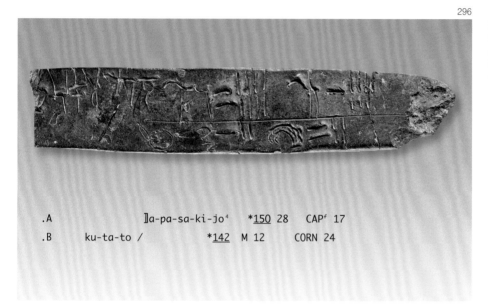

```
.A                    ]a-pa-sa-ki-jo⁴   *150 28   CAPᶠ 17
.B        ku-ta-to /              *142  M 12      CORN 24
```

296. Linear B tablet recording she-goats and goat horns. Palace at Knossos (Mc 4455 + 8449 + 8554 + fr. at Herakleion Museum no. 132). Late Minoan IIIA2 early, 1375-1350 BC. 13.3 (L) × 3.5 cm (W). AN1910.217.

The Mc series of Linear B tablets from Knossos, part of which is the tablet illustrated here (Fig. 296), records proportional taxation in four commodities, including she-goats (CAPᶠ) and goat horns (CORN). The distinctive form of the horns was identified by Evans as belonging to a wild goat known in Crete as kri-kri or agrimi. As the tablets were found in what Evans described as an 'Arsenal', it is not impossible that the collected commodities might have been used in the manufacture of bows or chariots.

8. Seals of Bronze Age Greece

HELEN HUGHES-BROCK
Independent Scholar, Oxford

It was a seal that first led Sir Arthur Evans to Minoan Crete (Figs. 264–267, 297; see also **Chapter 7**). His first few journeys are recorded in lively diaries and notebooks illustrated with skilful sketches of sites and seals.[1] Evans continued collecting all his life and gave or bequeathed his seals to the Ashmolean. Bought from peasants or dealers, few have a sure provenance. Many represent the cream of Cretan seal-engraving, reflecting Evans's taste and wealth. More 'ordinary' seals, an important element in Aegean glyptic as a whole, are under-represented, as are seals of the Pre-Palatial period (third millennium BC) and seals from western Crete and the Mainland. Augmented by some seals from other sources, the Ashmolean collection amounts to the largest outside Greece.[2]

MAINLAND BEGINNINGS

Stamping or printing a design on something is an idea that goes back to the Stone Age. Neolithic sites in northern Greece and neighbouring regions have yielded terracotta and stone stamps with simple abstract patterns, perhaps used for applying pigments to decorate cloth, animal skins or the human body: the early ones, beginning in the seventh millennium BC, are known as *pintaderas* from the Spanish verb *pintar*, 'to paint'. Stone stamps, known from the fifth millennium BC, could have been used for resist-dyeing, like batik, or to stamp designs on bread.[3]

True seals, pressed into lumps of wet clay used mostly to safeguard closed pots and baskets, are found from the middle of the third millennium BC in Early Bronze II levels. Both seals and sealing lumps occur at Peloponnesian and island sites, bearing geometric patterns which are often intricate and sophisticated like those on the green stamp-cylinder said to be from a grave on Amorgos (Figs. 158–159). This object belongs to a world of wide cultural exchange: its much-debated origin may be Syrian rather than Cycladic. Rollers and stamps, some perhaps wooden, were also used to decorate clay hearths and jars and to mark clay blocks which may be weights. Like the Neolithic stamps, nearly all come from excavations and are in Greek museums. The practice stopped after a few generations and seals do not reappear on the Mainland until the Shaft Grave era in the middle of the second millennium BC.

297. Material from the Arthur Evans Archive. Evans went to Crete in 1894 to find out more about the existence of pre-alphabetic writing in the Aegean inspired by seals he had seen in Oxford and Athens.

153

298. Seal in the shape of an animal (owl). Ivory. Southern Crete. Early Minoan III–Middle Minoan IA, 2200–1950 BC. 1.7 (H) × 1.35 (seal face W). AN1938.917.

299–301. Animal-shaped seal with face of the same oval shape as a scarab's. 'White piece' material. Possibly from Ayia Pelagia, Crete. Early Minoan III–Middle Minoan IA, 2200–1950 BC. 1.1 × 1.3 × 0.9 cm. AE.1200a.

302–303. Loop signet with three pairs of buds (S-spirals) on the seal face. Said to have been found at or near Knossos. Middle Minoan I–II, 2100–1800 BC. Gold (Au 88.4%, Ag 11.5%, Cu 0.1%). 1 (face Diam.) × 1.4 cm (H of grip). Weight: 12.25 gr. AN1938.1112.

CRETE BEFORE THE 'PALACES'

Crete, characteristically, went her own way. Certain evidence for seals and sealing begins in Early Minoan II (2700–2200 BC), roughly contemporary with the Mainland development but differing notably, particularly in the materials. Beside the soft local steatite and chlorite, animal bones are used and imported hippopotamus ivory, almost certainly from Egypt and thus one of the many Egyptian contributions to Minoan seals. The materials of the so-called 'white pieces' group are a Minoan creation, involving a soft substance like talc, a manmade 'glaze' and heat treatment – the first synthetic material in the Aegean. These hundred or more very small seals with finely carved linear and leaf-like patterns were a brief fashion, produced to recipes (few as yet scientifically analysed) probably experimented with by a few families or workshops and inspired originally by glazed scarabs from Egypt.[+] One tiny white seal shaped like an animal may be an Egyptian-inspired monkey (Figs. 299–301). Shape is often influenced by the properties of the material. Indeed Minoan sealmakers delighted in exploring and exploiting materials (Fig. 298). A few seals found notably at Archanes bear the earliest occurrences of Hieroglyphic script signs (Figs. 248–249). The largest finds of Pre-Palatial seals (late third millennium BC) are made in south-central Crete, where Evans travelled little. Because the tombs there were communal, used over generations, the chronology and development of Pre-Palatial sealmaking are hard to establish with any certainty.

298

299　　300　　301

302　　303

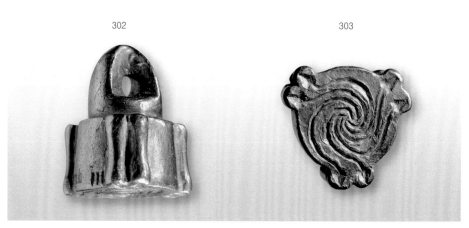

THE 'FIRST PALACES' (CIRCA 1950–1800 BC): NEW STONES, NEW TOOLS, AND WRITING

The advent of semi-precious hard stones coincided with the introduction of the lapidary lathe, perhaps a Mesopotamian invention, and bow-driven rotary tools. Bone, ivory and 'white pieces' disappear as Minoan sealmakers, delighting in their new opportunities, enter the most adventurous and innovative phase in their history. Signets and prisms appear in amethyst and red or green jasper from Egypt, blue chalcedony, local rock crystal, faience, ivory, and (rarely) gold (Figs. 302–303), silver, and bronze. The popular cornelian (Figs. 304–305) probably arrived, directly or indirectly, from several sources, for example Egypt, Anatolia, Mesopotamia and even India.[5] Rare lapis lazuli, arriving via Mesopotamia, Syria or Egypt, originated in Afghanistan or Persia or Pakistan. Solid and tubular drills produce dots and circles for eyes, rocks, and curving goat horns (Figs. 306–307). Bow-driven fast cutting wheels make sharp straight lines. Drill and wheel are combined to create geometric patterns like the stylised lilies on a signet ring of Egyptian yellow jasper (Figs. 308–309). The cat, introduced from Egypt, and a harp, long known in Egypt and Mesopotamia, appear as pictorial elements alongside the Hieroglyphic signs which had first aroused Evans's interest (Figs. 264–267, 310–312). Clay sealings impressed by Hieroglyphic seals reveal a true administrative system at work in and around the palaces which housed the seal workshops.[6] Writing disappeared from seals when the Hieroglyphic script was abandoned (see also **Chapters 5** and **7**).

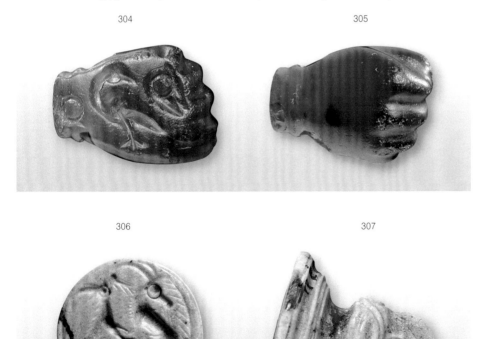

304 305

306 307

304–305. Cornelian seal in the shape of a clenched human fist. A bracelet has been carved around the wrist, across which the seal is pierced. The other side shows a bird with head turned back. Said to be from Crete. Middle Minoan II, 1900–1700 BC. 1.2 (L) × 0.65 cm (Th.). AN1938.1144.

306–307. Loop signet seal showing wild goats on rocky landscape on the seal face. From East Crete (Praisos or Chandras). Middle Minoan II–III, 1900–1700 BC. Agate. 1.35 (Diam.) × 1.4 cm (H). AN1938.934.

308–309. Loop signet, yellow jasper seal with cruciform design of eight interlocking C-spirals on the seal face. Said to be from Knossos. Middle Minoan II, 1900–1800 BC. Yellow jasper. 1.4 (Diam.) × 1.5 cm (H). AN1938.933.

310–312. Three-sided prism seal. This finely engraved seal shows on one side a seated cat with its face turned to the viewer and three Cretan Hieroglyphic signs and a fourth symbol (resembling a snake) around her. The other two sides bear Cretan Hieroglyphic signs flanked by nicely engraved patterns of palmettes and buds respectively. Said to be from Central Crete or the Lasithi district. Middle Minoan II, 1900–1800 BC. Cornelian. 1.7 (L) × 0.85cm (W). AN1938.791.

Meanwhile, cheaper, less elegant seals were being made for a different class of owner. Local soft steatite was worked with hand-held knives, gouges and solid drills to produce large numbers of seals; some 600 are known so far. A workshop excavated at Mallia reveals much about the techniques and stages of manufacture (Figs. 313–318).[7] These rather crude-looking seals were used for sealing too. Who, then, owned seals, and why? Most are three-sided prisms with pictorial motifs. Animals are a popular motif, especially the ever-present goat; the long-horned Cretan wild goat, *agrimi* or *kri-kri*, can be followed throughout Aegean glyptic. Also depicted

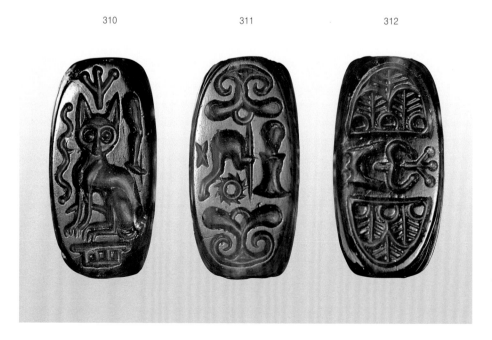

310 311 312

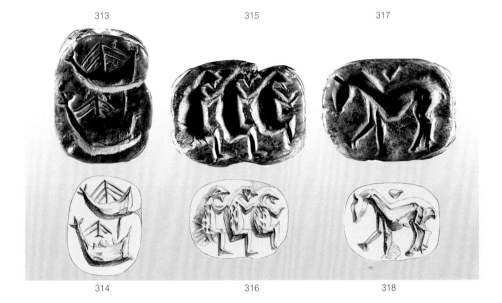

313 315 317

314 316 318

are ships, a rayed disk, and a curious motif which looks like vessels hung from a pole: might they be cheeses? or loomweights, sometimes with a man weaver? Suggestions abound. Sometimes people are shown, whose gestures have been variously interpreted, most interestingly by Lucy Goodison.[8] The Ashmolean has more than sixty prisms of this kind. Of the two on display in the Aegean World gallery, one may show a potter at work, with the other faces showing a man with three jugs and a pair of women perhaps worshipping the sundisk (Figs. 319–324). On the other a man sits before what may be a gaming board, much though it looks like a TV set.

313–318. Three-sided steatite prism of a type found in the Mallia workshop: a ship, its seated oarsmen(?), animal – something to do with trade and transport? Probably from Crete. Middle Minoan II, 1900–1800 BC. Object: L. 1.4, W. of sides 1.1 cm. AN1938.757.

319–324. Three-sided prism seal; a) two women adoring the solar symbol; b) a potter with a two-handled jar; c) a man with three jugs. Said to be from Kastelli Pediadas. Middle Minoan II, 1900–1800 BC. Steatite. 1.3 (L) × 1.25 cm (W). AN1938.746.

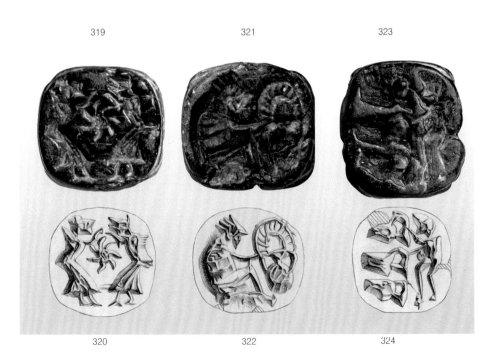

319 321 323

320 322 324

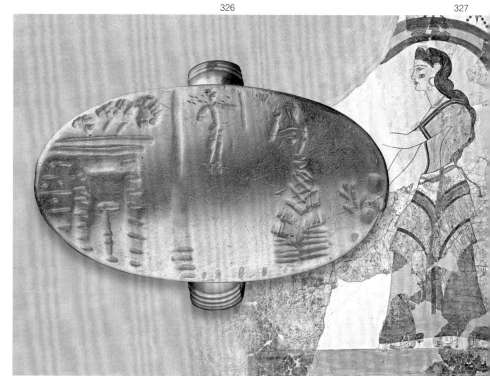

326

327

325

325–326. Signet ring with a 'scene of worship': woman, flying figure and façade. Said to come from Knossos. Late Minoan I, 1700–1450 BC. Gold (Au 93%, Cu 7%). 2.2 (bezel L) × 1.2 (bezel W) × 1.20–1.30 cm (inner hoop Diam.). Weight: 5.3 gr. AN1938.1127. Purchased by Arthur Evans at Herakleion in 1894 on the second day of his first trip to Crete.

327. House of the Ladies. Room 1. East section. South wall: Female figure. Notice the stricking similarity in the woman's flounced skirt on the Theran fresco and the gold ring on the left. H. 2.20, W. 2.05 m. 1700–1600 BC. Akrotiri, Thera.

328–330. Signet ring engraved with two figures driving a chariot drawn by Cretan wild goats. Said to come from Spiliaridia near Avdou, Central Crete. Late Minoan II–IIIA1, 1450–1375 BC. Agate. 2.8 (bezel L) × 2.1 (bezel W) × 1.4 cm (inner hoop Diam.). AN1938.1051.

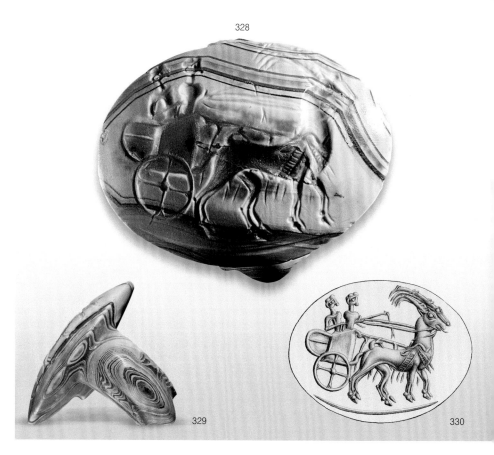

328

329

330

THE 'NEW PALACES' (CIRCA 1800–1450 BC): THE GOLDEN AGE

With technique built up over generations and with fine imported stones at their disposal, engravers produced masterpieces of carefully modelled, detailed figures and scenes. The greatest appear on gold rings, where they provide some of the principal evidence for Minoan religion (Figs. 325–327). The figures, usually women, worship, perhaps in a trance, at the 'epiphany' of a small hovering male god or spirit, pull at branches of a tree, and are involved with a ship which may represent the journey to the afterlife, a notion conceivably already represented in prisms found at Mallia. Perhaps the journey could also be made in a chariot drawn by wild goats: the agate ring (Figs. 328–330) matches a scene on the famous sarcophagus from Ayia Triada, which unmistakably relates to death. A whole series of scenes possibly concerned with the afterlife appears on the enormous, and still controversial, 'Ring of Nestor' (Figs. 331–332), including two originally foreign hybrids, the common griffin (Figs. 336–337) and the rare 'Babylonian dragon'.[9] A third such immigrant was the popular Egyptian demon Taweret (an upright pregnant hippopotamus with lion's mane, and a crocodile hanging down her back), who turned into the so-called 'Minoan genius', which performs ceremonial actions (Figs. 334–335).[10] Male religious figures appear occasionally as long-robed priests (Fig. 333), or possibly singing (Figs. 55–56). Sacred symbols, such as double axe, bull's head and 'horns of consecration', occur on seals as in other media.

331–332. 'Ring of Nestor'. Said to come from tholos tomb A at Kakovatos, mainland Greece. This ring is one of the most controversial Aegean objects in the Ashmolean's collection. Is it a masterpiece of ancient craftsmanship or a modern forgery? Doubts over its authenticity have been raised because of its complex decoration. The bezel is divided into four fields which are decorated with various figures and animals, including a winged griffin, a lion and a 'Minoan dragon'. For Evans, these scenes were interpreted as representing a Minoan 'after-world'. Late Minoan I, 1700–1450 BC (if original; otherwise, early 20th century AD). Gold (Au 97%, Cu 3%). 3.27 (L of bezel) × 2.14 (W of bezel) × 1.14–1.56 cm (inner hoop Diam.). Weight: 31.76 gr. AN1938.1130.

331

332

159

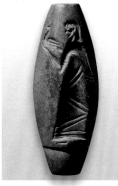

333

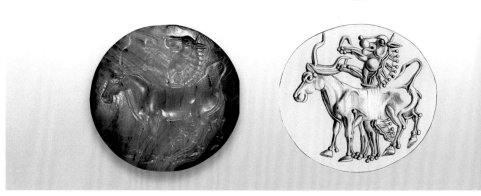

334 335

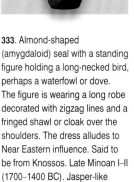

333. Almond-shaped
(amygdaloid) seal with a standing
figure holding a long-necked bird,
perhaps a waterfowl or dove.
The figure is wearing a long robe
decorated with zigzag lines and a
fringed shawl or cloak over the
shoulders. The dress alludes to
Near Eastern influence. Said to
be from Knossos. Late Minoan I–II
(1700–1400 BC). Jasper-like
green stone. 3.5 (L) × 0.9 cm
(Th.). AN1938.1050.

334–335. Agate lentoid seal
showing a 'Minoan genius' with
lion head and legs and paws on
human arms. The genius is
holding the lead-rope of a bull or
cow. The 'Minoan genius' derives
from the Egyptian Taweret (The
Great One), an Egyptian female
deity, protectress of fertility and
childbirth. With body and head of
hippopotamus or lion, pendulous
human breasts, a lion's mane and
paws and a crocodile's back and
tail, Taweret was loosely
transformed, sometime around
1900–1800 BC, into the 'Minoan
genius' – a wasp-like figure active
as a servant, often in offerings and
sacrifices. Said to be from Crete.
Late Minoan I, 1700–1450 BC.
Diam. 2.2 × Th. 1 cm.
AN1938.1041.

336–337. Sealstone depicting
a bull attacked by two griffins.
Said to be from Knossos. Late
Minoan II–IIIA1, 1450–1375 BC.
Haematite. 2.53 (Diam.) × 1 cm
(Th.). AN1938.1075.

336

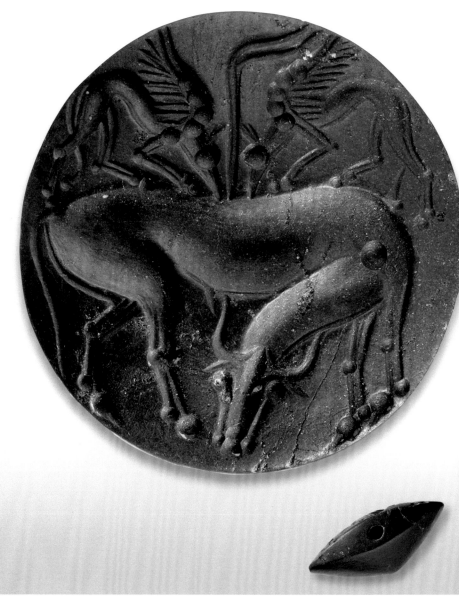

337

338

340

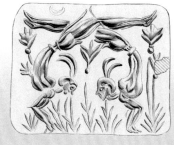

339

341

338–339. Sealstone depicting acrobats in a field of lilies. From Knossos, said to have been found on a hill about 800 m north of the palace. Middle Minoan III–Late Minoan I, 1800–1450 BC. Chalcedony. 2.15 (L) × 1.8 (W) × 0.8 cm (Th.). AN1938.955.

340–341. Sealstone depicting a wild goat leaping over rocks. Provenance unknown. Middle Minoan II–III, 1900–1700 BC. Agate. 1.9 (L) × 1.45 (W) × 0.54 cm (Th.). AN1938.946.

342–343. Clay sealing. One of the sides is decorated with a goat-headed figure with outspread wings. This sealing is of a type associated with the so-called 'Zakro Master', whose work was characterised by a flowing style featuring fantastical beasts and monsters. Room VII, House A, Zakros, Crete. Late Minoan IB, 1600–1450 BC. 1.70 cm (Diam. of seal impressions). AE.1199t. Given by the British School at Athens.

344. Sealstone depicting two dolphins jumping out of the water close to a rocky coastline. From Palaikastro, East Crete. Middle Minoan III–LM I, 1800–1450 BC. Steatite covered with gold foil (Au 90.2%, Ag 8.1%, Cu 1.6%). 1.75 (L) × 1.53 (W) × 0.7 cm (Th.). AN1938.963.

A butterfly probably expresses rebirth in the afterlife. Bull-leaping was doubtless a ceremony or ritual, not merely entertainment. Are the acrobats on the blue chalcedony cushion-shaped seal (Figs. 338–339) performing for some ceremony too, or merely for entertainment? Strange hybrids carved by a maverick at Zakro (Figs. 258–259, 342–343) presumably 'meant' something, to him if not to others, but what?[11] Lively and sensitive nature studies appear, especially on cushion-shaped seals. On (Figs. 340–341) the engraver exploits the banded agate in a very Minoan way, using the plain area for the branch and 'hiding' the wild goat with its magnificent sweeping horns in the banded part. A cushion showing two dolphins is made, unusually, of ordinary local steatite, but has a gold covering (Fig. 344). On lentoid (lentil-shaped) seals there are lovely studies of waterbirds, sometimes in a papyrus marsh, a scene from Egyptian wall-painting (Figs. 345–347).

342

343

344

161

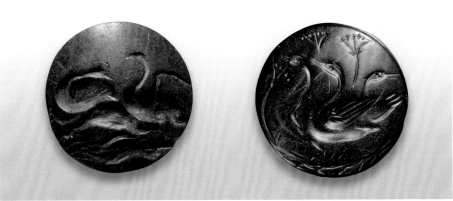

345 346

345. Sealstone depicting waterfowl – Evans's favourite seal. Said to have been found near Mirabello, East Crete. Middle Minoan III–Late Minoan I, 1800–1450 BC. Jasper-like hard stone. 1.7–1.55 (Diam.) × 0.7 cm (Th.). AN1938.971.

346. Sealstone depicting three waterfowl swimming amid papyrus. Said to be from Knossos. Middle Minoan III–Late Minoan I, 1800–1450 BC. Green jasper. 1.7 (Diam.) × 0.63 cm (Th.). AN1938.1066.

347. Sealing of waterfowl. From the 'Arsenal' or 'Armoury' deposit in the Palace at Knossos. Stylistic date: Late Minoan II, 1450–1400 BC. Context date: Late Minoan IIIA1, 1400–1375 BC. Burnt clay. 2.7–2.9 (max. L) × 3.3 cm (Diam.). AN1938.1068.

348. Impression of lentoid steatite seal: a man and a woman saluting in worship. Probably from Crete. Late Minoan I, 1700–1450 BC. Object: 2.05 (Diam.) × 0.70 cm (Th.). AN1938.1009.

349. 'Talismanic' seal with a stylised depiction of a puzzling subject resembling a modern tankard. Some scholars have called it a 'shrine'. Said to be from East Crete. Middle Minoan III–Late Minoan I, 1800–1450 BC. Agate. 2.25 (L) × 1.6 (W) × 0.7 cm (Th.). AN1938.984.

Simpler engraving also flourished in the form of the 'Cretan Popular' style (see Fig. 348: a man and a woman worshipping with the traditional Minoan 'salute' like small bronze figurines from the Psychro Cave) and two other, distinctive, styles. The 'Talismanic' school (Middle Minoan III–Late Minoan I, circa 1800–1450 BC) uses arcs, circles and straight lines to produce a particular repertoire of stylised, sometimes puzzling, motifs such as vessels, marine creatures, and something which resembles a beer tankard (Fig. 349).[12] Upwards of 1000 'Talismanic' stones are known but barely 25 sealings; hence the rather unsatisfactory name, going back to a theory that they were used as talismans. Evidently they were popular, but not used by officials in high places. The related 'Cut Style', overlapping with the 'Talismanic', starting and ending a little later, also leaves toolwork undisguised but relies on straight cuts and a small repertoire of lions, griffins, goats, and birds. The bird motif appears on a heart-shaped Egyptian amethyst, an uncommon Minoan bead shape (Fig. 351), and on a high-quality (sadly fragmentary) lapis lazuli (Fig. 350), one of only 19 lapis lazuli seals known. Two 'Cut Style' seals from the Psychro Cave (Fig. 352) are made of a new blue material introduced from the East, glass. The first glass seals were simply engraved, like stone. Did the sealmakers think glass was some kind of magic, meltable stone?

347

348 349

350 351 352

350. Sealstone depicting a bird of prey with outstretched wings (in flight?). No provenance. Late Minoan II–IIIA, 1450–1375 BC. Lapis lazuli. 1.8 (L) × 1 (W) × 0.32 cm (Th.). AN1941.1238.

351. Sealstone depicting a bird with outstretched wings. Said to be from Knossos. Middle Minoan III–Late Minoan I, 1800–1450 BC. Amethyst. 1.45 (L) × 1.15 (W) × 0.6 cm (Th.). AN1938.977.

352. Seal depicting a goat pierced with a javelin. Psychro Cave, Lasithi, Crete. Late Minoan II–IIIA1, 1450–1375 BC. Glass. 1.4 (Diam.) × 0.6 cm (Th.). AE.700.

353–354. Signet ring with a bull-leaping scene. Said to come from a chamber tomb at Archanes. Late Minoan II–IIIA1, 1450–1375 BC. Gold (Au 97%, Cu 2.5%). 3.4 (L of bezel) × 2.2 (W of bezel) × 1.55–1.85 cm (inner hoop Diam.). Weight: 20.5 gr. AE.2237 (originally AE.1804).

THE MYCENAEAN CONNECTION

It took time for the Mycenaean Greeks to discover, appreciate and adopt seals and sealing practices. At Late Minoan II–III Knossos, in the 15th–14th centuries BC, seals and rings were of course familiar (Figs. 353–355), but seal-based administration became simpler, seal ownership patterns probably changed, and so did seals. Some of the old semi-precious hard stones give way to new ones, while lumps of clay continue to be stamped with fine antique seals and rings (Figs. 359–360). Seals are now predominantly lentoid (Fig. 357) and on average bigger. Animals, peaceful or fighting, largely replace human scenes, and religious iconography shows different trends, as elaborate cult scenes probably associated with the old régime give way to the 'Mistress of Animals' and 'Master of Animals' flanked by griffins or lions as on the enormous seal from the Psychro Cave (Fig. 358).[13] The one purely Cretan hybrid appears now – the Minotaur! (Fig. 356).

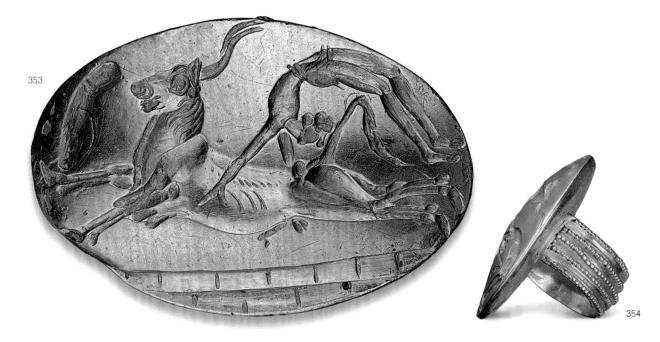

353

354

355

356

355. Ring. Bezel decorated with a papyrus plant and an ivy leaf. Said to come from the neighbourhood of Knossos. Late Minoan II–IIIA1, 1450–1375 BC. Bronze with traces of gilding. 2.27 (bezel L) × 1.3 (bezel W) × 0.6–1.85 cm (bent hoop W). AN1938.1053.

356. Sealstone depicting a half-man and half bull-figure ('Minotaur') and two 'fillers': a 'figure-of-eight shield' and an 'impaled triangle'. Psychro Cave, Lasithi, Crete. Lapis lacedaemonius (Spartan basalt). Late Minoan II–IIIA1, 1450–1375 BC. 2.3 (Diam.) × 0.9 cm (Th.). AN1938.1071.

357. A lentoid seal showing a man with three oxen. Provenance unknown. Late Minoan I–II, 1700–1400 BC. Red jasper. 1.7 (Diam.) × 0.6 cm (Th.). AN1938.1026.

358. A lentoid seal depicting a 'Mistress of animals' – a woman flanked by griffins. Psychro Cave, Lasithi, Crete. Late Minoan II–IIIA1, 1450–1375 BC. Cornelian. 3.37–3.53 (Diam.) × 1.5 cm (Th.). AE.689.

On the Mainland seals and rings are among the luxuries in the Mycenae Shaft Graves and they continue to appear in rich graves, notably in a monumental tomb at Vapheio near Sparta, whose occupant had 29 seals. Perhaps he was an early collector! Seals embellished with gold mounts or string-hole caps suggest a Mycenaean inclination to show off. The most popular stone is fancy agate of various colours and markings. Lapis lacedaemonius, a distinctive green-flecked dark stone, comes from near Sparta but it was not used as much as one might expect and may, curiously, have been worked only by Cretans. Although details can sometimes point clearly to either Crete or the Mainland, it is often impossible to determine whether a seal is Minoan or Mycenaean – where it was made, by whom and for whom. The religion of the two peoples was certainly not the same, for example, but how is this reflected on seals? Even asking the questions only raises more questions.

357

358

DECLINE AND FALL

Hard-stone engraving ceases in both regions in the 14th century BC. Soft stones, used continuously in Crete, now appear only on the Mainland. In Crete fluorite is a hallmark of this late period and the motifs are linear and angular (Fig. 361). 'Mainland Popular' stone seals, engraved with hand-held tools, favour animals and ornamental devices. The one innovation is casting glass seals in stone moulds, a method taken over from jewellery production; motifs are awkwardly executed animals (Fig. 362). Such mass production belies the point of a seal but is a splendid revealer of long-distance contacts. It seems to have been concentrated at places away from the Mycenaean palace centres, particularly at sites in central Greece which have been excavated only since the 1960s. Social and economic change is at work here.

Though the art of making them died out, seals were still around in the late 13th and 12th centuries BC, as antiques, chance finds, tomb-robbers' loot or family heirlooms. Possibly some people used them for marking stores or merchandise, but to others they were perhaps just something to wear or have around, leftovers from a bygone and more elegant age.

359. Sealing showing three female figures, one holding a vessel. 'Archives Deposit' in the area of the 'Domestic Quarter', East Wing, Palace at Knossos. Stylistic date: Late Minoan I, 1700–1450 BC. Context date: Late Minoan IIIA, 1400–1300 BC. Clay. 2.7–2.8 (L of bezel) × 1.8 cm (W of bezel). AN1938.1015a.

360. Sealing showing couchant bull facing right, and spiral pattern. From the Royal Tomb at Isopata to the north of the Palace at Knossos. Stylistic date: Late Minoan I–II, 1700–1400 BC. Context date: Late Minoan II–IIIA1, 1450–1375 BC. Burnt clay. 3.6 (max. L) × 1.7–1.8 cm (lentoid seal Diam.). AN1938.1082.

361. Fluorite seal with linear decoration. Psychro Cave, Lasithi, Crete. Given to the Museum by Evans. Late Minoan III, 1400–1300 BC. Diam. 1.3 × Th. 0.82 cm. AE.713.

362. Impression of a blue glass lentoid seal cast in a two-piece mould: two rams or goats and a branch or tree. Crete, Rethymno district. Late Minoan III, 1400–1300 BC. Diam. 1.5 cm (Diam.) × 0.75 cm (Th.). AN1941.144.

361 362

Endnotes

CHAPTER 2

1 Hogarth 1909, 48–9. David Hogarth (1862–1929) was Evans's successor to the Keepership of the Ashmolean (1909–1927) and an accomplished Aegean and East Mediterranean archaeologist.

2 On Evans and the transformation of the Ashmolean under his keepership see Thomas 1999; on his vision to transform the Ashmolean to a first-rate home of archaeology, largely inspired by his predecessor, Henry Parker (Parker 1870), Greville Chester (Chester 1881), and his father, John Evans, see Evans 1884.

3 For a brief summary of the museum's long history and recent transformation see Brown 2009, 5–37. For the Aegean gallery and its transformations see also Galanakis (forthcoming). For the history of the Museum in general see Ovenell 1986; MacGregor 1997; 2000.

4 Sherratt 2000b.

5 The Ashmolean collection of Cycladic antiquities was exemplary published a few years ago (Sherratt 2000a).

6 Evans 1943, 350.

7 On the de Jong cartoons see Hood 1998; on de Jong as an archaeological illustrator see Papadopoulos 2007.

8 PofM II, 704–712; Sherratt 2000, 7–8.

9 On Chester and his contribution to the Ashmolean see Seidmann 2006. For Chester's vision for the Ashmolean see Chester 1881.

10 These early explorations, accompanied by the transcribed diaries of Arthur Evans, were published a few years ago (Brown 2000).

11 On Kalokairinos see Kopaka 1989–1990; 1995.

12 The story of Sir John Evans is presented in the 'European Prehistory' Gallery at the Ashmolean. For an excellent collection of articles on the life of Sir John Evans see MacGregor 2008.

13 There are various interpretations regarding the 'Priest-King'. All are summarized and discussed in Shaw 2004.

14 Hughes-Brock 2009.

15 On Evans and his dealings in Athens in the early 1890s see Galanakis 2008; 2013.

16 Aesop's *Fables* in Penguin's Popular Classics Series no. 20 (1996), Chapter V.

17 Isaakidou and Tomkins 2008.

18 For a summary of this complex problem see Alberti 2004 and Preston 2008.

19 For a brief overview see most recently Hallager 2008.

20 Myres in Bosanquet et al. 1902–1903, 275.

21 Panagiotaki 1999 and Hatzaki 2009.

22 Warren 1969; Bevan 2007.

23 On Minoan painting see: Morgan 2005; Brysbaert.

24 Boardman 1961.

25 Hogarth 1910, 71.

26 Hogarth 1899–1900, 100–101.

27 More on these archaic plaques in Lebessi 1985 (on the sanctuary at Kato Symi Viannou).

28 This vision of Evans to create an open-air museum is discussed in Galanakis (forthcoming); see also Lapourtas 1995 for the influence that the museum might have exercised on Evans's decisions at Knossos.

29 On de Jong's influence see Kienzle 1998. On the influence of Evans's architects on the final appearance of the restored Palace see Palyvou 2003.

30 On Evans and the Gilliérons see Lapatin 2002, 120–139; also Stürmer 1994; 2004.

31 Galanakis 2008.

32 For a recent summary see Pulak 2010.

33 For an excellent collections of articles on the production and consumption of the 'Minoans' see Hamilakis and Momigliano 2006.

34 Dickinson 1986, 24.

CHAPTER 3

1 Evans 1921–1936. The complete list of Arthur Evans's scholarly writings fills an impressive seven pages of closely-written text in MacGillivray 2000, 331–337.

2 The original Greek work was *Μυκῆναι και Μυκηναίος Πολιτισμός* (Athens, 1893).

3 His conclusions on literacy could not be well-founded because this was before the discovery of the Linear B script, and decades before Michael Ventris's decipherment in 1952 that would prove conclusively that the language behind this script was an early form of archaic Greek (see also **Chapter 7**).

4 Wilkes 1976 and Brown 1993.

5 Evans 1943, 350.

6 Evans was mainly influenced by Karl Hoeck's work *Kreta* (1823–1829). The Göttingen scholar published a three-volume collection of Greek and Latin sources on Crete. He called Vol II: *Das Minoische Kreta* (Minoan Crete) essentially using the term 'Minoan' in a chronological sense to refer to Crete's 'mythological' age. See in detail Karadimas and Momigliano 2004.

7 Pendlebury 1969, 11.

8 Though see Blakolmer 2006 for the interesting suggestion that Minoan art and early twentieth century art coincidentally had certain aesthetic principles in common, so the fresco restorers were in fact true to the Minoan originals and were not unduly influenced by the styles prevalent in their own time.

9 See Hitchcock and Koudounaris 2002 for both sides of the debate.

10 Quoted in MacGillivray 2000, 245.

11 See Lapatin 2002 and 2006 for extensive accounts of Minoan forgeries, including the Ashmolean's 'boy-God', and their place in the history of reception of Minoan Crete.

12 'Wanting to believe' seems to have been the main reason for such mistakes. In fact Evans was well aware of the dangers of forgery, and Leonard Woolley describes going with him to a workshop in Crete that was full of fakes, particularly of ivory and gold figurines (Woolley 1962, 21–23). Evans himself, quite remarkably, tells of the 'boy-God' turning up with other objects in Paris a few years after WWI, and remarks: 'But the boy was in bad company. Of the numerous associated objects – all said to be Minoan and to have been found at the same spot – it was hard to recognize any genuine relic beyond one or two fragments.' (*PofM* vol. III, 443) In spite of all this, he continued to believe that the 'boy-God' was genuine.

13 Joan Evans's biography (Evans 1943), remains the basic account but is very clearly the work of an affectionate and much younger half-sister. MacGillivray's *Minotaur* (MacGillivray 2000) is much more critical. See also Fitton 1995, for brief accounts of the lives of Schliemann and Evans and some of the main strands of biographical approaches to them.

14 Hamilakis 2002.

15 *PofM* vol. III, 52.

CHAPTER 4

1 The Ashmolean's AE.235 (AN1893.63) is an example of a true bronze dagger, probably dating from roughly 2300 BC. This was possibly brought ready-made to the Cyclades from further east, where tin bronze first appeared (in north-west Syria) circa 3000 BC.

2 When the representations on the 'frying pans' from Chalandriani were first published, there was some uncertainty about which end was the prow and which the stern on the boats they portrayed. The excavator, Christos Tsountas, assumed that the high end was the prow. However, since then, with the help of a three-dimensional clay model from Palaikastro in Crete and with the addition of some experimental reconstructions, it has been shown convincingly that the high end was the stern (see also Roberts 1987).

3 Some of the pots from the settlement site of Phylakopi on Melos illustrated here (e.g. **Figs. 179–182**) and from Knossos (**Fig. 183**) belong to the Middle and early Late Bronze Age (circa 1600–1600 BC).

4 The description 'archaic figure of Aphrodite', as applied to marble figurines, first appeared in the Ashmolean Accessions' Register in 1889. A figurine of folded arm type of Dokathismata variety (**Fig. 173**) was characterised in 1896 as an 'archaic figure of Asiatic Goddess (proto-Semitic), later known as Astarte, Aphrodite, etc.'

5 The settlement site of Phylakopi, which started life early in the Early Cycladic period, was first excavated in the 1890s; Grotta on Naxos in 1949; and the fortified settlements of Kastri on Syros, close to the Chalandriani cemetery, and Panormos on Naxos in the 1960s. More recently, excavations at Skarkos on Ios and Markiani on Amorgos have begun to give us more information about the habitations of the living in the Early Cycladic period.

6 Particularly clearly by Broodbank 1989 and 2000.

7 It has often been suggested that the marble 'palettes' often found in graves were receptacles designed particularly for grinding pigments. However, there is little or no evidence (in the form of pigment residues) that this is what they were used for. The shape of the Ashmolean palette AE.181 (AN1893.67), which imitates the section of a longbone (**Fig. 154**), suggests that there may have been some symbolic significance. For what it is worth, there are one or two instances of 'palettes' of this shape being found in close association with female figurines, for which (it has been suggested) they would provide suitable 'cradles' or 'beds'.

8 There are around 50 vine leaf impressions on the bases of similar bowls from the cemetery at Chalandriani on Syros. They are also found on Amorgos, Paros, Naxos

and Siphnos, as well as on the contemporary Greek mainland and Crete. The practice also occurs at much the same time or slightly earlier at Tarsus in Cilicia, on the south-east Mediterranean coast of Turkey.

9 The decoration on AE.542 (**Fig. 180**), a beaked jug typical of Middle Bronze Age Cycladic White ware, consists of patterns which can be related to representations of clothing on later wall paintings from Crete and the Cyclades, which suggests that it echoes textile patterns.

10 This is well illustrated by the differential prices commanded by marble figurines which have been 'attributed' by modern connoisseurs to notional Early Cycladic 'artists' and those which have not. For instance, in a Sotheby's Sale of Antiquities in London, dated 6th July 1995, a fragmentary folded arm figurine (lot no. 32) attributed to the 'Steiner Master' had an estimate of £20,000–£25,000 attached to it. It was finally sold for £35,600. A no more fragmentary figurine of similar appearance (lot no. 28), but without formal attribution, was estimated at only £4000–£6000 and was finally sold for £7130, almost 5 times less than the 'Steiner Master' figurine.

CHAPTER 5

1 Recent investigations appear to have confirmed an early human presence, not necessarily permanent, on the island in the 9th millennium BC, with the possibility of still earlier visits: Strasser et al. 2010; also Kopaka and Mantzanas 2009.
2 Broodbank 2000, 341–349.
3 Karadimas and Momigliano 2004; see also Huxley 2000 on the history of British archaeology on Crete; Preston Day et al. 2004 on American archaeology there; and SAIA 1984 on Italian.
4 A word is necessary about terminology and chronology. Minoan culture is divided into phases in two ways. Evans developed a tripartite scheme for the Cretan Bronze Age, based on a perceived sequence of rise, florescence and decline, and calibrated against changes through time in the form and decoration of its ubiquitous ceramics. Thus his Minoan culture had 'Early', 'Middle' and 'Late Minoan' phases, each divided into three: I, II and III. These in turn, where appropriate, were subdivided into A, B and C. Absolute dates were assigned to these phases based on links to the Egyptian dynastic chronology. Although these, in theory, allow fairly precise and narrow phasing of ceramics, it became clear that there were certain key cultural shifts that took place on a larger time scale that did not fit exactly on to Evans's tripartite scheme. So, for example, the earliest palatial buildings at Knossos do not belong to the very first phase of the 'Middle Minoan', and, similarly, while many palatial and other sites suffer destruction within the 15th century BC, Knossos continues as a palatial centre for some generations. A more useful general terminology, therefore, divides Minoan culture into Pre-Palatial (before the palaces), Proto-Palatial (the time of the first, or 'old' palaces), Neo-Palatial (the 'new' palace period), Third or Final Palace period (the era of Knossos's Linear B administration), and Post-Palatial (the world after Knossos's destruction). See also the chronological table at the end of the book.
5 For a recent collection of papers on the topic, see Schoep et al. 2012.
6 See Klynne 1998 for an exploration of the complexities of reconstructing Knossos's palatial architecture; also Macdonald 2005 for the palace's history in general.
7 See Whitelaw 2004 on the different ways major sites developed at the end of the Pre-Palatial period.
8 It is possible that the characteristic Minoan symbol known since Evans as the 'horns of consecration' in fact represents mountain horizons (as a very similar sign did in Pharaonic Egypt), not the stylized horns of a bull: Powell 1977.
9 Discussion in Driessen et al. 2002.
10 On population estimates for Aegean Bronze Age settlements, see Whitelaw 2001; also Whitelaw 2012 on urbanisation.
11 Other palaces presented different approaches, for example Phaistos, where the Neo-Palatial palace had a monumental, stepped approach. On the question generally, see, e.g., Letesson and Vansteenhuyse 2006; Adams 2007.
12 Barber 1991.
13 See Palyvou 2000; Renfrew 2000.
14 Davis 1995.
15 See, e.g., Sherratt 2000.
16 Discussion, for example, in Hamilakis, 2002; Driessen *et al.*, 2002.
17 Bennet 1985; cf. Driessen 2001.
18 Preston 1999; 2004.
19 Bennet 1990.
20 Pulak 2010.
21 Shaw 2006.

CHAPTER 6

1 Alan Wace and Carl Blegen were the first to establish a chronology for the Greek mainland by adapting the tripartite system that Arthur Evans had pioneered for Minoan Crete. On the basis of the archaeological strata that they found in excavations at Mycenae and in various excavations around Corinth, they divided the period from circa 1700 BC to 1200 BC into three main phases roughly contemporary with Late Minoan I-III: Late Helladic I, Late Helladic II, and Late Helladic III. These have subsequently been subdivided and more clearly defined by Arne Furumark, Oliver Dickinson, Jeremy Rutter, and Elizabeth French (Alan Wace's daughter). Archaeologists are accustomed to refer collectively to all three phases as the Mycenaean period, recognizing Early (Late Helladic I and II) and Late (Late Helladic III) stages within it. Each is characterised by distinctive shapes and styles of pottery. Absolute dates for the start of the Mycenaean period are at this moment hotly debated, however, and some scholars favour a high chronology according to which the Late Helladic I period would begin in the 17th century BC. For a recent update on both the 'low' and 'high' chronology front see the articles in Manning and Bruce 2009.
2 Dickinson 1977.
3 McDonald and Thomas 1990, 50.
4 See French 2002, 14–16, on the topography of the site. Concerning Mycenae and its environs, French et al. 2003 is particularly valuable for its detail.
5 Greeks of historical times were astonished by the massive size of the blocks in the walls of Mycenae and sometimes attributed their construction to one-eyed giants, the Cyclopses of Greek mythology; the word is still used as a technical term in Mycenaean architectural studies (e.g. 'Cyclopean masonry').
6 Schliemann 1880, 80–84.
7 See Vermeule 1975 for an elegant and authoritative discussion of the imagery depicted in the many different media represented in the Shaft Graves.
8 Mylonas 1964.
9 Davis 2008.
10 Rutter 2010.
11 Robinson 2002.
12 Cavanagh and Mee 1998.
13 French 2002, 70–71.
14 French 2002, 57–62.
15 French 2002, 84–92.
16 Blegen and Rawson 1966, 94 and fig. 16.
17 See Lang 1969, 194–196, for an overview of the wall-painting program of the Throne Room.
18 Bennet 2011, 151–155.
19 Stocker and Davis 2004.
20 Bennet 2008, 187–188.
21 Pulak 2010 discusses the contents of one such ship that sank off the coast of modern Turkey while carrying a particularly rich cargo that included Cypriot and Mycenaean pottery.
22 Dickinson 2006, 63–64.

CHAPTER 7

1 Introductions to Cretan Hieroglyphic and Linear A include: Ventris and Chadwick 1973; Schoep 2002, especially Chapter 1; Hallager 1996; Chadwick 1990. The documents are published in: Godart and Olivier 1996 [hereafter *CHIC*] and Godart and Olivier 1976–1985 [hereafter *GORILA*].
2 See Schoep 2002, 18–19. There is some slight possible evidence that Cretan Hieroglyphic may have survived up to 1450 BC.
3 Introductions to Linear B include: Chadwick 1958; Chadwick 1976; Chadwick 1990.
4 However, the language – or languages – represented by Linear A was (or were) undoubtedly still being spoken on the island, possibly even as late as the 1st millennium BC. For a discussion of the language(s?) see Schoep 2002, 43–50. The latest attestation of a Linear A inscription is a votive inscription on a clay figurine from Poros, one of the ports of Knossos, dated by style to LM IIIA1 or 1400–1375 BC (Schoep 2002, 20, with references).
5 The notorious Phaistos disc is stamped with an unrelated script; see e.g. Chadwick 1990.
6 Kythera: *CHIC* no. 267; Samothrace: *CHIC* nos. 135–137.
7 A new tablet from Iklaina in Messenia is the first and so far only document from a second order centre (depending also on whether one considers Tiryns and Midea second order centres or not).

8 The transport stirrup jars (1400–1200 BC) are about 40cm high and have a capacity of 12–14l. More than 500 are known today from around 90 sites in the Aegean, the central and eastern Mediterranean. Over 170 examples are inscribed. The majority were manufactured in western Crete, in the Chania region. Central Crete, both north and south, was another significant region of manufacture, while a probable eastern Cretan production centre has also been suggested recently in the most thorough publication by Haskell et al. 2011.

9 Evans already had a good idea that the palace was likely to yield such artefacts since he had been shown a Linear B tablet in Herakleion in 1895, a surface find probably thrown up by Minos Kalokairinos's 1878 excavations: see Bennet 2000; Firth 2000–2001, 65, with further references.

10 The letter is in the archives of the Mycenaean Epigraphy Room, Faculty of Classics, Cambridge. It is worth noting that a key factor in Chadwick's recognition of Ventris's solution was his service as a code-breaker during the Second World War, first in Alexandria and later at Bletchley Park (Station X) where the Enigma code was deciphered. In Chadwick's experience, Ventris's decipherment looked like what a code looks like when it begins to 'break'. He could not of course mention this at the time, however, as code-breaking activities during the war were kept highly secret for decades. See Chadwick 2001.

11 Particularly important was a meeting of scholars at Gif-sur-Yvette near Paris in April 1956, where Ventris and Chadwick were much celebrated, and an atmosphere of international cooperation and friendship was established which is still referred to as *l'esprit de Gif*.

12 The best account of the decipherment is Chadwick's 1958 classic bestseller; for a fuller account of Ventris's life see Robinson 2002.

13 Cypriot Syllabic was a misleading guide to the decipherment of Linear B because the sign forms had changed so much it was not always clear which signs corresponded. Also, the spelling rules were radically different, something which Evans could not of course have known at the time. Most scholars eventually abandoned the attempt to drawn on Cypriot Syllabic for deciphering Linear B.

14 The classic article on the Mycenaean economy is Killen 1985 (and for an updated version see Killen 2008).

15 Killen 1964. For a relatively recent account see Halstead 2001.

16 Killen 1994.

CHAPTER 8

1 The Cretan diaries of Arthur Evans were published by the late Ann Brown a few years ago (Brown 2001).

2 The definitive publication of the Ashmolean seals is Hughes-Brock with Boardman 2009 in the international German-based series of catalogues of Aegean seal collections. This supersedes Kenna 1960. Many Ashmolean seals figure in Boardman 2001 and in Krzyszkowska 2005. The latter is a full and up-to-date account of Bronze Age seals, a useful guide on every aspect although not cited here in every instance.

3 For the Neolithic stamps see Makkay 1984 and 2005; for a brief account see Krzyszkowska 2005, 33–35. For the Early Bronze Age Mainland and islands see Krzyszkowska 2005, 36–56.

4 Krzyszkowska 2005, 72–74; Sbonias 1995: 113–118; Hughes-Brock 2000, 125. Pre- and Proto-Palatial seals are classified and discussed by shape, material and motif in Yule 1980 (dating and materials are occasionally out of date).

5 The cuneiform archives of Mesopotamian kingdoms record exchanges of goods with Crete (*Kaptara*, called *Caphtor* in the Old Testament).

6 See Krzyszkowska 2005, 95–118.

7 Krzyszkowska 2005, 92–95. See Evely 1993, chapter XII, 'Sealstones' (pages 146–171) for details of manufacturing processes throughout the history of Minoan sealmaking, with examples drawn mostly from the Ashmolean collection.

8 Goodison 1989.

9 This and the 'Ring of Minos' (Dimopoulou-Rethemiotaki and Rethemiotakis 2004) have mysterious histories and were long considered fakes by many. The lost original of 'Minos' surfaced dramatically in 2002. Its iconography has good parallels but that of 'Nestor' is unique and problematical. X-rays and ultra-sound tests should provide conclusive evidence for both.

10 Hughes-Brock 2000, 122; Weingarten 1991 and 2000.

11 Weingarten 1983.

12 Onassoglou 1985; Krzyszkowska 2005, 133–137.

13 Boardman 1961.

Reading List

ABBREVIATIONS

CHIC = Godart, L. and Olivier, J.-P. 1996. *Corpus Hieroglyphicarum Inscriptionum Cretae, avec la collaboration de J.-C. Poursat* (*Études crétoises* 30), Paris.

COMIK = Chadwick, J., Godart, L., Killen, J.T., Olivier, J.-P., Sacconi, A. and Sakellarakis, I.A. 1986–1998. *Corpus of Mycenaean Inscriptions from Knossos* (4 vols.), Cambridge.

CMS = Corpus der minoischen und mykenischen Siegel.

GORILA = Godart, L. and Olivier, J.-P. 1976–1985. *Recueil des Inscriptions en Linéaire A* (5 vols.), Paris.

KT[5] = Killen, J.T. and Olivier, J.-P. 1989 (5th ed.). *The Knossos Tablets* (*Minos Supplement* 11), Cambridge.

PofM = Evans, A.J. 1921–1936. *The Palace of Minos at Knossos* (4 vols. with index), London.

SM = Evans, A.J. 1909. *Scripta Minoa* I, Oxford.

PUBLICATIONS OF ASHMOLEAN MATERIAL

Boardman, J. 1961. *The Cretan Collection in Oxford. The Dictaean Cave and Iron Age Crete*, Oxford.

Brown, A. 1983. *Arthur Evans and the Palace of Minos*, Oxford.

Brown, A. 1993. *Before Knossos… Arthur Evans's Travels in the Balkans and Crete*, Oxford.

Brown, A. with Bennett, K. (ed.) 2001. *Arthur Evans's Travels in Crete, 1894–1899*, Oxford.

Brown, C. 2009. *Ashmolean: Britain's First Museum*, Oxford.

Catling, H.W. and Mannack, T. 2010. *Oxford, Ashmolean Museum. The Greek Geometric and Orientalizing Pottery* (*Corpus Vasorum Antiquorum – Great Britain, Fascicule 24; Oxford Fascicule 4*), Oxford.

Hood, R. 1998. *Faces of Archaeology in Greece. Caricatures by Piet de Jong*, Oxford.

Hughes-Brock, H. with Boardman, J. 2009. *Corpus der minoischen und mykenischen Siegel VI: Ashmolean Museum*, Mainz.

Momigliano, N. 1999. *Duncan Mackenzie. A Cautious Canny Highlander and the Palace of Minos at Knossos*, London.

Sherratt, S. 2000. *Arthur Evans, Knossos and the Priest-King*, Oxford.

Sherratt, S. 2000. *The Captive Spirit: Catalogue of Cycladic Antiquities in the Ashmolean Museum*, Oxford.

THE ASHMOLEAN'S WEBPAGE FOR THE SIR ARTHUR EVANS ARCHIVE

http://sirarthurevans.ashmus.ox.ac.uk/

GENERAL READING

Andreadaki-Vlasaki, M., Rethemiotakis, G. and Dimopoulou-Rethemiotaki, N. (eds.) 2008. *From the Land of the Labyrinth: Minoan Crete, 3000–1100BC. Essays and Catalogue*, New York.

Barber, R.L.N. 1987. *The Cyclades in the Bronze Age*, London.

Betancourt, P.P. 1985. *The History of Minoan Pottery*, Princeton.

Betancourt, P.P. 2007. *Introduction to Aegean Art*, Philadelphia.

Bintliff, J. 2012. *The Complete Archaeology of Greece. From Hunter-Gatherers to the 20th century A.D.*, Oxford.

Branigan, K. (ed.) 2001. *Urbanism in the Aegean Bronze Age*, Sheffield.

Broodbank, C. 2000. *An Island Archaeology of the Early Cyclades*, Cambridge.

Cadogan, G. 1976. *Palaces of Minoan Crete*, London.

Cadogan, G., Hatzaki, E. and Vasilakis, A. (eds.) 2004. *Knossos: Palace, City, State*, London.

Cavanagh, W. and Mee, C. 1998. *A Private Place: Death in Prehistoric Greece*, Jonsered.

Chadwick, J. 1976. *The Mycenaean World*, Cambridge.

Chadwick, J. 1987. *Linear B and Related Scripts*, Cambridge.

Cline, E. (ed.) 2010. *The Oxford Handbook of the Bronze Age Aegean*, Oxford.

Cullen, T. (ed.) 2001. *Aegean Prehistory: A Review*, Boston.

Davis, J.L. and Bennet, J. (eds.) 2008 (2nd ed.). *Sandy Pylos. An Archaeological History from Nestor to Navarino*, Princeton.

Deger–Jalkotzy, S. and Lemos, I. (ed.) 2006. *From the Mycenaean Palaces to the Age of Homer*, Edinburgh.

Demakopoulou, K. (ed.) 1988. *The Mycenaean World: Five centuries of early Greek Culture, 1600–1100 BC*, Athens.

Dickinson, O.T.P.K. 1994. *The Aegean Bronze Age*, Cambridge.

Dickinson, O.T.P.K. 2006. *The Aegean from Bronze Age to Iron Age*, London.

Doumas, C. 1992. *The Wall-Paintings of Thera*, Athens.

Driessen, J. and Macdonald, C.F. 1997. *The Troubled Island. Minoan Crete before and after the Santorini Eruption* (Aegaeum 17), Liège and Austin.

Driessen, J., Schoep, I. and Laffineur, R. (eds.) 2002. *Monuments of Minos. Rethinking the Minoan Palaces* (Aegaeum 23), Liège and Austin.

Duhoux, Y. and Morpurgo-Davis, A. (eds.) 2008–2011. *A Companion to Linear B: Mycenaean Greek Texts and their World* (2 vols.), Louvain-la-Neuve.

Farnoux, A. 1996. *Knossos. Unearthing a Legend*, New York.

Fitton, J.L. 1996. *The Discovery of the Greek Bronze Age*, London.

Fitton, J.L. 1999 (2nt ed.). *Cycladic Art*, London.

Fitton, J.L. 2002. *Minoans*, London.

French, E.B. 2002. *Mycenae: Agamemnon's Capital. The Site and its Setting*, Stroud and Charleston, SC.

French, E.G. and Wardle, K.A. (eds.) 1988. *Problems in Greek Prehistory*, Bristol.

Galaty, M.L. and Parkinson, W.A. 2007. *Rethinking Mycenaean Palaces II. Revised and Expanded Second Edition*, Los Angeles.

Gere, C. 2006. *The Tomb of Agamemnon. Mycenae and the Search for a Hero*, London.

Gere, C. 2009. *Knossos and the Prophets of Modernism*, Chicago and London.

Graham, J.W. 1987 (rev. ed.). *Palaces of Crete*, Princeton.

Grant, M. 2001 (rev. ed.). *In Search of the Trojan War*, London.

Hagg, R. and Marinatos, N. (eds.) 1984. *The Minoan Thalassocracy: Myth and Reality*, Stockholm.

Hamilakis, Y. (ed.) 2002. *Labyrinth Revisited: Rethinking 'Minoan' Archaeology*, Oxford.

Hamilakis, Y. and Momigliano, N. (eds.) 2006. *Archaeology and European Modernity: Producing and Consuming the 'Minoans'*, Padova.

Harding, A.F. 1984. *The Mycenaeans and Europe*, London.

Hemingway, S. 2012. *Art of the Aegean Bronze Age* (The Metropolitan Museum of Art Bulletin LXIX:4, Spring issue), New York.

Higgins, R.A. 1997 (2nd ed.). *Minoan and Mycenaean Art*, London.

Hood, S. 1978. *The Arts in Prehistoric Greece*, Harmondsworth.

Hooker, J.T. 1976. *Mycenaean Greece*, London.

Hope Simpson, R. and Dickinson, O.T.P.K. 1979. *A Gazetteer of Aegean Civilization in the Bronze Age I: The Mainland and the Islands*, Göteborg.

Hope Simpson, R. and Hagel, D.K. 2006. *Mycenaean Fortifications, Highways, Dams and Canals*, Sävedalen.

Huxley, D. (ed.) 2000. *Cretan Quests. British Explorers, Excavators and Historians*, London.

Iakovidis, S. 1983. *Late Helladic Citadels on Mainland Greece*, Leiden.

Immerwahr, S. 1990. *Aegean Painting in the Bronze Age*, Philadelphia.

Krzyszkowska, O. 2005. *Aegean Seals: An Introduction*, London.

Lapatin, K. 2002. *Mysteries of the Snake Goddess. Art, Desire and the Forging of History*, Boston.

Latacz, J. and Theune-Grosskopf, B. (eds.) 2001. *Troia: Traum und Wirklichkeit*, Stuttgart.

Macdonald, C.F. 2005. *Knossos*, London.

Manning, S.W. 1999. *A Test of Time: The Volcano of Thera and the Chronology and History of the Aegean and East Mediterranean in the Mid Second Millennium BC*, Oxford.

Manning, S.W. and Bruce, M.J. (eds.) 2009. *Tree-rings, king archaeology & environment: papers presented in honor of Peter Kuniholm*, Oxford.

McDonald, W.A. and Thomas, C.G. 1990 (2nd ed.). *Progress into the Past. The Rediscovery of Mycenaean Civilization*, Bloomington and Indianapolis.

McEnroe, J.C. 2010. *Architecture of Minoan Crete. Constructing Identity in the Aegean Bronze Age*, Austin.

Morris, I. and Powell, B. (eds.) 1997. *A New Companion to Homer*, Brill.

Morgan, L. (ed.) 2005. *Aegean Wall Painting. A Tribute to Mark Cameron*, London.

Mountjoy, P. 1993. *Mycenaean Pottery. An Introduction*, Oxford.

Myers, J.W., Myers, E. and Cadogan, G. (eds.) 1992. *The Aerial Atlas of Ancient Crete*, Berkeley.

Mylonas, G.E. 1966. *Mycenae and the Mycenaean Age*, Princeton.

Olivier, J.-P. and Vandenabeele, F. 1979. *Les Idéogrammes Archéologique du Linéaire B* (Études Crétoises 24), Paris.

Palyvou, C. 2005. *Akrotiri Thera: An Architecture of Affluence 3500 Years Old*, Philadelphia.

Preziosi, D. and Hitchcok, L. 1999. *Aegean Art and Architecture*, Oxford.

Renfrew, C. 1972 (repr. 2011). *The Emergence of Civilization. The Cyclades and the Aegean in the Third Millennium BC*, London.

Robinson, A. 2002. *The Man who Deciphered Linear B. The Story of Michael Ventris*, London.

Schoep, I., Tomkins, P. and Driessen, J. (eds.) 2011. *Back to the Beginning: Reassessing Social and Political Complexity on Crete during the Early and Middle Bronze Age*, Oxford.

Schofield, L. 2007. *The Mycenaeans*, London.

Shaw, J.W. 2009. *Minoan Architecture: Materials and Techniques*, Padova.

Shelmerdine, C. (ed.) 2008. *The Cambridge Companion to the Aegean Bronze Age*, Cambridge.

Taylor, W. 1994 (rev. ed.). *The Mycenaeans*, London.

Ventris, M.G.F. and Chadwick, J. 1973. (2nd ed.), *Documents in Mycenaean Greek. Three Hundred Selected Tablets from Knossos, Pylos and Mycenae with Commentary and Vocabulary*, Cambridge.

Vermeule, E. 1972. *Greece in the Bronze Age*, Chicago.

Voutsaki, S. and Killen, J.T. (eds.) 2001. *Economy and Politics in the Mycenaean Palace States*, Cambridge.

Wardle, K.A. and Wardle, D. (eds.) 1997. *Cities of Legend: The Mycenaean World*, London.

Warren, P.M. 1989. *The Aegean Civilizations*, New York.

Warren, P.M. and Hankey, V. 1989. *Aegean Bronze Age Chronology*, Bristol.

Wright, J.C. (ed.) 2004. *The Mycenaean Feast*, Princeton.

Online Resources (accessed 15 December 2012)

Aegaeus – Society for Aegean Prehistory:
http://www.aegeussociety.org/en/

Corpus of the Minoan and Mycenaean seals:
http://arachne.uni-koeln.de/drupal/?q=de/node/196

Hershenson, C.R. (ed.). *Nestor Bibliography of Aegean Prehistory and Related Areas*: http://classics.uc.edu/nestor/index.php/nestorbib

Palaima, T.G. (ed.). *Studies in Mycenaean Inscription and Dialect*:
http://paspserver.class.utexas.edu/

Rutter, J.B. *The Prehistoric Archaeology of the Aegean*:
http://www.dartmouth.edu/~prehistory/aegean/

Younger, J.G. (ed.). *Linear A*: http://people.ku.edu/~jyounger/LinearA/

Younger J.G. (ed.). *Sphragis*: http://people.ku.edu/~jyounger/Sphragis/

CHAPTER 2

Alberti, L. 2004. 'The Late Minoan II-IIIA1 Warrior Graves at Knossos: The Burial Assemblages', in Cadogan, G., Hatzaki, E. and Vasilakis, A. (eds.), *Knossos: Palace, City, State* (British School at Athens Studies 12), London, 127–136.

Bevan, A. 2007. *Stone Vessels and Values in the Bronze Age Mediterranean*, Cambridge.

Boardman, J. 1961. *The Cretan Collection in Oxford. The Dictaean Cave and Iron Age Crete*, Oxford.

Bosanquet, R.C., Dawkins, R.M., Tod, M.N., Duckworth, W.L.H. and Myres, J.L. 1902–1903. 'Excavations at Palaikastro. II', *The Annual of the British School at Athens* 9, 274–387.

Brown, A. with Bennett, K. (ed.) 2001. *Arthur Evans's Travels in Crete, 1894–1899*, Oxford.

Brown, C. 2009. *Ashmolean. Britain's First Museum*, Oxford.

Brysbaert A. 2008. *The Power of Technology in the Bronze Age Eastern Mediterranean: The Case of the Painted Plaster* (*Monographs in Mediterranean Archaeology* 12), London.

Chester, G.J. 1881. *Notes on the Present and Future of the Archaeological Collections*, Oxford.

Dickinson, O.T.P.K. 1986. 'Homer, the Poet of the Dark Age', *Greece and Rome* 33:1, 20–37.

Evans, A.J. 1884. *The Ashmolean as a Home of Archaeology in Oxford. An Inaugural Lecture given in the Ashmolean Museum (November 20, 1884)*, Oxford.

Evans, J. 1943. *Time and Chance. The Story of Arthur Evans and his Forebearers*, Oxford.

Galanakis, Y. 2008. 'Doing Business: Two Unpublished Letters from Athanasios Rhousopoulos to Arthur Evans in the Ashmolean Museum, Oxford', in Kurtz, D. with Meyer, C., Saunders, D. Tsingarida, A. and Harris, N. (eds.), *Essays in Classical Archaeology for Eleni Hatzivassiliou 1977–2007*, Oxford, 297–310.

Galanakis, Y. 2013. 'Prehistoric Research on Amorgos and the Beginnings of Cycladic Archaeology', *American Journal of Archaeology* 117:2, forthcoming.

Galanakis, Y. (forthcoming). 'Exhibiting the Minoan Past: Oxford to Knossos', in Panagiotopoulos, D. (ed.), *Minoan Archaeology. Challenges and Perspectives for the 21st Century*, Heidelberg.

Hallager, E. 2008. 'Crete', in Cline, E. (ed.), *The Oxford Handbook of the Bronze Age Aegean*, Oxford, 149–159.

Hamilakis, Y. and Momigliano, N. (eds.) 2006. *Archaeology and European Modernity: Producing and Consuming the Minoans* (*Creta Antica* 7), Padova.

Hatzaki, E. 2009. 'Structured Deposition as Ritual Action at Knossos', in D'Agata, A.-L. and van de Moortel, A. (eds.), *Archaeologies of Cult: Essays on Ritual and Cult in Crete in Honor of Geraldine C. Gesell* (*Hesperia Supplement* 42), Princeton, 19–30.

Hogarth, D.G. 1899–1900. 'The Dictaean Cave', *The Annual of the British School at Athens* 6, 94–116.

Hogarth, D.G. 1909. *Ashmolean Summary Guide*, Oxford.

Hogarth, D.G. 1910. *Accidents of an Antiquary's Life*, London.

Hood, R. 1998. *Faces of Archaeology in Greece: Caricatures by Piet de Jong*, Oxford.

Hughes-Brock, H. with Boardman, J. 2009. *Corpus der minoischen und mykenischen Siegel VI: Ashmolean Museum*, Mainz.

Isaakidou, V. and Tomkins, P. (eds.) 2008. *Escaping the Labyrinth. The Cretan Neolithic In Context* (*Sheffield Studies In Aegean Archaeology* 8), Oxford.

Kienzle, P. 1998. *Conservation and Reconstruction at the Palace of Minos at Knossos* (Unpublished PhD thesis, University of York).

Kopaka, K. 1989–1990. 'Μίνωος Καλοκαιρινού Ανασκαφές στην Κνωσό', *Palimpseston* 9–10 (*Vikelaia Library, Herakleion*), 5–69.

Kopaka, K. 1995. 'Ο Μίνως Καλοκαιρινός και οι πρώτες ανασκαφές στην Κνωσό', *Proceedings of the 7th International Cretological Conference*, vol. A1, Rethymno, 501–511.

Lapourtas, A. 1995. 'Arthur Evans and his Representation of the Minoan Civilisation at Knossos', *The Museum Archaeologist* 22, 71–82.

Lebessi, A. 1985. *Το Ιερό του Ερμή και της Αφροδίτης στη Σύμη Βιάννου. I.1: Χάλκινα Κρητικά Τορεύματα*, Athens.

MacGregor, A. 1997. 'The Ashmolean Museum', in Brock, M.G. and Curthoys, M.C. (eds.), *The History of the University of Oxford: Nineteenth-Century Oxford*, Oxford, 598–610.

MacGregor, A. 2000. *The Ashmolean Museum*, London.

MacGregor, A. (ed.) 2008. *Sir John Evans 1823–1908. Antiquity, Commerce and Natural Science in the Age of Darwin*, Oxford.

Morgan, L. (ed.) 2005. *Aegean Wall Painting. A Tribute to Mark Cameron* (*British School at Athens Studies* 13), London.

Ovenell, R.F. 1986. *The Ashmolean Museum, 1683–1894*, Oxford.

Palyvou, C. 2003. 'Architecture and Archaeology. The Minoan Palaces in the Twenty-First Century', in Papadopoulos, J.K. and Leventhal, R.M. (eds.), Theory and Practice in Mediterranean Archaeology: Old World and New World Perspectives (Cotsen Advanced Seminars 1), Los Angeles, 205–233.

Panagiotaki, M. 1999. *The Central Palace Sanctuary at Knossos* (*British School at Athens Supplement* 31), London.

Papadopoulos, J.K. 2007. *The Art of Antiquity: Piet de Jong and the Athenian Agora*, Athens.

Parker, J.H. 1870. *The Ashmolean Museum. Its History, Present State, and Prospects*, Oxford.

Preston, L. 2008. 'Late Minoan II to IIIB Crete', in Shelmerdine, C. (ed.), *The Cambridge Companion to the Aegean Bronze Age*, Cambridge, 310–326.

Pulak, C. 2010. 'Uluburun Shipwreck', in Cline, E. (ed.), *The Oxford Handbook of the Bronze Age Aegean*, Oxford, 862–876.

Seidmann, G. 2006. 'The Rev. Greville John Chester and 'The Ashmolean Museum as a Home for Archaeology in Oxford'', *Bulletin of the History of Archaeology* 16:1, 27–33.

Shaw, M.C. 2004. 'The 'Priest-King' Fresco from Knossos: Man, Woman, Priest, King, or Someone Else?', in Chapin, A.P. (ed.), *ΧΑΡΙΣ: Essays in Honor of Sara A. Immerwahr* (*Hesperia Supplement* 33), Princeton, 65–84.

Sherratt, S. 2000a. *Catalogue of Cycladic Antiquities in the Ashmolean Museum. The Captive Spirit*, 2 vols., Oxford.

Sherratt, S. 2000b. *Arthur Evans, Knossos and the Priest-King*, Oxford.

Stürmer, V. 1994. *Gilliérons Minoisch-Mykenische Welt. Ein Ausstellung des Winckelmann-Instituts Katalog*, Berlin.

Stürmer, V. 2004. 'Gilliéron als Vermittler der ägäischen Bronzezeit um 1900', *Studia Hercynia* 8, 37–44.

Thomas, B. 1999. 'Hercules and the Hydra: C.D.E. Fortnum, Arthur Evans and the Ashmolean Museum', *Journal of the History of Collections* 11:2, 159–169.

Warren, P.M. 1969. *Minoan Stone Vases*, Cambridge.

CHAPTER 3

Blakolmer, F. 2006. 'Bronze Age Crete and the European Modern Style', in Hamilakis, Y. and Momigliano, N. (eds.), *Archaeology and European Modernity: Producing and Consuming the Minoans* (*Creta Antica* 7), Padova, 219–240.

Brown, A. 1993. *Before Knossos... Arthur Evans' travels in the Balkans and Crete*, Oxford.

Evans, A.J. 1921–1936. *The Palace of Minos at Knossos* (4 vols. with index), London.

Evans, J. 1943. *Time and Chance: the Story of Arthur Evans and his Forbears*, London.

Fitton, J.L. 1995. *The Discovery of the Greek Bronze Age*, London.

Hamilakis, Y. 2002. 'What Future for the 'Minoan' Past? Re-thinking Minoan Archaeology', in Hamilakis, Y. (ed.), *Labyrinth Revisited: Rethinking 'Minoan' Archaeology*, Oxford, 2–28.

Hitchcock, L. and Koudounaris, K. 2002. 'Virtual Discourse: Arthur Evans and the Reconstructions of the Minoan Palace at Knossos' in Hamilakis, Y. (ed.), *Labyrinth Revisited: Rethinking 'Minoan' Archaeology*, Oxford, 40–58.

Hoeck, K.F.C. 1823–1829. *Kreta. Ein Versuch zur Aufhellung der Mythologie und Geschichte, der Religion und Verfassung dieser Insel, von den ältesten Zeiten bis auf die Römer-Herrschaft* (3 vols.), Göttingen.

Karadimas, N. and Momigliano, N. 2004. 'On the term 'Minoan' before Evans's Work in Crete (1894)', *Studi Micenei ed Egeo-Anatolici* 46:2, 243–258.

Lapatin, K. 2002. *Mysteries of the Snake Goddess: Art, Desire and the Forging of History*, Boston.

Lapatin, K. 2006. 'Forging the Minoan Past', in Hamilakis, Y. and Momigliano, N. (eds.), *Archaeology and European Modernity: Producing and Consuming the Minoans* (*Creta Antica* 7), 89–105.

MacGillivray, J.A. 2000. *Minotaur: Sir Arthur Evans and the Archaeology of the Minoan Myth*, London.

Pendlebury, J.D.S. 1969 (6th ed.). *A Handbook to the Palace of Minos at Knossos with its Dependencies*, London.

Tsountas, C. and Manatt, J.I. 1897. *The Mycenaean Age: A Study of the Monuments and Culture of pre-Homeric Greece*, London.

Wilkes, J.J. 1976. 'Arthur Evans in the Balkans 1875–81', *Bulletin of the Institute of Archaeology, University of London* 13, 25–56.

Woolley, L. 1962. *As I seem to Remember*, London.

CHAPTER 4

Atkinson, T.D., Bosanquet, R.C., Edgar, C.C., Evans, A.J., Hogarth, D.G., Mackenzie, D., Smith, C. and Welch, F.B. 1904. *Excavations at Phylakopi in Melos*, London.

Barber, R.L.N. 1987. *The Cyclades in the Bronze Age*, London.

Broodbank, C. 1989. 'The Longboat and Society in the Cyclades in the Keros–Syros Culture', *American Journal of Archaeology* 93, 319–337.

Broodbank, C. 2000. *An Island Archaeology of the Early Cyclades*, Cambridge.

Carter, T. 1997. 'Blood and Tears. A Cycladic Case Study in Microwear Analysis: the Use of Obsidian Blades from Graves as Razors?', in Bustillo, M.A. and Ramos–Millán, A. (eds.), *Siliceous Rocks and Culture*, Madrid, 256–271.

Coleman, J.E. 1985. '"Frying Pans' of the Early Bronze Age Aegean', *American Journal of Archaeology* 89, 191–219.

Davis, J.L. 1987. 'Perspectives on the Prehistoric Cyclades: An Archaeological Introduction', in Getz-Preziosi, P. (ed.), *Early Cycladic Art in North American Collections*, Richmond, 4–45.

Doumas, C.G. 1977. *Early Bronze Age Burial Habits in the Cyclades*, Göteborg.

Getz-Gentle, P. 1996. *Stone Vessels of the Cyclades in the Early Bronze Age*, Philadelphia.

Getz-Preziosi, P. 1987. *Sculptors of the Cyclades: Individual and Tradition in the Third Millennium B.C*, Ann Arbor.

Gill, D. and Chippindale, C. 1993. 'Material and Intellectual Consequences of Esteem for Cycladic Figures', *American Journal of Archaeology* 97, 601–659.

Hendrix, E. 1997–1998. 'Painted Ladies of the Early Bronze Age', *The Metropolitan Museum of Art Bulletin*, New Series 55:3, 4–15.

Hoffman, G. 2002. 'Painted Ladies: Early Cycladic II Mourning Figures?', *American Journal of Archaeology* 106, 525–550.

Marthari, M. 2001. 'Altering Information from the Past: Illegal Excavations in Greece and the Case of the Early Bronze Age Cyclades', in Brodie, N., Doole, J. and Renfrew, C. (eds.), *Trade in Illicit Antiquities: The Destruction of the World's Archaeological Heritage*, Cambridge, 161–172.

Nakou, G. 1995. 'The Cutting Edge: A New Look at Early Aegean Metallurgy', *Journal of Mediterranean Archaeology* 8:2, 1–32.

Renfrew, A.C. 1967. 'Cycladic Metallurgy and the Aegean Early Bronze Age', *American Journal of Archaeology* 71, 1–20.

Renfrew, C. 1972 (repr. 2011). *The Emergence of Civilization. The Cyclades and the Aegean in the Third Millennium BC*, London.

Renfrew, A.C. 1991. *The Cycladic Spirit*, London.

Roberts, O. 1987. 'Wind-Power and the Boats from the Cyclades', *International Journal of Nautical Archaeology and Underwater Exploration* 16:4, 309–311.

Sherratt, S. 2000, *Catalogue of Cycladic Antiquities in the Ashmolean Museum: The Captive Spirit*, Oxford.

Torrence, R. 1986. *Production and Exchange of Stone Tools: Prehistoric Obsidian in the Aegean*, Cambridge.

CHAPTER 5

Adams, E. 2007. 'Approaching Monuments in the Prehistoric Built Environment: New Light on the Minoan Palaces', *Oxford Journal of Archaeology* 26, 359–394.

Barber, E. 1991. *Prehistoric Textiles. The Development of Cloth in the Neolithic and Bronze Ages with Special Reference to the Aegean*, Princeton.

Bennet, J. 1985. 'The Structure of the Linear B Administration at Knossos', *American Journal of Archaeology* 89, 231–249.

Bennet, J. 1990. 'Knossos in Context: Comparative Perspectives on the Linear B Administration of LM II-III Crete', *American Journal of Archaeology* 94, 193–212.

Broodbank, C. 2000. *An Island Archaeology of the Early Cyclades*, Cambridge.

Davis, E. 1995. 'Art and Politics in the Aegean: The Missing Ruler', in Rehak, P. (ed.), *The Role of the Ruler in the Prehistoric Aegean* (Aegaeum 11), Liège and Austin, 11–22.

Driessen, J. 2001. 'Centre and Periphery: Some Observations on the Administration of the Kingdom of Knossos', in Voutsaki, S. and J. Killen (eds.), *Economy and Politics in the Mycenaean Palace States. Proceedings of a Conference held on 1–3 July 1999 in the Faculty of Classics, Cambridge*, Cambridge, 96–112.

Driessen, J. and Macdonald, C. F. 1997. *The Troubled Island: Minoan Crete before and after the Santorini Eruption* (Aegaeum 17), Liège.

Driessen, J., Schoep, I. and Laffineur, R. (eds.) 2002. *Monuments of Minos: Rethinking the Minoan Palaces* (Aegaeum 23), Liège.

Hamilakis, Y. (ed.) 2002. *Labyrinth Revisited: Rethinking 'Minoan' Archaeology*, Oxford.

Huxley, D. (ed.) 2000. *Cretan Quests: British Explorers, Excavators and Historians*, London.

Karadimas, N. and Momigliano, N. 2004. 'On the Term 'Minoan' before Evans's Work in Crete (1894)', *Studi Micenei ed Egeo–Anatolici* 46, 243–258.

Klynne, A. 1998. 'Reconstructions of Knossos: Artists' Impressions, Archaeological Evidence and Wishful Thinking', *Journal of Mediterranean Archaeology* 11, 206–229.

Kopaka, K. and Matzanas, C. 2009. 'Palaeolithic Industries from the Island of Gavdos, near Neighbour to Crete in Greece', *Antiquity* 83 (Project Gallery): http://www.antiquity.ac.uk/projgall/kopaka321/ (accessed 16 March 2012).

Letesson, Q. and Vansteenhuyse, K. 2006. 'Towards an Archaeology of Perception: 'Looking' at the Minoan Palaces', *Journal of Mediterranean Archaeology* 19, 91–119.

Macdonald, C. F. 2005. *Knossos*, London.

Manning, S.W. and Bruce, M.J. (eds.) 2009. *Tree-rings, kings & Old World archaeology & environment: papers presented in honor of Peter Kuniholm*, Oxford.

Morgan, L. (ed.) 2005. *Aegean Wall Painting: A Tribute to Mark Cameron* (British School at Athens Studies 13), London.

Palyvou, C. 2000. 'Concepts of Space in Aegean Bronze Age Art and Architecture', in Sherratt, S. (ed.), *The Wall Paintings of Thera: Proceedings of the First International Symposium*, vol. 1, Athens, 413–436.

Powell, B.B. 1977. 'The Significance of the so–called 'Horns of Consecration'', *Kadmos* 16, 70–82.

Preston, L. 1999. 'Mortuary Practices and the Negotiation of Social Identities at LM II Knossos', *The Annual of the British School at Athens* 94, 131–143.

Preston, L. 2004. 'A Mortuary Perspective on Political Changes in Late Minoan II–IIIB Crete', *American Journal of Archaeology* 108, 321–348.

Preston Day, L., Mook, M.S. and Muhly, J.D. (eds.) 2004. *Crete Beyond the Palaces: Proceedings of the Crete 2000 Conference*, Philadelphia.

Pulak, C. 2010. 'Uluburun Shipwreck', in Cline, E. (ed.), *The Oxford Handbook of the Bronze Age Aegean*, Oxford, 415–429.

Renfrew, C. 2000. 'Locus Iste: Modes of Representation and the Vision of Thera', in S. Sherratt (ed.), *The Wall Paintings of Thera: Proceedings of the First International Symposium*, vol. 1, Athens, 135–158.

SAIA. 1984 = *Creta Antica: Cento Anni di Archeologia Italiana (1884–1984)*, Rome.

Schoep, I., Tomkins, P. and Driessen, J. (eds.) 2012. *Back to the Beginning: Reassessing Social and Political Complexity on Crete during the Early and Middle Bronze Age*, Oxford.

Shaw, J.W. 2006. *Kommos: A Minoan Harbor Town and Greek Sanctuary in Southern Crete*, Princeton.

Sherratt, S. 2000. *Arthur Evans, Knossos and the Priest–King*, Oxford.

Strasser, T., Panagopoulou, E., Runnels, C., Murray, P., Thompson, N., Karkanas, P., McCoy, F. and Wegmann, K. 2010. 'Stone Age Seafaring in the Mediterranean: Evidence from the Plakias Region for Lower Palaeolithic and Mesolithic Habitation of Crete,' *Hesperia* 79, 145–190.

Whitelaw, T.M. 2001. 'From Sites to Communities: Defining the Human Dimensions of Minoan Urbanism', in Branigan, K. (ed.), *Urbanism in the Aegean Bronze Age* (Sheffield Studies in Aegean Archaeology 4), Sheffield, 15–37.

Whitelaw, T.M. 2004. 'Alternative Pathways to Complexity in the Southern Aegean', in Barrett, J.C. and Halstead, P. (eds.), *The Emergence of Civilisation Revisited* (Sheffield Studies in Aegean Archaeology 6), Oxford, 232–256.

Whitelaw, T.M. 2012. 'The Urbanisation of Prehistoric Crete: Settlement Perspectives on Minoan State Formation', in Schoep, I., Tomkins, P. and Driessen, J. (eds.), *Back to the Beginning: Reassessing Social and Political Complexity on Crete during the Early and Middle Bronze Age*, Oxford, 114–176.

CHAPTER 6

Bennet, J. 2008. 'The Aegean Bronze Age', in Scheidel, W., Morris, I.M. and Saller, R.P. (eds.), *The Cambridge Economic History of the Greco–Roman World*, Cambridge, 175–210.

Bennet, J. 2011. 'The Geography of the Mycenaean Kingdoms', in Duhoux, Y. and Morpurgo–Davies, A. (eds.), *A Companion to Linear B: Mycenaean Greek Texts and their World*, vol. 2 (*Bibliothèque des Cahiers de l'Institute de Linguistique de Louvain* 120), Louvain–la–Neuve, 137–168.

Blegen, C.W. and Rawson, M. 1966. *The Palace of Nestor at Pylos in Western Messenia I. The Buildings and Their Contents*, Princeton.

Cavanagh, W.G. and Mee, C. 1998. *A Private Place: Death in Prehistoric Greece*, Jonsered.

Davis, J.L. 2008. 'Minoan Crete and the Aegean', in Shelmerdine, C.W. (ed.), *The Cambridge Companion to the Aegean Bronze Age*, Cambridge, 186–208.

Dickinson, O.T.P.K. 1977. *The Origins of Mycenaean Civilisation* (*Studies in Mediterranean Archaeology* 49), Göteborg.

Dickinson, O.T.P.K. 2006. *The Aegean from the Bronze Age to the Iron Age: Continuity and Change between the Twelfth and Eighth Centuries B.C.*, London.

French, E. 2002. *Mycenae: Agamemnon's Capital. The Site in its Setting*, Gloucestershire.

French, E.B., Iakovidis, S.E., Ioannides, C., Jansen, A., Lavery, J. and Shelton, K. 2003. *Archaeological Atlas of Mycenae* (*The Archaeological Society at Athens Library* 229), Athens.

Lang, M. 1969. *The Palace of Nestor at Pylos in Western Messenia II. The Frescoes*, Princeton.

McDonald, W.A., and Thomas, C.G. 1990. (2nd ed.), *Progress into the Past. The Rediscovery of Mycenaean Civilization*, Bloomington.

Mylonas, G.E. 1964. *Grave Circle B of Mycenae*, Lund.

Pulak, C. 2010. 'Uluburun Shipwreck', in Cline, E. (ed.), *The Oxford Handbook of the Bronze Age Aegean,* Oxford, 862–876.

Robinson, A. 2002. *The Man Who Deciphered Linear B*, London.

Rutter, J.B. 2010. 'Mycenaean Pottery', in Cline, E. (ed.), *The Oxford Handbook of the Bronze Age Aegean,* Oxford, 415–429.

Schliemann, H. 1880. *Mycenae: A Narrative of Researches and Discoveries at Mycenæ and Tiryns*, New York.

Stocker, S.R. and Davis, J.L. 1984. 'Animal Sacrifice, Archives, and Feasting at the Palace of Nestor', in Wright, J.C. (ed.), *The Mycenaean Feast* (*Hesperia* 73), Princeton, 179–195.

Vermeule, E. 1975. *The Art of the Shaft Graves at Mycenae*, Cincinnati.

CHAPTER 7

Bendall, L.M. 2003. *The Decipherment of Linear B and the Ventris–Chadwick Correspondence*, Cambridge.

Bennet, J. 2000. 'Linear B and Linear A', in Huxley, D. (ed.), *Cretan Quests: British Explorers, Excavators and Historians,* London, 129–137.

Chadwick, J. 1958. *The Decipherment of Linear B,* Cambridge.

Chadwick, J.1976. *The Mycenaean World*, Cambridge.

Chadwick, J. 1990. 'Linear B and Related Scripts', in Hooker, J. (ed.), *Reading the Past,* London.

Chadwick, J. 1999. 'Linear B: Past, Present and Future', in Deger-Jalkotzy, S., Hiller, S. and Panagl, O. (eds.), *Floreant Studia Mycenaea*, Vienna, 29–38.

Chadwick, J. 2001. 'A biographical fragment: 1942-5', in Smith, M. and Erskine, R. (eds.), *Action This Day: Bletchley Park from the breaking of the Enigma code to the birth of the modern computer*, London, 110-126.

Firth, R.J. 2000–2001. 'A Review of the Find–places of the Linear B Tablets from the Palace of Knossos', *Minos* 35–36, 63–290.

Hallager, E. 1996. *The Minoan Roundel and Other Sealed Documents in the Neopalatial Linear A Administration* (*Aegaeum* 14), Liège.

Halstead, P. 2001. 'Mycenaean Wheat, Flax and Sheep: Palatial Intervention in Farming and its Implications for Rural Society', in Voutsaki, S. and Killen, J.T. (eds.), *Economy and Politics in the Mycenaean Palace States*, Cambridge, 38–50.

Haskell, H.W., Jones, R.E., Day, P.M. and Killen, J.T. 2011. *Transport Stirrup Jars of the Bronze Age Aegean and East Mediterranean* (*Prehistory Monographs* 33), Philadelphia.

Killen, J.T. 1964. 'The Wool Industry of Crete in the Late Bronze Age', *The Annual of the British School at Athens* 59, 1–15.

Killen, J.T. 1985. 'The Linear B Tablets and the Mycenaean Economy', in Duhoux, Y. and Morpurgo-Davies, A. (eds.), *Linear B: a 1984 survey* (*Bibliothèque des Cahiers de l'Institute de Linguistique de Louvain* 26), Louvain-la-Neuve, 241–298.

Killen, J.T. 1994. 'Thebes Sealings, Knossos Tablets, and Mycenaean State Banquets'. *Bulletin of the Institute of Classical Studies* 39, 67–84.

Killen, J.T. 2008. 'Mycenaean Economy', in Duhoux, Y. and Morpurgo-Davies, A. (eds.), *A Companion to Linear B: Mycenaean Greek Texts and their World* (*Bibliothèque des Cahiers de l'Institute de Linguistique de Louvain* 120), Louvain-la-Neuve, 159–200.

Schoep, I. 2002. *The Administration of Neopalatial Crete: A Critical Assessment of the Linear A Tablets and Their Role in the Administrative Process* (*Minos Supplement* 17), Salamanca.

Olivier, J.-P. 1986. 'Cretan Writing in the Second Millennium BC', *World Archaeology* 17, 377–389.

Robinson, A. 2002. *The Man Who Deciphered Linear B*, London.

Ventris, M.G.F. and Chadwick, J. 1973. (2nd ed.), *Documents in Mycenaean Greek. Three Hundred Selected Tablets from Knossos, Pylos and Mycenae with Commentary and Vocabulary*, Cambridge.

CHAPTER 8

Brown, A. with Bennett, K. (ed.) 2001. *Arthur Evans's Travels in Crete, 1894–1899*, Oxford.

Boardman, J. 1961. *The Cretan Collection in Oxford. The Dictaean Cave and Iron Age Crete*, Oxford.

Boardman, J. 2001. *Greek Gems and Finger Rings*, Oxford.

Dimopoulou-Rethemiotaki, N. and Rethemiotakis, G. 2004. *The Ring of Minos and Gold Minoan Rings. The Epiphany Cycle*, Athens.

Evely, R.D.G. 1993. *Minoan Crafts: Tools and Techniques. An Introduction*, vol. 1 (*Studies in Mediterranean Archaeology* 92:1), Göteborg.

Goodison, L. 1989. *Death, Women and the Sun: Symbolism of Regeneration in Early Aegean Religion* (*University of London, Institute of Classical Studies, Bulletin Supplement* 13), London.

Hughes-Brock, H. 2000. 'Animal, Vegetable, Mineral: Some Evidence from Small Objects', in Karetsou, A. (ed.), Κρήτη-Αίγυπτος. Πολιτισμικοί δεσμοί τριών χιλιετιών, Athens, 120–127.

Hughes-Brock, H. with Boardman, J. 2009. *Corpus der minoischen und mykenischen Siegel VI: Ashmolean Museum*, Mainz.

Kenna, V.E.G. 1960. *Cretan Seals with a Catalogue of the Minoan Gems in the Ashmolean Museum*, Oxford.

Krzyszkowska, O. 2000. 'The Eye of the Beholder: Some Nineteenth Century Views of Aegean Glyptic', in Müller, W. (ed.), *Minoisch-mykenische Glyptik: Stil, Ikonographie, Funktion* (*CMS Beiheft* 6), Berlin, 149–163.

Krzyszkowska, O. 2005. *Aegean Seals. An Introduction* (*Bulletin of the Institute of Classical Studies Supplement* 85), London.

Makkay, J. 1984. *Early Stamp Seals in South–East Europe*, Budapest.

Makkay, J. 2005. *Supplement to the Early Stamp Seals of South–East Europe*, Budapest.

Onassoglou, A. 1985. *Die 'Talismanischen' Siegel* (*CMS, Beiheft* 2), Berlin.

Pini, I. 2000. 'Eleven early Cretan scarabs', in Karetsou, A. (ed.), Κρήτη-Αίγυπτος. Πολιτισμικοί δεσμοί τριών χιλιετιών, Athens, 107–113.

Sbonias, K. 1995. *Frühkretische Siegel: Ansätze für eine Interpretation der sozial–politischen Entwicklung auf Kreta während der Frühbronzezeit* (*BAR-IS* 620), Oxford.

Weingarten, J. 1983. *The Zakro Master and his Place in Prehistory* (*Studies in Mediterranean Archaeology* 88), Göteborg.

Weingarten, J. 1991. *The Transformation of Egyptian Taweret into the Minoan Genius: A Study of Cultural Transmission in the Middle Bronze Age* (*SIMA pocket-book* 26), Partille.

Weingarten, J. 2000. 'The Transformation of Egyptian Taweret into the Minoan Genius', in Karetsou, A. (ed.), Κρήτη-Αίγυπτος. Πολιτισμικοί δεσμοί τριών χιλιετιών, Athens, 114–119.

Yule, P. 1980. *Early Cretan Seals: A Study of Chronology* (*Marburger Studien zur Vor- und Frühgeschichte* 4), Mainz.

The Chronology of Bronze Age Aegean (all dates BC)

DATES	1. CYCLADES	
3200-2800	Early Cycladic I	
2800-2300	Early Cycladic II	Early Bronze Age
2300-2100	Early Cycladic III	
2100-1900	Middle Cycladic I	
1900-1800	Middle Cycladic II	Middle Bronze Age
1800-1700	Middle Cycladic III	
1700-1600	Late Cycladic I	
1600-1400	Late Cycladic II	Late Bronze Age
1400-1050	Late Cycladic III	

DATES	2. CRETE	
3100-2700	Early Minoan I	
2700-2400	Early Minoan IIA	
2400-2200	Early Minoan IIB	Pre-Palatial (Before the 'Palaces')
2200-2100	Early Minoan III	
2100-1950	Middle Minoan IA	
1950-1900	Middle Minoan IB	Proto-Palatial
1900-1800	Middle Minoan II	('Old Palaces')
1800-1700	Middle Minoan III	
1700-1600	Late Minoan IA	Neo-Palatial ('New Palaces')
1600-1450	Late Minoan IB	
1450-1400	Late Minoan II	Third-Palace or Mono-Palatial
1400-1375	Late Minoan IIIA1	(Linear B Knossos)
1375-1300	Late Minoan IIIA2	
1300-1200	Late Minoan IIIB	'Post-Palatial' or Final-Palatial
1200-1050	Late Minoan IIIC	

DATES	3. MAINLAND GREECE		
3100-2700	Early Helladic I		
2700-2400	Early Helladic IIA		
2400-2200	Early Helladic IIB	Early Bronze Age	
2200-2100	Early Helladic III		
2100-1900	Middle Helladic I		
1900-1800	Middle Helladic II	Middle Bronze Age	
1800-1700	Middle Helladic III		
1700-1600	Late Helladic I		
1600-1450	Late Helladic IIA	Early	
1450-1400	Late Helladic IIB	Mycenaean	Late
1400-1375	Late Helladic IIIA1		Bronze
1375-1300	Late Helladic IIIA2	Late	Age
1300-1200	Late Helladic IIIB	Mycenaean	
1200-1050	Late Helladic IIIC		

NOTE: The present table follows the 'high' chronology. There is, however, strong ongoing debate over the chronology of the eruption of the Santorini volcano, which according to the pottery sequence is dated to the end of Late Minoan IA (for an excellent collection of recent articles on the subject see Manning and Bruce 2009). Recent results of scientific dating techniques suggest a date for the eruption sometime late in the 17th century BC (between 1630 and 1600 BC) instead of the one supported by the traditional chronology (around 1500 BC). The effect of an earlier date for the Santorini eruption is to extend the first phase of the Late Bronze Age, compressing the Middle Bronze Age. By circa 1400 BC things are back in balance again. Absolute dates in this chart have been rounded for clarity and should be cautiously used as with all archaeological dates.

Index

Figure Credits

American School of Classical Studies, Athens: p. 129, fig. 232
Archaeological Society at Athens: p. 121, fig. 214
Arthur Evans Archive, Ashmolean Museum: p. 15, fig. 8; p. 23, fig. 17; p. 24, figs. 22, 24; p. 35, figs. 38–39; pp. 36-37, figs. 40–44; p. 50, figs. 73, 75; p. 56, fig. 94; pp. 62–63, figs. 109–113; pp. 72–73, figs. 129–130; p. 75, fig. 133; pp. 78-79, figs. 136–137; p. 80, fig. 138; p. 109, fig. 196
CMS archive: p. 40, figs. 50, 52, 54, 56; p. 138, figs. 268–171; p. 157, figs. 314, 316, 318, 320, 322, 324; p. 154, figs. 298-301, p. 158, fig. 330; p. 160, fig. 335; p. 161, fig. 339, 341; p. 162, fig. 348; p. 165, figs. 361–362
Chronis Papanikolopoulos: p. 107, fig. 192
Faculty of Classics, University of Cambridge: p. 139, fig. 274
Heraklion Archaeological Museum: p. 109, fig. 195; 111, fig. 204 and p. 115, fig. 209
Heraklion Archaeological Museum and the Ashmolean Museum: p. 24, fig. 23
John Bennet: p. 106, fig. 191
Kapon Editions archive: p. 108 and p. 117, figs. 194 and 211
Managing Committee of the British School at Athens: p. 112, fig. 206; p. 125, figs. 222–223
National Archaeological Museum, Athens: p. 86, fig. 144, p. 149, fig. 293, p. 89, fig. 152
The Trustees of the British Museum: p. 76, figs. 134–135
21st Ephorate of Prehistoric and Classical Antiquities, Greece: p. 99, fig. 178
The National Geographic Society: p. 103, fig. 184 and p. 119, fig. 212
Thera Excavations: p. 113, fig. 207, p. 158, fig. 327
The Institute of Nautical Archaeology at Austin, Texas: p. 131, fig. 240
University of Cincinnati: p. 122, figs. 218–219 and p. 128, figs. 230–231

All other figures are courtesy of the Ashmolean Museum (Picture Library), University of Oxford. All objects given to the Museum by Arthur Evans, unless otherwise stated.